Gods in Granite

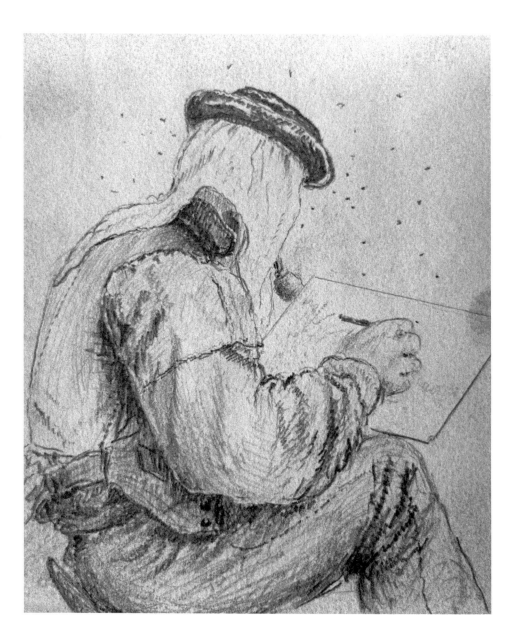

Unknown artist, Artist Sketching, *ca. 1870. Drawing. Courtesy of George Walter Vincent Smith Art Museum, Springfield, Massachusetts.*

Gods in Granite

The Art of the White Mountains of New Hampshire

ROBERT L. McGRATH

 SYRACUSE UNIVERSITY PRESS

Copyright © 2001 by Syracuse University Press
Syracuse, New York 13244-5160
All Rights Reserved
First Edition 2001

01 02 03 04 05 6 5 4 3 2 1

The paper used in this publication meets the minimum requirements of American National Standard for Information Sciences—Permanence of Paper for Printed Library Materials, ANSI Z39.48-1984. ∞

LIBRARY OF CONGRESS CATALOGING-IN-PUBLICATION DATA

McGrath, Robert L., 1935–
 Gods in granite : the art of the White Mountains of New Hampshire / Robert L. McGrath. — 1st ed.
 p. cm.
 Includes bibliographical references and index.
 ISBN 0-8156-0663-x (cloth : alk. paper)
 1. White Mountains (N.H. and Me.)—In art. 2. Painting, American. 3. Painting, Modern—19th century. 4. Painting, Modern—20th century. I. Title.

ND1460.W47 M37 2000
758'.17422 — dc21 00-059530

Book design by Christopher Kuntze

Manufactured in Canada

Nature is beautiful because it looks like art and art can only be called beautiful if we are conscious of it as art while yet it looks like nature.

— IMMANUEL KANT

We don't need new landscapes. We need new eyes.

— MARCEL PROUST

The good of going into the mountains is that life is reconsidered.

— RALPH WALDO EMERSON

Robert L. McGrath has been a professor of art history at Dartmouth College for more than thirty years. He is a specialist in American art and has published widely in the field, including numerous essays on landscape painting in New England and New York. He has curated exhibitions for the Adirondack Museum, the Old Forge Arts Center, and the Hood Museum of Art. He is currently planning an exhibition of the art of the White Mountains for the year 2002 at the Currier Gallery of Art.

Contents

Illustrations

Acknowledgments

M Y FIRST debt is to the geological forces that long ago created the White Mountains as a place for modern retreat and recreation. A still greater debt is owed to the artists and writers who shaped the cultural forces that over time have conferred meaning upon the peaks and valleys of northern New Hampshire. Credit must also be accorded to Senator John Weeks of Massachusetts, who in 1911 sponsored the federal legislation that created the White Mountain National Forest. Without his foresight, those tired old mountains and woods would be even more besieged and beleaguered than ever by the forces of ignorance and greed.

I further wish to acknowledge the many fine scholars of American art whose work has helped me to understand the constantly shifting relationship between nature and culture; they will find their names throughout the text and in the footnotes and bibliography. May they find here the expression of my gratitude for their research and insight. Special thanks go to Betsy Alexander, Mark Oldham, and Lisa Lindstrom for assistance above and beyond the call of duty. A generous grant from the Dean of Faculty at Dartmouth College helped provide the color illustrations for this publication. This volume has been supported, in part, by a grant from the Robert and Dorothy Goldberg Charitable Foundation.

Finally I wish to offer the expression of my deepest affection to my family, the members of which, singly and collectively, helped me climb every mountain. To them, who also know and love the White Mountains, I dedicate this study.

Hanover, New Hampshire
November 1999

Introduction

In the mountains of New Hampshire there is a union of the picturesque, the sublime, and the magnificent; there the bare peaks of granite, broken and desolate, cradle the clouds; while the vallies and broad bases of the mountains rest under the shade of noble and varied forests; and the traveller who passes . . . on his way to the White Mountains . . . cannot but acknowledge, that although in some regions of the globe nature has wrought on a more stupendous scale, yet she has nowhere so completely married together grandeur and loveliness—there he sees the sublime melting into the beautiful, the savage tempered by the magnificent.

—Thomas Cole, "Essay on American Scenery," 1835

FOR MUCH of the past two centuries the White Mountains of New Hampshire have served as the most important "wilderness" in America. Located in proximity to the great urban centers of the East, they have attracted countless artists, writers, scientists, travelers, and tourists to experience, study, and reflect upon the beauty and meaning of mountains, lakes, and forests. Written, and more especially, visual accounts of the cultural encounter with this fabled region form the basis for this study.

Viewed as an actual location and a metaphoric landscape—as both fact and symbol—the White Mountains initiated Romantics and moderns alike into the experience of nature while promoting ideological definitions of American identity at several critical junctures of our national history. Possessing greater "associations" than the Catskills, the Adirondacks, or the Rockies, these granite peaks and verdant forests played a large role in the formation of several of the major governing myths of American experience. Associationism, history, religion, and agrarianism are but a few of the rubrics under which meaning has been imparted to the land; topography, romanticism, realism, and modernism form the corollary aesthetics. As priests, patriots, scientists, aesthetes, and athletes, artists have perceived the White Mountain wilderness as a repository of complex, and often divergent, national and regional meanings.

From first to last the "Seven Wonders of New Hampshire"—Mounts Washington and Chocorua, the Franconia and Crawford Notches, the Flume, the Old Man of the Mountain, and Lake Winnepesaukee—supplied the romantic imagination with vistas of sublime grandeur and picturesque beauty. To more modern sensibilities these same sites intimated patterns of energy and force or, alternatively, places of retreat and renewal. As an undefiled wilderness of the imagination, the White Mountains constituted a psychological refuge from the pressures of rising industrialism, while the bracing climate of the actual region afforded relief in summer from the sweltering heat of the cities. Specifically, the villages of North Conway and West Campton, America's first art colonies, provided room, board, and companionship for artists, while the environing land bodied forth a recognizable topography together with an array of pictorial symbols and ritualized myths for one of our first regional schools of landscape painting.

Above all, the revelation of God's presence in the natural world was the principal thematic of the painters of the White Mountains. Here among the peaks and valleys was to be found one of those special places, an *axis mundi* in which "the sacred irrupted into the world" (Eliade 1959, 37). A space for the production of a divine ecology, the wilderness was at once a place of delight and the ground for a mystical reverence toward nature. From such chargedly numinous sites as Pulpit Rock and Cathedral Ledge the White Mountain landscape was redolent of Christian spirituality. The material presence of older epic land forms known variously as "stairs" and "graves," however, revealed that there were also "giants in the earth," pagan entities that conjured a primordial history for the region. For still others, a voyage through the great notches of the region was imagined as a descent into the abysses of the Inferno. In the imagination of the heroine of one mid-nineteenth-century novel, the White Mountains elicited powerful sexual fantasies.[1]

As emblems of sacred travail and aspiration, mountains especially were understood to signify the presence of the divine in nature and to form a material link between heaven and earth. Viewed as natural symbols ranging from gothic cathedrals to the "New Jerusalem on high," metaphoric mountain summits represented the goal of the universal Christian pilgrim in quest of the "Prepared Throne" of the Almighty. Above all, as votive icon and national symbol, Mount Washington— "The Crown of New England"—was an especially privileged manifestation of God's unique covenant with America.

1. Reynolds (1988, 218–19) quotes from George Templeton Strong's work of c. 1849, *The History of an Amorous and Lively Girl, of Exquisite Beauty, and Strong Natural Love of Pleasure:* "He tore open my bosom, and putting his lips to the 'White Mountains,' caused me the most thrilling pleasures."

By contrast to the soaring mountain summit, the verdant valley was more often viewed as an Edenic paradise for the delectation and instruction of the American Adam (and Eve), the site of a "New Hampshire, everlasting and unfallen." As a means of figuratively honoring the highlands and the lowlands (while revealing "the invisible with the visible") painting served to crystallize spiritual experience into material form for a deeply receptive public whose cultural imagination was further stimulated by novels, poems, and guide books.

In addition to divine exaltation, "pleasurable terror" was also experienced in the "storied associations" of this rugged wilderness. Fear, anxiety, and stress were engendered in excited minds by tragic tales of the Indians and settlers who first inhabited this mythic landscape. Released from nature's traditional role as passive backdrop to human enterprise, the White Mountains, wild and seductive, induced dread and delight while simultaneously warning men of the limits of their own power. To this end nature was persistently subjected by the romantic imagination to various forms of emblematic anthropomorphism. In countless painted landscapes arboreal actors bow before granite gods and cloud deities while babbling brooks, weeping waterfalls, and raging storms animate the mountains, forests, and valleys.

Beneath the legendary heights, beauty and tranquility resided in the soft intervales between the mountain ranges. In these gardens of nostalgia an abiding pastoral harmony informed the condominium between man and nature. To the artist of bucolic sensibility the welcoming vales afforded a perpetual *locus amoenus* wherein cows grazed, the warm sun shone in a cloudless sky, and it was always summer. A peaceful paradise, the lowlands were places devoid of physical privations and the strenuous exertions of human labor. Rather, leisure and social accord formed the most distinctive human behavior within the inhabited landscape. In sum, few places in America can lay claim to having served so many for so long as a sustained cultural resource. A "sacred place" hallowed by association, custom, and usage, the White Mountains functioned to ritualize for generations of Americans the past and the present, the real and the ideal, the nation and the region.

Both as myth and fact the White Mountains persistently played (and continue to play) a central role in the formation and evolution of the national vision of nature. Novelists from Francis Parkman to John Updike, poets from John Greenleaf Whittier to Wallace Stevens and painters from Thomas Cole to Carleton Plummer have discovered in the north country a landscape yielding diverse cultural energies and paradigms for the construction of many of the country's foundational myths.

This is not to claim, however, that there has ever been an enduring consensus about the meaning of the White Mountains. Ralph Waldo Emerson, for example, found them too high and the men too small,[2] whereas Robert Frost, a century later (and after the fall from innocence), claimed the men were too tall and the mountains too short. For Thomas Cole and Henry David Thoreau the region was the Garden of Paradise; for the writer Herman Melville and the painter William Zorach the land lay somewhere East of Eden. While the nineteenth-century clergyman Thomas Starr King invoked gastronomic metaphors to deplore the cultural consumption of the landscape,[3] another contemporaneous observer found the White Mountains the most serviceable locale for "killing time and spending money ever yet devised by lazy ingenuity" (Fox 1842, 208). These historical judgments, and others like them, bracket an ongoing dialectic between place and perception that continues to shape our vision of this literary and pictorial landscape as well as its objective correlative, the land itself.

To be sure, no regional landscape—despite the contentions of Knicker-bockers—can be understood to speak authoritatively for the nation as a whole. New Englanders, however, in naming the major peaks after American presidents, laid claim to a form of political and cultural hegemony. To many regional chauvinists the White Mountains—first sighted by Cabot and Verrazano at the beginning of the sixteenth century (the rising sun first touches the continent on the summit of Mount Washington)—denote by the process of synecdoche America at large together with the ideals of democratic freedom. The Presidentials still dominate the landscape of the nation's first electoral primaries, and the country's earliest

2. Emerson was particularly drawn to Mount Monadnock, which, on May 3, 1845, he climbed. Setting his thoughts to verse, he wrote a poem that he titled *Monadnoc*, which he published two years later. A symbol of "purposeful Creation" and human freedom, the mountain should, he avowed, allow for the locals "in these crags a fastness find / To fight pollution of the mind." Instead when he observed the typical inhabitant of the region, he discovered: "He was no eagle, and no earl— / Alas! my foundling was a churl, / With heart of cat and eyes of bug, / Dull victim of his pipe and mug" (quoted in Allen 1981, 486).

3. "People, in the majority of instances, reach Conway the same day that they left Boston and caught their first view of Winnipiseogee. They hurry through North Conway to 'the Notch,' whether it rains or shines, the day after. They ascend Mount Washington the third day; and, on the fourth, are driven to Franconia for an equally rapid glimpse of its treasures. . . . A large proportion of the summer travelers in New Hampshire bolt the scenery, as a man, driven by work, bolts his dinner at a restaurant" (Starr King 1859, 17). See also Miller 1993, 150n. 38 for a selection of "Alimentary metaphors" pertaining to the consumption of landscape. Starr King's gastronomic metaphor descends, albeit through inversion, from St. Augustine's claim that the clergy should savor the text of the Bible, chewing on its succulent meanings. For this tradition of literary mastication, see Camille 1992 (63–64).

reporting voting precinct, Dixville Notch, lies deep within them. By virtue of the state's motto, "Live free or die," New Hampshire lays claim to the symbolic locus of the last stand of the Yankee. Despite these exceptionalist claims, however, the representation of the White Mountains has, in point of fact, been inflected consistently by the art of other places. The complexities of this cultural dialogue between regional art and American identity—how specific vision illuminates and is in turn illuminated by the national ideal of landscape—forms another of the principal concerns of this study.

Among the White Mountains' many nineteenth-century devotees, the region claimed as its foremost apologist the Reverend Thomas Starr King. Pastor of the First Unitarian Church of Boston, he was well endowed both physically and spiritually to celebrate the topographic and moral geography and to interpret the symbolic land forms. For Starr King the White Mountains were both text and image, the "Book of Nature" as well as "Nature's Picture Gallery." In his famous guidebook, *The White Hills: Their Legends, Landscape and Poetry*, published in 1859, Starr King provided impassioned readings of the landscape as a form of visible revelation: "In the verbal scripture, mountains correspond to the truths of the highest plane" (1859, 6). Alternatively, he treated mountain scenery as an art form by equating White Mountain tourism with a visit to a museum. For Starr King sight, especially, was the most elevated of the senses and the one that most clearly apprehended the Creator's presence in the world. Sight, however, must be guided by insight and fortified by the careful and loving study of nature. Aligned along an axis between things and transcendence, vision yielded truths at once physical and metaphysical, natural and supernatural. Few theologians of place during the nineteenth century exercised greater influence than this mountain minister, who claimed that a visit to the White Mountains "supplies the most resources to a traveler" and confers "the most benefit on the mind and taste" of any region in America (1859, 402). For more than a generation Starr King instructed his devout readership where to go, where to stand, what to see, and what to think.

Writing a few years later, the inveterate traveler Bayard Taylor reaffirmed Starr King's assessment of the White Mountains as a natural picture gallery. Both describing and defining a reenvisioned relationship between art and nature, he claimed: "much of the [White Mountain] landscape consists of remembrances of New York studios. Every foreground was made up of sketches by Shattuck, Coleman and the younger painters; every background was a complete picture by Kensett" (1862, 344–45). Through such mental machinations the nexus between

the country and the city lay embedded within the fictive domain of the painted canvas, when life, according to Taylor, imitated art.

The New England Transcendentalists Ralph Waldo Emerson and Henry David Thoreau also inscribed and enacted a theology of word and deed in the sacred spaces of the White Mountains. As devout pilgrims both climbed Mount Washington (led by the famous guide and mountain man Ethan Allen Crawford) and wrote radiant accounts of their respective encounters with the "Monarch of New England."

During the closing decades of the nineteenth century, Henry Ward Beecher, another influential clergyman, also summered in the White Mountains. His renowned sermons at the Twin Mountain House attracted thousands of tourists, who gathered beneath a large tent to experience the exalted rhetoric of the "Boston Boanerges."[4] Like Starr King, Beecher avowed that nature is "hieroglyphic," the repository of divine signs and symbols.[5] The task of decoding this "natural" language fell to exegetes like these pantheist-ministers, who could best perceive the links between the material and spiritual worlds.

Significantly, the White Mountains were also the subject of the first landscape photographs in America. More revelations of social history than spiritual truths, these early photographs helped to define and encode the principal tourist sites in the region. From the daguerreotypes of Samuel Bemis to the thousands of stereographs produced by the Kilburne brothers of Littleton, New Hampshire, photographic images of the White Mountains entered countless American homes to promote appreciation for nature through this special form of armchair tourism.[6]

Turning specifically to those landscape paintings that form the basis of this study, it is axiomatic that White Mountain artists sought persistently to reveal the

4. Compare with McGrath 1978 (15–20) for a discussion of Henry Ward Beecher's role in the White Mountains.

5. Beecher's "hieroglyphic" is not to be confused with Karl Marx's "social hieroglyphic," the emblem of concealed social relations. Marx's "social hieroglyphic," however, is also a potentially useful, albeit elusive, concept for the study of White Mountain landscapes. While neo-Marxist art historians of British landscape painting such as John Barrell (1980), Ann Bermingham (1986), and David H. Solkin (1982) view benign paintings of the rural English countryside as an attempt to conceal reactionary politics and oppressive social practices, it is not evident that similar intentions inform paintings of the White Mountains.

6. For an excellent discussion of early tourist photography in the White Mountains, see Southall 1979. See also Naef 1975 where he observes: "If one location must be cited as the birthplace of American landscape photography, it is that of the White Mountains, which was perhaps the first mountainous wilderness area to receive the attention of an audience consisting primarily of city dwellers" (280).

universal in light of the specific. A scene of Mount Washington might serve to gratify viewers through the ability to recognize a well-known site while simultaneously evoking for more sensitive and nuanced minds the presence of the divine in the world. As physical description revealed spiritual inscription, the informed spectator enacted a ritualized litany of response to the sacred land forms. For still others the same mountain bespoke the regional landscape, nature's nation, or, alternatively, the destiny of New England as "the privileged carrier of national identity" (Miller 1993, 16).[7] Grounded less in the actual topography than in a diversity of cultural practices, representations of the "Crown of New England" (i.e., Mount Washington) often produced conflicted readings ranging from a monument to the ideals of democracy to associations of monarchy. In short, the audience for White Mountain paintings was stratified, and its responses varied in conformity with individual tastes, needs, knowledge, and aspirations. According to art historian Angela Miller the multivalent meanings imposed on the American wilderness by nineteenth-century painters well served a politically and socially complex constituency and the nationalist doctrine of "E pluribus unum" (1993, 15). Their collective vision having evolved over time from conventional formulas for nature to increasingly naturalistic transcripts, artists successively repressed the imperatives of myth, history, and language, without ever wholly renouncing nature's numinous character or, in some instances, reacting against her purported spirituality.

Viewed from the current social perspective, paintings of the White Mountains are as intriguing for what they do not show us as for what the artists chose to represent. Erased for the most part from these pictures are scenes of labor or physical exertion. Snow, rain, and wind are rarely encountered, and the sting of the ubiquitous black fly is unknown to the travelers and tourists who populate the fictive landscape. Evading through the workings of the human imagination the realities of labor, property, and climate, painters of the White Mountains largely configured the region as a mythic preserve released from the exigencies of mundane experience.

Paradoxically, White Mountain views, painted for the most part in New York or Boston studios, tend to be inflected by the values and assumptions of the metropolitan center rather than the place itself.[8] Only such "native" nineteenth-century artists as Edward Hill (who nonetheless painted for an urban clientele) seem

7. For another thoughtful account of the political function of landscape painting see Anderson and Ferber 1990 (105).

8. According to Mitchell (1994, 1–2), landscape painting does not merely symbolize power relations, but is, in itself, an instrument of cultural power. Although we agree with this assertion in principle, it is not always possible to discern with any certainty (see Mitchell 1994, 8–9) the impact of works of art on use and understanding of the environment.

remotely aware of the actual, working landscape. On the whole, the festive occupants of White Mountain paintings contemplate the natural world rather than animate it through physical activity.

In large measure, winter and spring—less than ideal seasons in the north country—do not figure prominently in the seasonal iconography. Moreover, the depredations of industry, technology, and, most conspicuously, logging are "naturalized" by the grand vista or, most often, excluded altogether. In short, artists constructed an idealized world—initially a landscape of adversity but more persistently over time a pastoral retreat—that bore little or no relationship to temporal and physical actualities. Better preserved on canvas than in fact, the White Mountains were viewed by painters and writers alike as a locus of cultural possibility rather than a realm for commercial exploitation. In this critical regard, the painted representations of these sacred mountains and peaceful valleys functioned after the mid–nineteenth century as a kind of pictorial wish-fulfillment, a safe refuge from the increasing pressures of industrial society upon the land itself.

While it is also tempting (in conformity with recent feminist scholarship) to view the iconography of the American landscape as gendered, in point of fact the summits and the lowlands were the fictive site of both masculine and feminine agency. Women were no more banished from high places than men excluded from the more domestic spheres of North Conway and the Pemigewasset Valley. Moreover, female writers and painters, though fewer in number than their male counterparts, do not differ markedly in their topographic descriptions and aesthetic appraisals of the White Mountains.

In addition to encoding a sacred iconography, painted views also served as cultural templates for comprehending nature. Wresting order out of the "tangled maze" of actuality, White Mountain paintings structured the perception of the north country for succeeding generations of American nature lovers. In this regard, these canvases should not be viewed as transparent windows on a "real" world; they are less replications of external reality than imaginative responses of individual artists to the experience of nature. As much as one might be tempted to view them as factual they are, at base, carefully edited interpretations of the mountain world. Art, in short, can mediate reality; but more often it constructs our conceptions of actuality. The notion that there is a "real" White Mountains mirrored in art is, at best, a critical myth devised for the purpose of naturalizing what is, at base, artificial. From first to last the actual land forms—the external referents—were absorbed by artists into preexisting pictorial conventions, and any tensions generated between the fictive and the real were elided into that imaginative realm locat-

ed somewhere between what we hope for and what we know. In short, the White Mountain landscape was mostly lodged in the human imagination, where it underwent diverse cultural transformations before being projected onto canvas.

"Nature," or more precisely the art of landscape through which it is most often reified, is neither fixed nor eternal. Rather it is a phenomenon persistently reshaped by people, habitations, technical interventions, and the imagination. An active mythology embodying the beliefs and aspirations of various cultural groups, it is best understood (and the White Mountains are no exception) as a visual fiction wherein religious, social, and political values can be affirmed (or, conversely, disguised) by "natural" laws.[9] In sum, nature, lacking the power of self-representation, is best viewed as a *tabula rasa* upon which artists inscribe their desires, anxieties, and aspirations, as well as the expectations of their clientele.

As suggested above, the process by which the actual world was transformed into a set of mythic vistas is a process of cultural reification. Substituting ideas about nature for reality itself, painters and writers created diverse conceptual paradigms for landscape. Why, it might be asked, have artists striven progressively to historicize, sacralize, pastoralize and, ultimately, aestheticize the White Mountains? Was it to honor the region and thereby protect it from the ravages of modern industrialism? Or, conversely, was it to provide the security of a "rhetorical screen" behind which nature could be more easily exploited by loggers, railroad builders, and hotel owners? Did landscape painting provide for a popular belief in the persistence of wild nature at the very moment of its near extirpation? Clearly no single answer will suffice to account for the disparity over time between the practices of artists and the economic and social history of the White Mountains. Arguably, painted vistas of pristine wilderness offered the assurance, in the face of a contrary reality, that nature was vast and infinite. Reluctant to give up the project of "nature's nation," artists constructed for a willing audience an unblemished view of the wild recollected in the tranquility of the studio long after it had ceased to exist. Even today many hikers and climbers, not to mention tourists and visitors, continue to seek a "wilderness experience" in the White Mountains, the first and largest National Forest east of the Mississippi. In this vital connection, the widespread reverence for nature generated by painted representations of wilderness also served to produce a political climate conducive to the creation of the National Park System.

With regard to the impact of technology on the land, the pictorial as well as the

9. For an excellent analysis of this phenomenon see Myers 1987, whose research on the meaning of the Catskills is a model of regional studies to which the methodology of this book is much indebted.

actual wilderness was systematically traversed, especially during the later 1800s, by the railroad. Artists, often in the employ of owners, minimized any potential conflict by intimating that nature and the machine could coexist in pictorial and actual harmony. The destructive aspects of modern industrialism were conveniently disguised by, among other things, the cult of pastoralism, which has been defined by the historian Leo Marx as the ideology of "the middle landscape" (1964, 5–6). In the final analysis, however, the dilemma of the simultaneous cultural and industrial exploitation of the White Mountains during the last century remains a perplexing mystery. At one level these paintings represented a kind of visual sanctuary, resistant to change, and therefore an "ideal preserve of myth." In reality, the White Mountains by the year 1900 were the most heavily logged region in America. If we acknowledge that art is often an act of recouping something in the process of being lost (Robert Frost's "momentary stay against confusion"), we will probably come closest to providing a plausible answer to these complex questions concerning the function of painted landscapes.

For all intents and purposes the imaginative displacement of the actual landscape by pictorial commodities (i.e., paintings) obscured the apparent dichotomy between nature and culture. With alchemical skill, works of art displayed a capacity to serve as surrogates for the reality that they purported to replicate. Both in the past as in the present, a resplendent painting of the Intervale at North Conway or of the Pemigewasset Valley displayed the remarkable capacity to become more "real" than the place itself, while collapsing the boundary between place and perception, "landscape and memory," altogether. Significantly, representations of the White Mountains were most often destined for the city and, as is often claimed, the love of nature is more conspicuous in urban centers than in the country. As such, both the preservation and the destruction of the White Mountains largely depended on ideas and values emanating from the metropolis where, then as now, economic and cultural power resides.

Although the organizing principle of this study is regional, no special claim is made for the unique role of the White Mountains in shaping a broader landscape aesthetic for America. The visual paradigms engendered over time by artists were also applied to the representation of the Catskills, the Adirondacks, the Sierras, and the Rockies. The art of landscape is far more than a simple mirroring process. Indeed, no art form is ever so reportorial or capable of transcending its own premises, as to duplicate the vagaries of the actual world.

To the related question of whether White Mountain paintings are in any sense governed by the peculiar qualities of form, light, and atmosphere encountered in

northern New England, a similar answer must be given. As appealing as the idea of geographical determinism may be to regional chauvinists, the extraordinary variety of pictorial responses to the White Mountains over time precludes any such notion. For the same reason it is difficult to argue for a discrete White Mountain school of painters, as apologists have done since the beginning of this century.[10] Rather, art generally depends as much upon the influence of other works of art as upon any direct apprehension of the external world.[11] As previously noted, the "formal" properties of White Mountain painting do not differ significantly from aesthetic strategies generated *inter alia* in the Hudson River Valley, along the New England coast, in the forest of Fontainebleau, or in further instances in Paris and New York City. If anything resembling an aesthetic unique to the White Mountains can be defined, it resides in those late-nineteenth-century landscapes by such artists as Edward Hill and Frank Shapleigh, where a rapid and expedient facture—what might be termed a "tourist touch"—can be located.

Qualitatively, paintings of the White Mountains range from masterworks to unskilled pastiches of scenery. Canvases by Cole, Marin, and Stella rank among the finest products of their respective periods. Conversely, thousands of views, painted primarily for tourist consumption, scarcely rise about the level of souvenirs. While Conceptual-Realism is the dominant aesthetic of most nineteenth-century White Mountain paintings, luminist and tonalist canvases were also produced in considerable numbers. Among modernist styles impressionism, symbolism, and expressionism were also employed in the depiction of the mountains, lakes, and forests. Finally cubism, abstraction and, more recently, postmodern strategies have also figured in the representation of the region.

For the most part the more expressive elements of White Mountain painting were formulated elsewhere. Only the specific topography—the content as opposed to the form—is consistently inflected by the place. As the great number, variety, and superior quality of many extant paintings make clear, however, the White Mountains were always a site of special importance to American artists. This study, then, is an effort to explore the complex interaction over time between artistic perception, public reception and the reality of place.

If painters are seen as the producers of a kind of fiction, viewers (the public) may be described as the consumers. The latter's needs are seldom identical with those of

10. The first historian to promulgate the idea of a "White Mountain School" was Samuel Isham (1910, 232). Recently Angela Miller (1993, 90n. 9) has reaffirmed the primacy of the Hudson River School, despite the White Mountains' "equal claim to being a national school."

11. The *locus classicus* for the study of convention in art is Gombrich 1960.

the former. In a fascinating study of American tourist attractions in the nineteenth century, John Sears has linked the medieval cult of pilgrimage to the phenomenon of romantic landscape tourism (1989, 3–11). Drawing on the adage that a "tourist is half a pilgrim, if a pilgrim is half a tourist," Sears has demonstrated that most popular tourist sites in nineteenth-century America, including the White Mountains, were places where God was experienced more closely than in mundane life. In this regard the "Seven Wonders of New Hampshire" are perhaps best understood as natural shrines in a pictured landscape liturgy. As natural icons for an informed and reverential viewership, White Mountain paintings reveal over time more fully and insightfully than the art of any other region of the nation the unique covenant that has always been claimed to exist between God, Americans and the land.

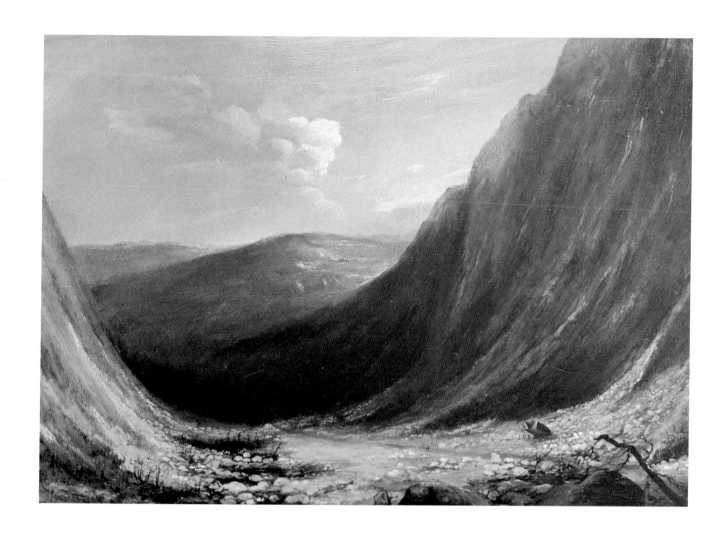

PLATE 1. Charles Codman, *View of Willey House and Crawford Notch Looking South*, 1830–33.
Oil on canvas. Courtesy of Conway Public Library, New Hampshire.

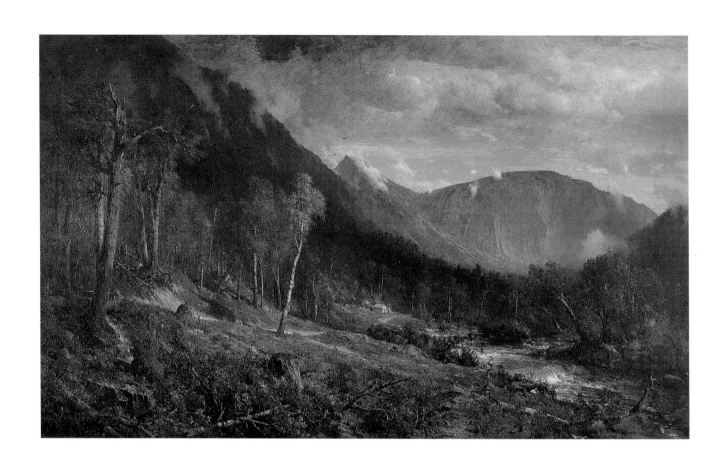

PLATE 2. Thomas Hill, *White Mountain Notch—Morning after the Willey Slide*, 1872. Oil on canvas, approx. 9 in. x 6 in. Courtesy of the New Hampshire Historical Society.

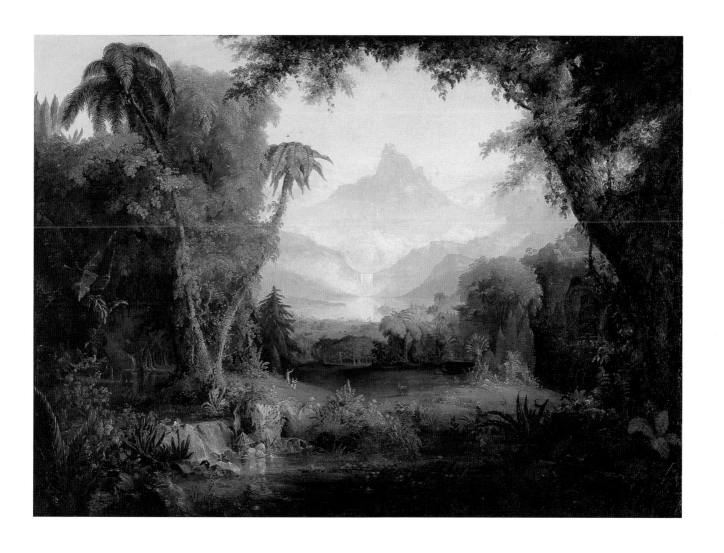

PLATE 3. Thomas Cole, *The Garden of Eden*, 1828. Oil on canvas, 39 in. x 45 in.
Courtesy of the Amon Carter Museum, Fort Worth, Texas.

PLATE 4. e. e. cummings, *Landscape with Stormy Sky*, ca. 1928–30.
Watercolor. Private collection.

PLATE 5. Régis François Gignoux, *White Mountain Landscape*, ca. 1866. Oil on canvas, 48 in. x 83¾ in. Courtesy of the Hood Museum of Art, Dartmouth College.

PLATE 6. Albert Bierstadt, *View of Moat Mountain, Intervale*, 1869. Oil, 19⅛ in. x 25⅞ in. Courtesy of the Currier Gallery of Art, Manchester, New Hampshire, Currier Funds.

PLATE 7. Thomas Doughty, *Rowing on a Mountain Lake*, ca. 1835. Oil on canvas, 17 in. x 14 in. Courtesy of the Hood Museum of Art, Dartmouth College.

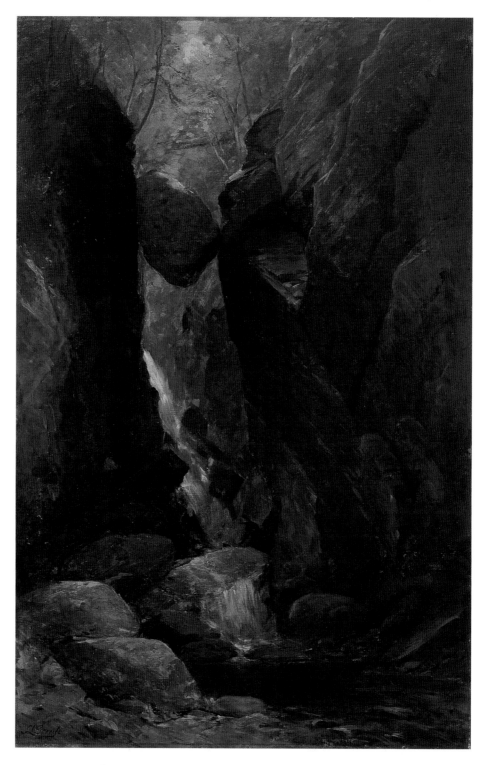

PLATE 8. Samuel Lancaster Gerry, *The Flume*, ca. 1865. Oil on canvas.
Courtesy of the New Hampshire Historical Society.

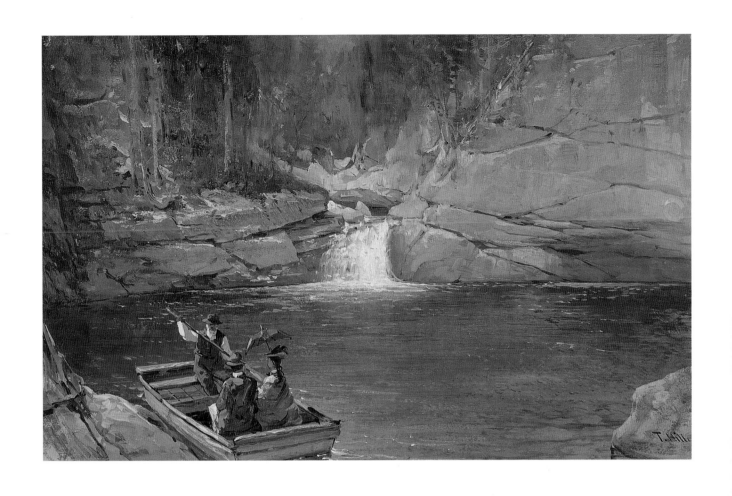

PLATE 9. Thomas Hill, *The Pool*, ca. 1875. Oil on mounted paper, 14 in. x 22 in.
Courtesy of the Garzoli Gallery, San Rafael, California.

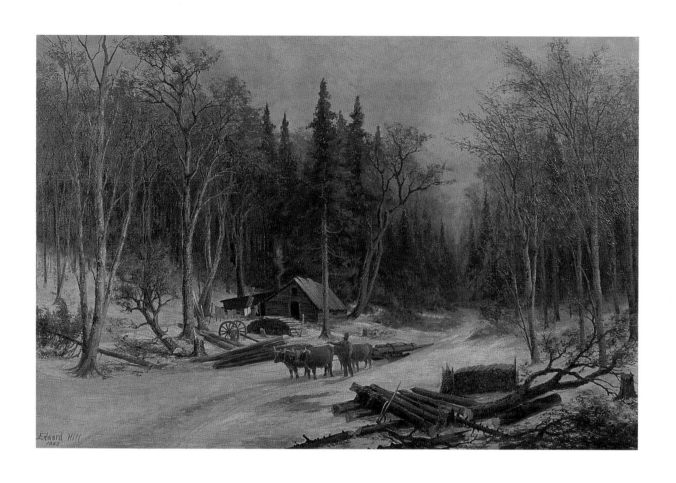

PLATE 10. Edward Hill, *Lumbering Camp in Winter*, 1882. Oil on canvas.
Courtesy of the New Hampshire Historical Society.

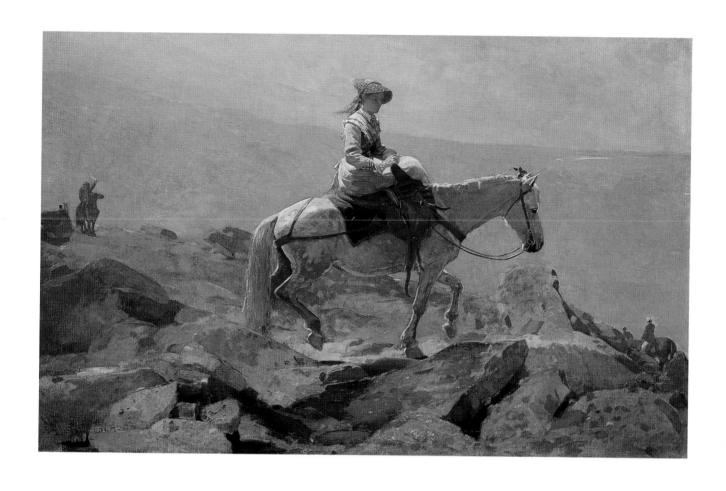

PLATE II. Winslow Homer, *The Bridle Path, White Mountains*, 1868. Oil on canvas, 24⅛ in. x 38 in. Courtesy of the Sterling and Francine Clark Art Institute.

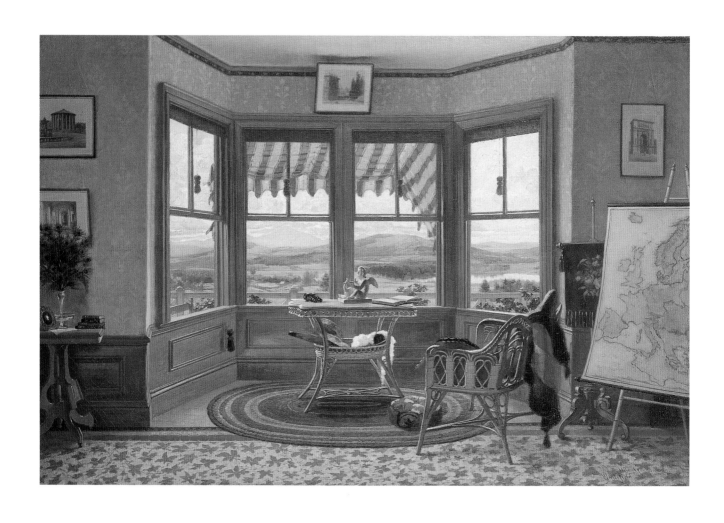

PLATE 12. Otto Grundmann, *Interior at the Mountains*, 1879. Oil on canvas.
Collection of Mr. and Mrs. Jeffrey R. Brown.

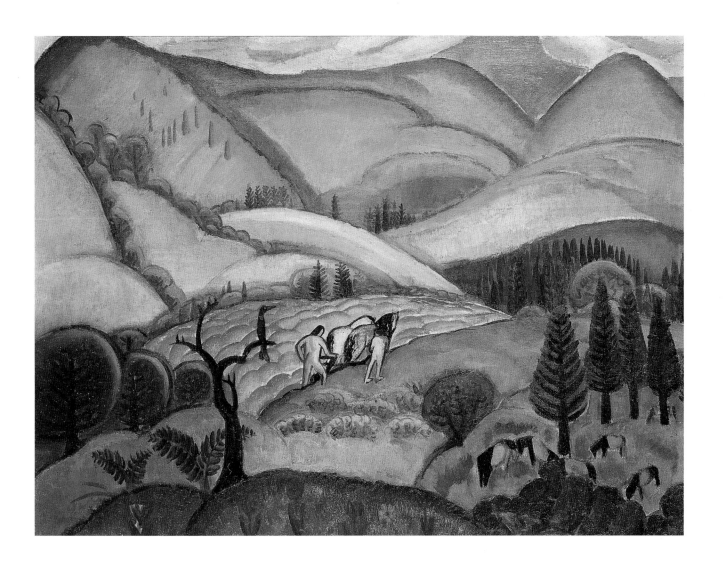

PLATE 13. William Zorach, *Plowing the Fields, New Hampshire*, 1917. Oil on canvas, 24 in. x 36 in. Courtesy of the Currier Gallery of Art, Manchester, New Hampshire, gift of Dr. and Mrs. R. Huntington Breed II, Mrs. Eleanore Freedman, the Friends, Mr. and Mrs. Saul Greenspan, Mr. and Mrs. James W. Griswold, Mr. and Mrs. Robert C. Holcombe, Mr. and Mrs. John F. Thurber, and Mr. and Mrs. Kimon S. Zachos.

PLATE 14. George Nick, *Over Pemigewasset River*, 1986. Oil on canvas, 40 in. x 40 in. Collection of Chemical Bank, New York.

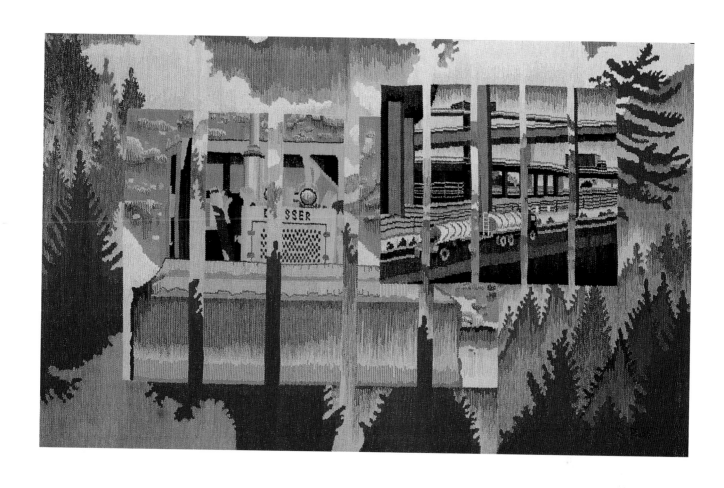

PLATE 15. Suzanne Pretty, *Fragmentation*, 1995–96. Woven tapestry of wool, silk, and cotton on linen warp, 41 in. x 66 in. Artist's collection.

PLATE 16. Robert Jordan, *The Trail to Champney Falls*, 1983.
Oil on canvas, 36 in. x 50 in. Artist's collection.

Gods in Granite

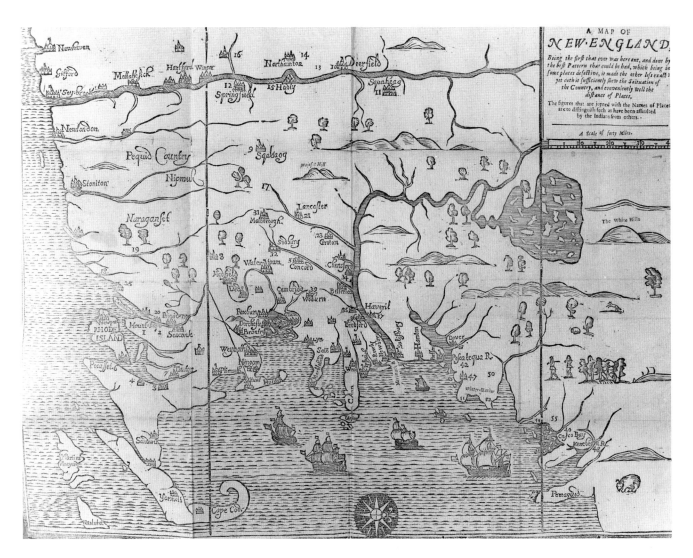

1. *John Foster,* Map of
New England, *1674.*
Illustration for William
Hubbard, Narrative of the
Troubles with the Indian
in New England.
Courtesy of the Firestone
Library, Princeton
University.

I

The Ideographic Image

The God who made New Hampshire
Taunted the lofty land
With little men

—Ralph Waldo Emerson, *Ode Inscribed to W. H. Channing*

The only fault I find with old New Hampshire
Is that her mountains aren't quite high enough.
I was not always so; I've come to be so.

—Robert Frost, *New Hampshire*

T HE FIRST IMAGES of the White Mountains are cartographic. Initially encountered in John Foster's map of New England of 1674 (fig. 1), their landforms and major waterways are denoted by simple graphic schema. At the periphery of the inhabited landscape, the "White Hills" are indicated by the profiles of two half-rounded hillocks. Bordering on *terra incognita*, yet proximate to the advancing line of civilization, these crude emblems suggest that the mountains were understood during the early colonial period more as symbols than as actual land shape, signs at the limits of representation. Brought within the control of space by the cartographer, the mountains could be appropriated culturally if not in fact, a place inscribed in word and image and claimed on paper before they had been possessed. Represented as "space" rather than "place," the White Mountains were comprehended through known rather than lived experience.

As early as 1642, it is claimed, the Irishman Darby Field had climbed the "Cristall Hill" in search of precious stones. The description in Governor John Winthrop's *Journal* of the ascent of the highest peak in the region provides sufficient information to allow for a rough reconstruction of Field's route.[1] The general impression received from the written account is of an alien place, hostile to the incursions of humans.

1. For a recent discussion of Field's route, see Waterman and Waterman 1989 (7–14).

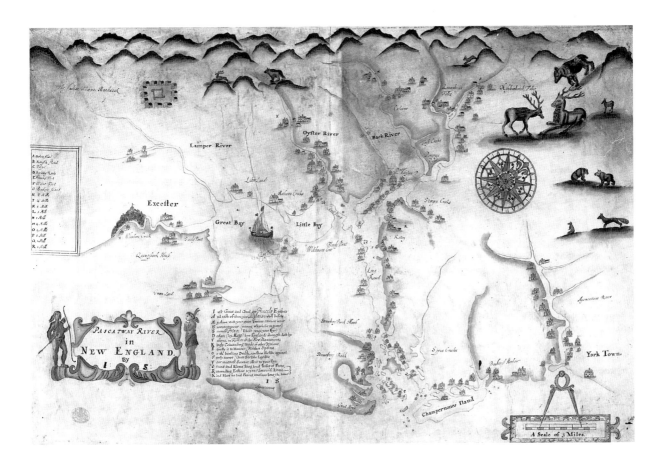

2. *"I. S. Americus,"* Map of the Piscataque River in New Hampshire and Maine, *ca. 1670. Watercolor and ink on vellum, 18⅛ in. x 27¼ in. Courtesy of the British Library, London.*

Thirty years later John Josselyn's *New-England's Rarities Discovered* (1672) describes another ascent of these mountains that affords an equally disquieting picture: "From the top you may see the whole country round about. The country beyond is daunting terrible, being full of rocky hills, as thick as mole hills in a meadow and cloathed with infinite thick woods" (1672, 3). Perhaps the first artist to make molehills out of mountains, the delineator of the seventeenth-century "Piscataque" map (fig. 2) depicts the White Hills as a series of shaded hillocks located at the margin of civilization. Their repeated pattern, animated by the addition of symbols for wild beasts, provides the sense of an impenetrable barrier to the North. The placement of the native village ("Manhacok") at the upper left locates the natives in proximity to the mountains, a part of wilderness rather than civilization. "Ask them whither they go when they die," Josselyn queried the Indians, "they will tell you pointing with their finger to Heaven beyond the White Mountains" (54). This early association of the mountains with spiritual transcendence provides an intimation of the later romantic conceit of the White Mountains as providing a "sweet foretaste of Heaven" (McCoubrey 1965, 104).[2]

2. See McGrath and MacAdam 1988.

Beyond these alternating descriptions of the terrible and transcendent visage of nature, Josselyn also recounts the appearance of "black flies so numerous that a man cannot draw of his breath but he will suck of them in." Two centuries later, artists will continue to complain bitterly of this dreaded affliction (see frontispiece).[3]

Little changed in the eighteenth century from that cartographic paradigm. Wars prevented extensive exploration of the region, and a developing taste for "picturesque" topography in art precluded the depiction of rugged mountainous scenery. Only during the last decades of the century did the general cultural aversion to wild places begin to recede. Explorers again penetrated the "White Hills," shortly to be followed by scientists, travelers, and artists. On 24 July 1776 it took six hours and fifty-one minutes for the party of the Dover, New Hampshire, minister Jeremy Belknap to climb the mountain that a few years later (1784) he named for General Washington. "A romantic imagination may find full gratification," he observed, "amidst these rugged scenes, if its ardor be not checked by the fatigue of the approach" (1777, 112).

A little over a decade later, fueled by the emerging rhetoric of romanticism, Belknap amplified these sentiments in his *History of New Hampshire*: "Almost everything in nature, which can be supposed capable of inspiring ideas of the sublime and beautiful is here realized. Aged mountains, stupendous elevations, rolling clouds, impending rocks, verdant woods, crystal streams, the gentle rill, and the roaring torrent, all conspire to amaze, to soothe and to enrapture" ([1793] 1970, 39). The conceptual path from anxiety to exaltation was, however, both rocky and arduous.

The first self-conscious American traveler, Timothy Dwight, president of Yale College, found much to excite his imagination when he traversed the White Mountains through its notches during the summer of 1797: "On the highest point awfully brooded a cloud, tossed into wild and fantastical forms and seemed to be the connecting link between earth and heaven." Like Belknap, Dwight was content to return to civilization, having experienced a "surfeit of the mountains' wild and solemn appearance" (1822, 98–99).

3. Letter from Asher Durand, 25 July 1855 from North Conway: "We are just settled down for the season in a situation that throws all others that I have found quite in the shade with Mount Washington full in view. . . . Look from the top of the Flume House westward through the Franconia Notch—it is quite Alpine—the flies are so terrible about there that I could not work" (Novak 1969, 87).

Frederic Edwin Church on a sketching trip to the White Mountains in 1850 reported that he and his associates were "muffled up with white handkerchiefs and keeping a bunch of shrubs actively playing about our heads to ward off the swarms of mosquitoes and black flies" (Church 1850). During a climb of Tuckerman Ravine in July 1858, Henry David Thoreau referred to his party as being "wet, ragged and bloody with black flies" (Howarth 1982, 256).

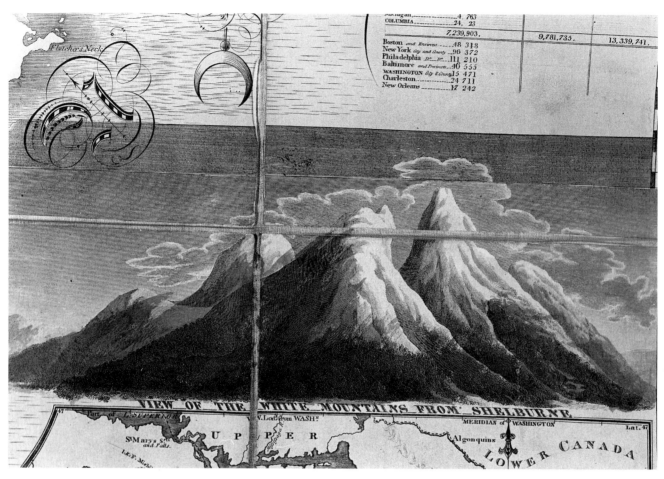

3. *Abel Bowen, after John Kidder,* View of the White Mountains from Shelburne. *Woodcut. Insert for Philip Carrigain's* New Hampshire by Recent Survey, *Concord, 1816. Courtesy of Dartmouth College Library.*

2

The Switzerland of America

The natural scenery of mountains is of greater elevation than any others in
the United States; Of lakes, of cateracts, of vallies it furnishes a profusion of
the sublime and the beautiful. It may be called the Switzerland of America.

—Phillip Carrigain, 1816

O NLY WITH the deeper stirrings of romanticism on the North American
continent did the prospect of wilderness begin to emerge in a more positive
light. Phillip Carrigain's map of New Hampshire, published at Concord in
1816, contains two images that inscribe the major land shapes of the region with
something more than rudimentary symbols. A small woodcut vignette inserted
into the map and entitled *View of the White Mountains from Shelburne* (fig. 3) depicts
them as rocky, isolated, cloud-piercing summits that bear an eternal blanket of
snow. Remote and inaccessible, they are located on the margins of both civilization
and the map. A second woodcut depicting the sharp declivity that forms *The Gap
of the White Mountains* (fig. 4) represents, for the first time, minuscule travelers
dwarfed by the steep walls of a chasm. A cascading waterfall plunges into the notch
before forming a stream, traversed by a flimsy bridge. In his *Travels*, Timothy
Dwight speculated that the gap was created by "some vast convulsion of nature"
undoubtedly "that of the deluge." The Silver Cascade, which he christened on the
spot, was acclaimed "the most beautiful cascade in the world—like a stream of bur-
nished silver" (1822, 101).[1]

Not unlike the early maps themselves, these schematic images were largely based
upon verbal descriptions rather than direct topographical observations. In addition
they also give the appearance of dependence upon imported European landscape
schemes. Caspar David Friedrich's early-nineteenth-century depiction of *The
Watzmann* (fig. 5), for example—a seminal image of a wild mountainous land-
scape—represents unattainable heights that distance the viewer while projecting

1. Belknap (1777, 112) also referred to the then unnamed cascade as "a strikingly picturesque
scene."

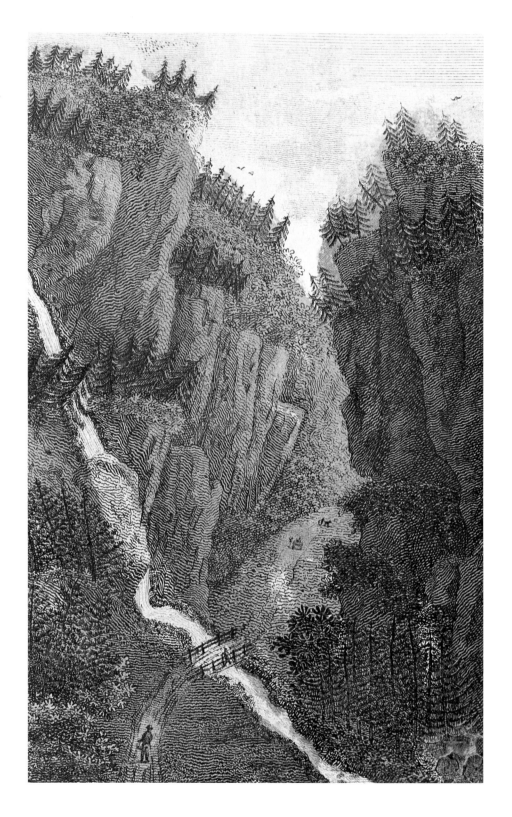

4. *Abel Bowen, after John Kidder,* The Gap of the White Mountains. *Woodcut. Insert for Philip Carrigain's* New Hampshire by Recent Survey, *Concord, 1816. Courtesy of Dartmouth College Library.*

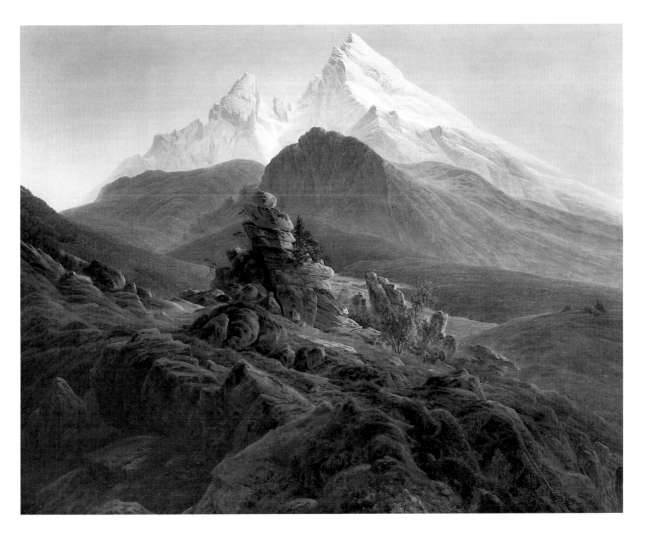

an aura of transcendent glory. The first pure mountainscape in the history of western art, Friedrich's canvas contains no figural surrogate for the observer; rather, the spectator is confronted with the unmediated image of a surging mountain summit. Through some as yet unknown form of cultural filiation, this foundational romantic scheme was apparently transmitted to the designer of the woodcuts for the Carrigain map.

Similarly, the British painter James Ward's *Gordale Scar, Yorkshire* (fig. 6) provides an academic model for the woodcut entitled *Gap of the White Mountains*. Ward's large canvas of what was considered an unpaintable subject became a *cause célèbre* at London's Royal Academy exhibition of 1811. Representing one of Britain's wildest sites, Ward's painting was among the earliest romantic views to stress the insignificance of human enterprise in the face of sublime nature.

Beyond the definition of an emergent vision of the wilderness, the Carrigain

5. Caspar David Friedrich, Der Watzmann, 1824–25. Oil on canvas. Courtesy of Nationalgalerie, Staatliche Museen Preussischer Kulturbesitz, Berlin.

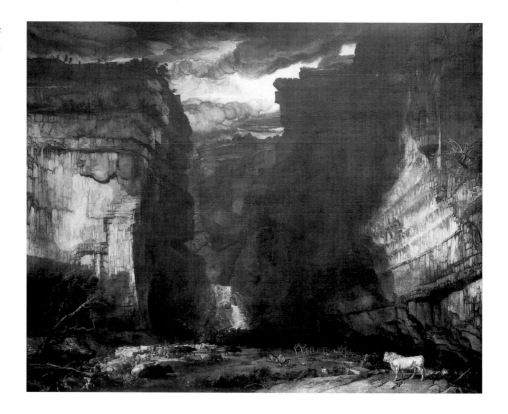

6. *James Ward,* Goredale Scar, *1811–15. Oil on canvas. Courtesy of the Tate Gallery, London.*

images were also employed as a means of thinking symbolically about the land. Though constituting less than one-fifth of the landmass of New Hampshire, the White Mountains function in the image-context of Carrigain's map as pictorial emblems for the entire topography of the state. As visual ideograms they assert a cultural alliance between New Hampshire's designated self-image and the emergent national ideal of wilderness. In the public imagination, New Hampshire was, and largely remains, the White Mountains.

During the first half of the nineteenth century, the Carrigain woodblocks were frequently reused to illustrate a wide variety of didactic writings about the state. The author of the 1823 *Gazetteer of the State of New Hampshire,* among the first to redeploy these images, claimed, with fulsome hyperbole, that the White Mountains are "the loftiest in New-England, and perhaps the United States." Drawing upon currently fashionable aesthetic theory, he further observed that they "furnish a rich profusion of the sublime and the beautiful. . . . Tis true," the author concludes, apologetically, "our majestic hills are not yet adorned with classical recollections . . . like the pass of Saint Bernard" (Farmer 1823, 12). A place without meaning, the mountains awaited historical events in order fully to enter into the national imaginary.

3

The Willey Catastrophe

THE LANDSCAPE OF TERROR

The number of visitors at the White Mountains has of late been considerably increased on account of the interest excited by the tremendous slides of avalanches on the 20th of August 1826.

—Gideon Miner Davison, *The Fashionable Tour: An Excursion to the Springs Niagara and Through the New England States*, 1828

A LITTLE OVER three decades after the apology proffered in the New Hampshire *Gazetteer*, Benjamin Willey composed a verbal elegy on the tragic destruction of his brother's family in the deep recesses of the White Mountain Notch. In his memorial account he compared them suggestively to "the monks of Saint Bernard, sheltering wanderers upon the Alpes." Ruminating upon the events of August 1826 he further observed, "We may stretch our conception of mental horror and . . . we should fail entirely of coming to the dreadful reality" (1856, 56). These lurid reflections upon an event that struck a resonant chord in the imagination of his contemporaries were among the many descriptions of the Willey tragedy published at the time and for many years thereafter.

As if on demand, history had conspired during the early nineteenth century to remedy the paucity of "classical recollections" associated with the White Mountains. The destruction of the Willey family, pioneer settlers in the heart of the Notch, by a massive landslide in the late summer of 1826 set off a reaction that reverberated throughout much of the century. Slaking the romantics' thirst for "poetical association," and simultaneously fueling their appetite for "gloom and doom," the Willey catastrophe stimulated a corresponding avalanche of verbal and pictorial responses to the actual slide. From the very outset of the reported tragedy, writers composed hagiographies of the martyred Willeys, while painters found in their miraculously preserved homestead the spectacle of an instantaneous "ruin." In the cultural imagination of the period, the deep notch, together with its precipitous

cliffs, afforded a perfect setting for a landscape of adversity as well as a pictorial battleground for the struggle between nature and culture. Within days of the disaster hordes of curiosity seekers descended upon the site in search of emotions and relics. It was to the imagination of this already overstimulated constituency that the printmakers and painters addressed their morbid pictorial descriptions.

Theodore Dwight, nephew of Yale's president, was among the first to include a detailed account of the slide in his guide book, *The Northern Traveller*, published shortly after the disaster. Alternating between attraction to and repulsion from, malignant nature, Dwight took painful pleasure in describing the avalanche as a "melancholy subject of reflection" (1826, 51). His narrative is accompanied by an engraving (fig. 7) that purports to be an accurate representation of the site and was doubtless intended to evoke sympathetic responses in the reader-observer. Frontal, static, and balanced, the image is, however, based on conventional pictorial formulas rather than on any evidence of direct observation. In its calculated symmetry and picturesque order it is a view shaped more by inherited artistic norms than the actual topography of the Notch. As a result, the derivative Claudian scheme, generally employed to denote harmony and order rather than chaos and desolation, functions in direct antithesis to Dwight's verbal gothicism. In addition the elevated

7. O. H. Throop, after a drawing by Daniel Wadsworth, The Site of the Willey Slide. *Engraving. Illustration for Theodore Dwight,* The Northern Traveler, *New York, 1826. Courtesy of Dartmouth College Library.*

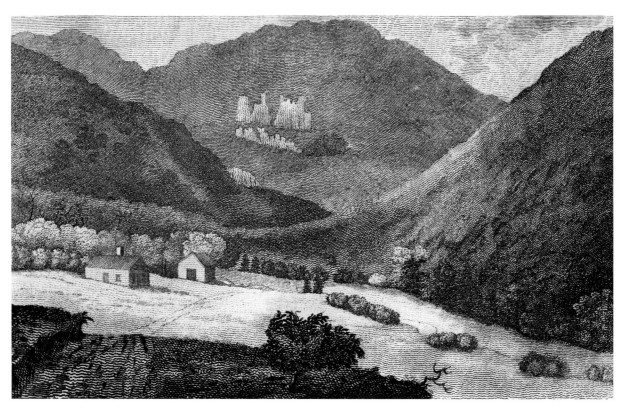

vantage of the image distances the spectator from the landscape, rendering it scenery to be viewed rather than space to be experienced vicariously. The resulting divide between subject and object cannot be bridged either consciously or subconsciously by a viewer suspended in an undefined spatial void.

Despite the physical chaos and desolation encountered by Dwight, he was able to extract a glimmer of hope from the surrounding wilderness: "When we see the torrent's path and the devastation of the avalanche, we regard nature in her more majestic and awful aspect as the enemy of civilization and humanity. But when we reflect again the broad sheets of untrodden snow that cap or zone the mountains above they appear like emblems of nature's purity." (1826, 27).

These emotional oscillations between anxiety and rapture before Janus-faced nature provided a characteristic response of the excited romantic spirit to the White Mountains in the aftermath of the tragedy.

In October 1828 painters Thomas Cole and Henry Cheever Pratt, attracted by written accounts of the disaster, also visited on a walking tour of the White Mountains the "ruins" of the Willey homestead. Perceiving himself as "a worm . . . beneath the towering precipices," Cole noted in his diary: "It is impossible for description to give an adequate idea of this scene of desolation" (Erwin 1990, 30).[1] By contrast, Pratt was more concerned with the logistics of traversing the Notch, claiming that it was "nearly as difficult as after the great storm of 1826" (Campbell 1978, 116).[2]

Both artists made sketches that eventuated in paintings that have since disappeared. The compositions are known, however, through prints made at the time. Pratt's view appeared as an illustration for a fictionalized account of the tragedy published in the gift book *The Token* (fig. 8) for Christmas of 1828. Cole's composition is known from a single lithographic copy containing the evocative title: *Distant View of the Slides That Destroyed the Whilley Family* (fig. 9). A comparison of their respective treatments of the subject reveals Cole to be at once more topographically faithful to the site and more luridly imaginative with regard to the event than was his traveling companion. Firmly rooted in the actualities of place, Cole's pictorial evocation of the disaster is also more emphatically redolent of gothic *angst*.

Eschewing the balanced, academic composition favored by Pratt, Cole constructed a sharp diagonal recession that dramatically juxtaposes the darkened near

1. "A dreadful mystery hangs over the events of that night—we walked among the rocks and felt as though we were but worms" (Erwin 1990, 30). See also Clark 1975 (90–97) for a general account of Cole's activities in the White Mountains in 1827–28.

2. For Pratt's diary see Campbell 1978 (109–33).

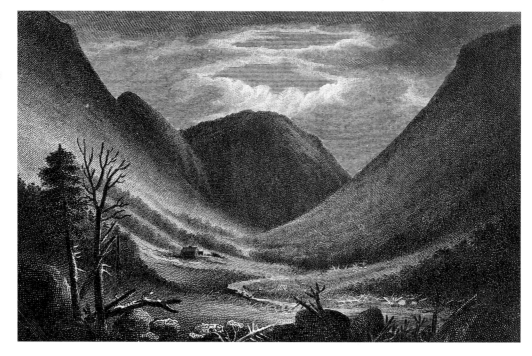

8. *Vistus Balch, after a lost painting by Henry Cheever Pratt,* View of the White Mountains after the Late Slide. *Engraving. Illustration for* The Token, *Boston, 1828. Courtesy of Dartmouth College Library.*

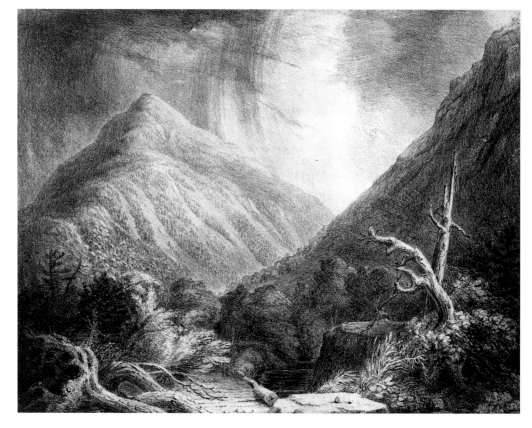

9. *Anthony Imbert, after a lost painting by Thomas Cole,* Distant View of the Slides That Destroyed the Willey Family, *ca. 1828. Lithograph, 11 in. x 8⅝ in. Courtesy of the Albany Institute of History and Art.*

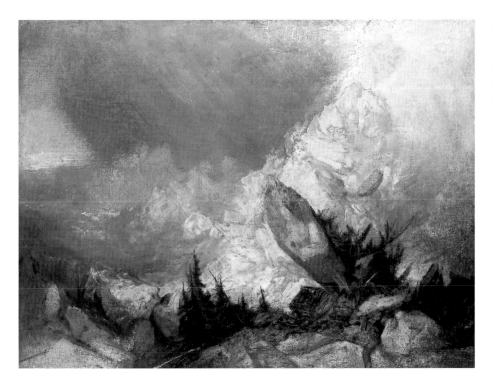

10. *J. M. W. Turner,* The
Fall of an Avalanche in
the Grisons, *1810. Oil on
canvas. Courtesy of the Tate
Gallery, London.*

side of the landscape with a panoramic view of the scarred face of Mount Willey,
"the great destroyer." By focusing upon the tensions generated by intersecting diag-
onals, he created a structure of oppositions denoting the elemental antagonisms
believed to reside in nature. In addition, Cole deliberately erased all signs of the
Willey house, thus emphasizing the forceful processes of nature rather than the
material incursions of humans. In contrast with Pratt's print, the low angle of vision
absorbs the spectator into the spatial construction, providing a clear analogy with
the artist's own vantage and, by extension, the notional experience of the Willeys.

Finally, an array of broken stumps and errant rocks, together with a gathering
storm, suggest the wildness of the site while evoking an appropriate ambient of
darkness and desolation. A blasted tree, a signifier of morbidity derived from sev-
enteenth-century Dutch painting, denotes the presence of death. Time, both geo-
logic and historic, is intimated by the presence of erratic boulders, while process—
the effect of natural forces—is marked by the path of avalanches and swirling vor-
tices of clouds. In one of the first occurrences in American painting, Cole employed
the pictorial theatrics of "gothick" sublimity that had earlier emerged in European
art near the turn of the century. Such novel and celebrated paintings as Joseph M.
W. Turner's *Fall of an Avalanche in the Grisons* (fig. 10) of 1810, for example, with its
sharp diagonal division between foreground and background enframed by gyrating

11. *Henry Cheever Pratt,*
On the Ammunoosuc
River, ca. 1830. Courtesy of
the Museum of Fine Arts,
Boston, bequest of Martha
C. Karolik for the M. and
M. Karolik Collection of
American Paintings.
Reproduced with permis-
sion. © *2000 by the*
Museum of Fine Arts.
All Rights Reserved.

storm clouds, affords a suggestive model for the American work. In striving to pro-
vide associational symbolism for his culturally impoverished nation, Cole imparts
to his image a vigorous emotional and psychological intensity.

When the two artists parted company after traversing the Notch, Pratt chose a
path in the direction of civilization while Cole continued to explore the mountain
wilderness. One of the few known extant works by Pratt, *On the Ammunoosuc River*
(fig. 11), was probably painted after sketches made near Littleton, New Hampshire,
where he arrived after visiting the Franconia region and viewing the famed
"Mountain Man." In this domesticated idyll human control of nature is featured,
perhaps as an antidote to the recently experienced terrors of the Notch. Located
beneath the falls of a humanly engineered dam, women and young girls—the chief
protagonists of the work—are positioned on rock ledges in the midst of a river.
Denoting both the blandishments of civilization (woman as culture) and the north

country's inexorable trajectory from wilderness to cultivation, Pratt's figures anticipate Cole's own verbal ruminations on progress in *An Essay on American Scenery* published a few years later: "On the margin of that gentle river the village girls may ramble unmolested . . . [their] neat dwellings, unpretending to magnificence, are the abodes of plenty, virtue, and refinement. . . . Where the wolf roams, the plow shall glisten . . . poets yet unborn shall sanctify the soil" (McCoubrey 1965, 99).

In this connection the female *staffage* might well be understood to function as living counterpoint to the ill-fated Willeys. Lacking any determined visual focus, Pratt's canvas stresses the structures and accoutrements of culture rather than the elemental powers of wilderness. In eliminating the foreground, the artist also provided no ingress into the image, further depotentiating any residual aura of uncontrollable nature. Having fled the mythic and actual horrors of the Notch, Pratt reflexively celebrated the constraining power of civilization.

A Pratt canvas recently acquired by Hartford's Wadsworth Atheneum, entitled *Thomas Cole Sketching in the White Mountains* (fig. 12), reinforces this theme. Locating the gallant Cole at the lower left of the canvas, Pratt surrounds the figure of the sketching artist with shepherds and well-dressed young girls. The scene is located in the Notch, beneath either the Crystal or the Silver Cascade, with the imagined profile of the Presidential Range rising beyond. Painted in commemoration of their joint venture in wilderness exploration, the work softens the image of the wild with cultivated activities.

Over the next several decades, the Crawford Notch continued to possess a magnetic attraction for both artists and writers. Around 1830 Charles Codman, a painter from Portland, Maine, shaped a stark and threatening view (plate 1) that recalls earlier graphic images of the dreadful defile (cf. fig. 8). In this narrowly enclosed view, framed by precipitous slopes that form a spatial cylinder, the artist further reduced the Willey homestead to a minuscule sign of human habitation. Two small figures traverse the hostile space and provide scale for the setting. Their active role of surrogacy renders the spectator both witness to, and participant in, the unfolding natural drama, while the composition's funnel-like structure further absorbs the viewer into the desolate scene. By design the "ruin" of the Willey House is envisioned in the process of reverting to nature, a place transfigured by time and reflection.

The Boston painter Alvan Fisher traversed the Notch in 1834, two years after Nathaniel Hawthorne's visit to the site to gather information for the well-known short story "The Ambitious Guest" based upon the events of the Willey tragedy. Fisher's turbulent view (fig. 13) also emphasizes the power of the mountains and the fragility of human enterprise. Like the writer Hawthorne, the painter intimates the

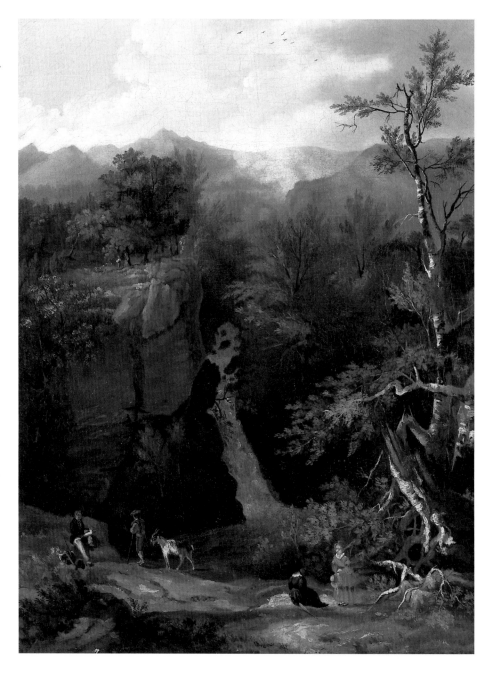

folly of living in an alien environment and, in accord with many contemporary
European painters of the sublime, he distills the image of nature into a churning
vortex of energy. The swirling storm clouds and the turgid atmosphere of the scene
are partially derived from Cole's earlier treatment of the theme, as well as from the
British painter Joseph M. W. Turner's confected Alpine sublimities (fig. 14). In
Fisher's canvas, all-consuming nature mirrors the destructive cycle of human desire

13. *Alvan T. Fisher,* The
Notch, *1834. Oil on canvas, 30½ in. x 42½ in.
Courtesy of Fruitlands
Museum, Harvard
University.*

14. *J. M. W. Turner,*
Valley of Aosta—
Snowstorm, Avalanche,
and Thunderstorm,
*1836–37. Oil on canvas, 36⅛
in. x 48¼ in. Courtesy of
the Art Institute of Chicago,
Frederick T. Haskell
Collection. Photograph courtesy of the Art Institute of
Chicago.*

15. Samuel Bemis, The Old Crawford House, 1840. Daguerreotype. Private collection.

that is the subtext of Hawthorne's celebrated narrative. Envisioning the Notch as a landscape of adversity, Fisher's view is one of the most compelling images of "gothick" sublimity from the period of early romanticism in America.

The continuing fascination with the Notch and its tragic history, as well as the emergent awareness of the region's potential for landscape tourism, no doubt accounts for the Bostonian Samuel Bemis's choice of the site for his 1840 daguerreotype of the Old Crawford House (fig. 15), one of several views taken in the locale. As the first landscapes in America made by a photographic process, Bemis's images are directly allied to the broader cultural interest expressed by artists and writers at the time. Characterized by one recent historian as "the birthplace of American landscape photography" (Naef 1980, 280), the White Mountains evolved during the course of the nineteenth century into one of the most frequently imaged regions of the country.[3] Bemis's focus upon an open foreground as well as the sharp geometries of architecture projected against the mountains and sky, however, stresses human habitat rather than the elemental powers of nature.

3. See Naef 1980 (280): "If one location must be cited as the birthplace of American landscape photography, it is that of the White Mountains, which was perhaps the first mountainous wilderness area to receive the attention of an audience consisting primarily of city dwellers."

Along related lines, "folk artists" and popular print makers also contributed to the iconography of the Willey tragedy, sustaining interest in the events of 1826 well past midcentury. An illustration for John Farmer's engagingly titled *Catechism of the History of New Hampshire* (fig. 16), published at Concord in 1829, depicts the Willey Slide in especially lurid graphic terms. An avalanche of earth and boulders snaps trees like twigs while threatening the fleeing figures of the Willeys. Intended to impress school children with the terrors of the White Mountain wilderness, the woodcut adumbrates the nearly contemporaneous reminiscences of an early inhabitant of the region: "Over it all, particularly the mountain region, there hung a pall of mystery. It was feared because unknown, shunned because of a reputation for bareness and arctic cold. Mothers brought unruly children to subjection by threatening to banish them to the White Mountains" (Cross 1924, 18).

Slightly over a hundred years after the Willey Slide, another lethal avalanche occurred in the White Mountains. According to an account in the *Boston Globe* of March 18, 1936, Eugene Hill became the first victim of a slide in the region since the

16. Anonymous, The Willey Slide. *Woodcut illustration for John Farmer,* A Catechism of the History of New Hampshire, *Concord, 1829. Courtesy of Dartmouth College Library.*

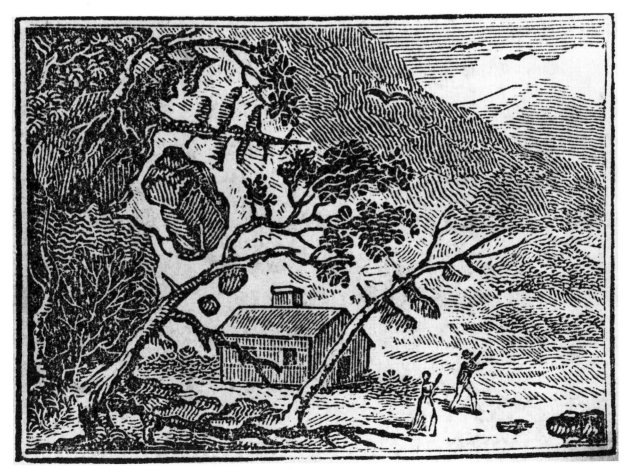

17. Avalanche in the White Mountains. *Belcher photograph, from the* Boston Globe, *March 18, 1936.*

ill-fated Willeys ("Great Flood" 1936). Ironically, the site of his death, luridly evoked in journalistic text and images, was only a few miles from the fabled Willey homestead. The newspaper photograph of the slide (fig. 17) forms a fortuitous, albeit intriguing, comparison with the woodcut published almost a century earlier.

In 1839 Thomas Cole visited the White Mountains for a final time. His traveling companion was his fellow Hudson River School painter, Asher B. Durand, and from this encounter emerged one of his most magisterial canvases. Entitled *A View of the Mountain Pass Called the Notch of the White Mountains* (fig. 18), this large (40" x 60") and beautifully integrated work represents the artist's attempt to resolve pictorially the perceived conflict between nature and culture. In his well-known *Essay on American Scenery*, published in 1835, Cole enunciated the belief that wilderness represented the highest form of moral landscape: "for those scenes of solitude from which the hand of nature has never been lifted, affect the mind with a more deep toned emotion than aught which the hand of man has touched" (McCoubrey 1965, 100). Mindful, however, of his patronage as well as the practical bias of the age, he quickly emended his conclusions: "But the cultivated must not be forgotten, for it is still more important to man in his social capacity." (McCoubrey 1965, 102). The dilemma posed by these conflicting values preoccupied Cole throughout his career and the epic painting of Crawford Notch doubtless represents an attempt to rec-

oncile his love of untamed nature with the utilitarian character of the time. In seeking a benign compromise, Cole hoped that the "quieter spirit" of culture, rather than the boom of industrialization, would temper, transform and partially preserve something of the once great American wilderness. It is a near certainty that *The Notch of the White Mountains* was painted in defense of this aspiration.

In the midst of a clearing, enframed by slopes of blazing autumn woods, a solitary traveler rides toward the famed Notch House of Ethan Allen Crawford. Located near the northern entrance to the gap, Crawford's hostel was the earliest accommodation for travelers to the region. Theodore Dwight, for example, referred to it in terms analogous to Cole's painting as "the only place where the hand of cultivation and the works of man present a gentle and tranquilizing contrast to the vast and sublime objects of nature" (1829, 63). Before the hostel the innkeeper (Ethan Allen Crawford?) awaits the arrival of the mounted rider while a Concord stage descends through the gate of the Notch.

In compliance with one of the central conventions of American landscape painting, the horseman, innkeeper, and stage are overshadowed by the immense scale of the natural setting. In the sky above, a cloud halo encircles the summit of Mount

18. Thomas Cole, A View of the Mountain Pass Called the Notch of the White Mountains, 1839. Oil on canvas, 40 in. x 61½ in. Andrew W. Mellon Fund, © Board of Trustees, National Gallery of Art, Washington D.C.

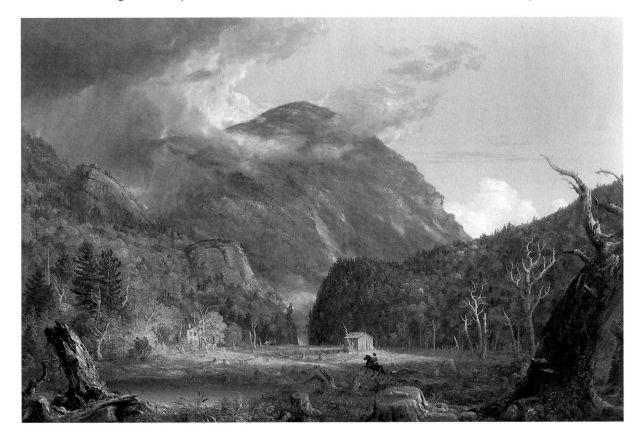

Webster—the aftermath of a passing storm. At the center of the clearing a radiant sunburst mirrors the cloud formation. Intimating a spiritual journey from storm and disaster to calm and salvation, the drama of light and dark provides a form of moral agency for the landscape. In the immediate foreground appears one of the most conspicuous symbols in the work, a man-made stump. This well-known device was employed by Cole to denote the transition from a state of pure wilderness to one of human cultivation. For Cole the most radically revisioned aspect of the work, however, is the depiction of the region as benign rather than hostile. For the first time in a depiction of the Notch, humanity is represented as existing in harmony with nature, rather than as a victim of her capricious force. At one level, Cole's painting can be understood as a topographic landscape; at another it functions allegorically to encode the desired reconciliation of wilderness with man's "social capacity."

The majority of Cole's artistic contemporaries, however, did not envision the Notch in such benevolent terms. For example, Benjamin Bellows Grant Stone's *Gate of the Notch* (fig. 19) from the late 1850s still views the region as a place of war-

19. Benjamin Stone, Gate of the Notch, *1858–59. Oil on paper, 6⅞ in. x 9⅞ in. Courtesy of Greene County Historical Society, New York.*

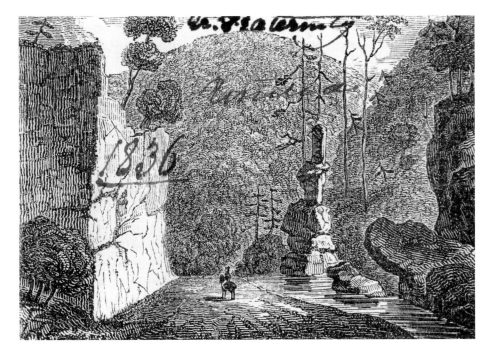

20. *Anonymous, after a drawing attributed to Daniel Wadsworth*, Notch of the White Hills, from the North. *Woodcut. Illustration for Theodore Dwight*, Things As They Are; Notes of a Traveller, *New York, 1834. Courtesy of Dartmouth College Library.*

ring natural forces. An admirer of Cole who rented the artist's old studio in Catskill, Stone rejected the master's revisionary view. Instead, Stone adhered to the conventional gothicism of the age, allying his painting with popular imagery as found, for example, in travel books like Theodore Dwight's 1834 *Things As They Are: Notes of a Traveller* (fig. 20).

Along related lines Herman Melville's two-part short story "The Paradise of Bachelors and the Tartarus of Maids," written in 1855 after an initial visit to the White Mountains, evocatively compares the Gate of the Notch with Dante's fabled portal to the Inferno. Between the Notch's "cloven walls" flows the "Blood River" (i.e., the Saco) towards a declivity known as the "Devil's Dungeon," located near the base of "Woedolor Mountain." In the valley, several miles below, is located an industrial behemoth, the Tartarus paper mill, whose violently gyrating cogs are tended by virginal maidens, attached to their machines as "mares haltered to the rack" (1855, 673).[4] Melville's shocking parody of the natural sublime, together with the invocation of its stepchild, the emergent technological-sublime, was composed four years after the arrival of the first railroad in the White Mountains. Providing a subverted conceptual bridge for the transformation of nature into culture, "Tartarus" is one of the most fevered productions of Melville's imagination.

4. For an imaginative Freudian reading of Melville's story, see Gretchko 1991 (127).

21. Frank H. Shapleigh,
Crawford Notch from
Mt. Willard, *1878. Oil on*
canvas, 22 in. x 36 in.
Private collection.

4

The Technological-Sublime

STRATEGIES OF ACCOMMODATION
AND OPPOSITION

The demon of progress had forced its way into the very sanctuary.
There were no longer any White Mountains.

—Samuel Adams Drake, *The Heart of the White Mountains*, 1882

I N 1875 the character of Crawford Notch was changed irrevocably by the intrusion of the machine into its dark and formidable recesses. Rated as one of the great technological feats of the age, the Maine Central Railroad line rose over 1,500 feet in twelve miles from its base at Bemis through the heart of the gap to its terminus at the Crawford House station. In route the train traversed the Willey Brook Bridge and stopped at the Willey station (for those who wished to visit the famed ruin) before ascending through the gate of the Notch. This hypostatized triumph of technology over nature provided a conceptual framework through which many of the values formerly ascribed to wilderness—power, beauty, sublimity—were conferred upon the machine.[1]

Frank Shapleigh's view of *Crawford Notch from Mount Willard* of 1878 (fig. 21) (scenery that the English traveler Anthony Trollope considered superior to anything along the Rhine) documents strikingly the emergence of these revised attitudes. Gazing from an elevated vantage upon the deep recess of the Notch, a group of tourists observes the ascending path of a railroad train. These figured surrogates, who both see and are seen, mediate the spectator's relationship to the fictive landscape. Symbols of mind or consciousness, they contemplate in the viewer's stead the intersection between nature, history, and technics. Near the center of the panoramic composition, the smoke of the train's engine is suggestively paralleled by mist

1. Drawing upon Leo Marx, J. Gray Sweeney (1977, 25) formulated the concept of the "technological-sublime."

arising from the valley floor. The scarred face of Mount Willey, the site of the fabled avalanche, is visually bisected by the rail lines and thereby depotentiated by a seemingly greater force. Eclipsed by the spectacle of the new technology, the terrors of the Notch yield to the notional spectators' wonderment at the potency of machines; the painted figures observe both the older locus of sublimity and the newer structures of technology, as the romantic obsession with power attains renewed expression. In addition, their totalizing gaze, which dominates the scene literally and metaphorically, is made to denote the mastery of humans over both nature and the machine. As a means of negotiating the divide between the ideas of nature as sublimity and as an exploitable commodity, Shapleigh's painting strives to accommodate two apparently conflicting value systems. In deploying the pictorial strategy of panoramic painting, the artist conflates the values of natural sublimity with the vitalism and energy of the machine.

To further inscribe its triumph over nature (as well as to promote its corporate interests), the Maine Central Railroad commissioned two paintings from the Portland, Maine, painter Harrison Bird Brown to serve as advertisements for the new technological order. The first is known from a photogravure poster depicting in break-neck perspective the Frankenstein Trestle (named after the White Mountain painter Godfrey Frankenstein) penetrating the *Heart of the Notch* (fig. 22).

22. Anonymous, after a painting by Harrison B. Brown, The Heart of the Notch, *1890. Lithograph, 11½ in. x 20⅛ in. Courtesy of Dartmouth College Library.*

Near the center of the composition the train is seen traversing the base of Mount Willard. Imposing what art historian Barbara Novak has designated "linear imperialism" upon the site (1980, 66), the artist instantiates the pictorial rhetoric of the "technological sublime" for the near side of the painting. At the right—the domain of nature—the Crystal Cascade plunges from storm-tossed peaks into the Saco River. Violent contrasts of light and dark lend an aura of turbulence to the scene, intimating an elision of the energies of the natural sublime with the marvels of the new technology.

The second popular image, a lithograph entitled *Mount Washington from the Frankenstein Trestle* (fig. 23), shifts the spectator's vantage and radically transforms the mood of the scene. In place of a dark and forbidding enclosure, the artist has substituted a radiant prospect of Mount Washington rising majestically above the tracks and conferring its benevolent authority upon the path of the railroad. Like many romantic painters, Brown depended upon a drama of light and dark to animate his compositions, but the expressive power of *chiaroscuro* is here employed in the service of machine technology rather than the celebration of primal wilderness. Invoking on behalf of the Maine Central Railroad both the fearsome and the

23. Anonymous, after a painting by Harrison B. Brown, Mt. Washington from Frankenstein (As Seen on the Line of the Maine Central R.R.), 1890. Lithograph published by Gray Lithography Co., New York. Courtesy of Dartmouth College Library.

benign powers of nature, Brown shaped successive images of humanity's triumph over the chaotic and no longer destructive natural order.

In this project Brown deployed a visual strategy developed by the Central Pacific Railroad a few years earlier in collaboration with the painter Albert Bierstadt. In 1871 Central Pacific vice president Collis P. Huntington commissioned from Bierstadt a painting of the Donner Pass in the Sierra Nevada where the railroad had encountered its greatest difficulty, and near where a group of tragically fated emigrants had expired during the winter of 1846–47. Bierstadt's celebrated painting clearly depicts the ascendancy of technology over malevolent nature and the resulting harmony brought about by the introduction of the machine into the natural world (Anderson and Ferber 1991, 233, fig. 58). In anticipation of Shapleigh's and Brown's compositions, Bierstadt elevated the viewer far above the spectacle of the unfolding infusion of the machine into nature.

In 1879 Moses Sweetser of Portland, Maine published the first White Mountain guide book that employed photographs rather than prints as illustrations. Significantly, the supporting imagery for Sweetser's florid text is devoted to machines rather than mountains. A low-angled view of the *Frankenstein Trestle* (fig. 24) is representative of the emergent industrial iconography employed by Sweetser. Displacing the past with the present, a complex armature of iron geometry is inscribed upon the organic forms of nature. In this newer context, modern industrialism controls the space of the image as new shapes arise to compete with nature. In the contest between the two great nineteenth-century "kingdoms of force," nature and the machine, the ascendant technology of the railroad strikingly anticipates later pictorial celebrations of such early modernist American icons as the Brooklyn Bridge.

Not all romantic painters were as enraptured with the intrusive potency of the machine as were Shapleigh and Brown. Thomas Hill's mammoth canvas of 1872, *White Mountain Notch—Morning after the Willey Slide* (plate 2), appears in retrospect to be an attempt to recover the once-potent aura of nature in the face of the persistent incursions of the modern world. Through the deliberate omission of the Willey House Hotel (which at the time of Hill's painting stood next to the historic homestead), the artist figuratively restored the site to its mythic past. History is reversed as the accretions of civilization are consciously erased, and myth is recouped through a vigorous and large-scale reinvocation of the operatics of the sublime. Conflated into a stirring image, the cultural and natural history of the Notch is both affirmed and denied in this striking canvas.

Hill's epic view, intended to rival the colossal scale and strident pictorial theatrics

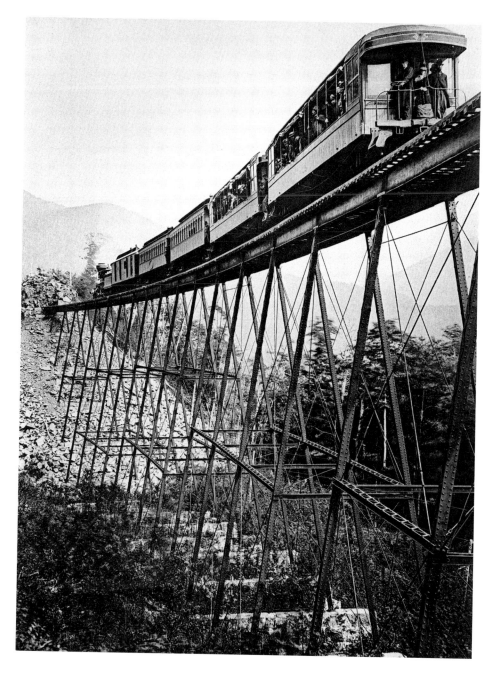

24. *Unknown photographer,*
The Frankenstein
Trestle. *Photograph.*
Illustration for Moses F.
Sweetser, Views in the
White Mountains,
Portland, Maine, 1879.
Courtesy of Dartmouth
College Library.

of Albert Bierstadt's popular western landscapes, was a *succés d'arrière saison.*
Painted three years before the Notch was tamed by the railroad, Hill's work repre-
sents a belated affirmation of the potency of the American wilderness. One of the
most celebrated paintings of its time, Hill's view was purchased for the extraordi-
nary price of $20,000, eclipsing at the time the fees of his rivals Church and
Bierstadt. His pictorial re-creation of White Mountain sublimity hung in the 1876

Philadelphia Centennial Exhibition where, according to a contemporary account, "no pictures were more favorably received" (Arkelian 1980, 31).

During the same centennial year of 1876, Herman Melville published a long and rambling epic poem entitled *Clarel.* Its central protagonist, a young American student of theology on a pilgrimage to the Holy Land, in recounting the history of his native land contrasts the pastoral ideal with

> The Great White Hills, mount flanked by mount,
> . . .
> Where, in September's equinox
> Nature put such terror on
> . . .
> Our mother, Earth: the founded rocks
> Unstable prove: the Slide! the Slide!
> Again he saw the mountain side
> Sliced open; yet again he stood
> Under its shadow, on the spot—
> Now waste, but once a cultured plot
>
> (Melville 1991)

Like Hill, Melville invokes the memory of the Notch's tragic history to symbolize the instability and uncertainties of the modern age. Having visited the White Mountains in 1847 on his honeymoon and again in 1870, Melville, like Hill, viewed the Willey Slide as one of the elemental tropes of pre-industrial America, a line of force extending the past into the present. Henry Adams's reflections upon the Corliss dynamo at the 1900 Paris Exposition (and the resultant displacement of power from the medieval Virgin to machine technology) provides an equally instructive analogy with Thomas Hill's grandiose painted "machine."

5

Chocorua

THE LANDSCAPE AS HISTORY

Where was the warrior's foot when night
Veiled in thick cloud the mountain height?
None heard the loud and sudden crash—
None saw the fallen warrior dash
Down the bare rock to high and white.
But he that drooped not in the chase
Made on the hills his burial place.

—Henry Wadsworth Longfellow, "Jeckoyva," 1825

IN THOMAS JAFFREY'S 1755 map of New England, published in London, a constellation of crude graphic symbols for hills and ponds dominates the topography of the north country (fig. 25). With the characteristic reticence of the early map makers, these features of the landscape (the nineteenth century accelerated the perception of them into mountains and lakes) are labeled with downsized designations. At the margin of civilization is found the silhouette of a schematic protuberance described as "Jackoyway's Hill." Situated due north of Kusumpe Pond (Squam Lake) and Winipesoget Pond (Lake Winnepesaukee) this enigmatic designation reoccurred in the 1771 edition before disappearing altogether from the 1784 version of the map. To date there has been no attempt to explain the cartographic appearance and subsequent disappearance of "Jackoyway's Hill" in the north country of New Hampshire. A poem written in 1825 by the young Henry Wadsworth Longfellow entitled Jeckoyva, however, provides a probable solution to this mystery. Longfellow's poem is the first known account of the popular legend of the Indian chief Chocorua, a tale that gripped with a mounting interest (equal to the contemporaneous obsession with the Willey tragedy) the cultural imagination of the romantics.[1]

1. For an account of the Chocorua Legend, see Mayo 1946 (303–12). In the preface to the poem, Longfellow provides an account of the legend that differs significantly from Cole's: "The Indian chief

25. *Thomas Jaffrey*, Map of
New England *(detail)*,
*1755. Courtesy of
Dartmouth College Library.*

Jeckoyva as tradition says perished alone on the mountain which now bears his name. Night over-
took him while hunting among the cliffs, and he was not heard of till after a long time, when his half-
decayed corpse was found at the foot of a high rock, over which he must have fallen. Mount Jeckoyva
is near the White Hills." See Longfellow 1893 (650).

When Thomas Cole in his *Essay on American Scenery* defined the supposed "grand defect" of the American landscape as "the want of associations," he further contended that "many a mountain stream and rock has its legend, worthy of the poet's pen or the painter's pencil" (McCoubrey 1965, 108). Among those native legends to which Cole alluded is the tragic narrative of the Indian chief Chocorua.

A tale of revenge, malediction, and death, it seized Cole's pictorial (and literary) imagination with increasing intensity during the 1820s and 1830s. During these two decades the artist painted the mountain on at least a dozen occasions as a direct consequence of his preoccupation with the legend of the Abenaki chieftain. According to the numerous and often conflicting accounts, Chocorua avenged the death of his son from accidental poisoning by murdering the wife and children of the white settler to whom he had entrusted his child before departing on a hunting trip. Trapped on the summit of a rocky peak in the White Mountains by his white pursuers, Chocorua chose death rather than capture. Before leaping to a heroic suicide from a prominent rock (which can still be seen near the summit), Chocorua cast a malediction upon the land cursing the white man, his crops, and his cattle.[2]

Possibly attracted by Longfellow's recently published poem, Cole climbed the mountain in October 1828 in order to make drawings of the summit and the fabled rock. In his sketch book he also noted, in verbal outline, the details of the legend. During the winter of 1828–29, Cole painted a large canvas entitled *The Death of Chocorua*, which a visitor to his studio described as being "of great force and motion" (Mayo 1946, 303). Although the painting has since been lost, an engraved copy, retitled *Chocorua's Curse* (fig. 26), was used to illustrate Lydia Maria Child's account of the legend published in the 1829 gift volume of *The Token* (Willis 1829). This graphic image is in general conformity with contemporaneous descriptions of Cole's canvas. Though much is lost in the engraving, there is sufficient evidence to suggest that the original painting was a work of considerable formal and narrative interest. Isolated upon a rocky promontory, the chieftain casts a hostile gaze upon his pursuers. Like a figure from a Greek sculptural tableau, Chocorua confronts his fate in the pose of a deity or warrior. Loosely derived from the famous Hellenistic sculpture *Dying Gaul*, the recumbent chief is cast in a role at once tragic and heroic as he contemplates his destiny.

Cole had surely observed the distant profile of Mount Chocorua on his 1827 trip to the White Mountains because he included it, together with the neighboring

2. Cole's sketchbook is in the Detroit Institute of Art. The drawing and a photograph of Chocorua's rock are reproduced in Clark 1975, figs. 4 and 5.

26. George W. Hatch, after
Thomas Cole, Chocorua's
Curse, 1830. Engraving.
Courtesy of Dartmouth
College Library.

Mount Paugus (named after another Abenaki chieftain), in the painting *Lake Winnepesaukee* (fig. 27), commissioned by his early Connecticut patron Daniel Wadsworth. Exhibited at the National Academy of Design in 1828, the painting was engraved by Asher B. Durand in the same year and reproduced two years later in William Cullen Bryant's pictorial and literary compendium *The American Landscape*.[3]

In this moody canvas two travelers are represented, one riding into the landscape, the other staring quizzically outward, engaging the viewer in the content of the painting. At the horizon, Chocorua and its neighbor (to borrow a title from the poet Wallace Stevens) rise above the mirror-still waters of the lake. While the artist envisioned Mount Chocorua as "an immense pyramid," and its neighbors as more rounded summits, enframing trees and stage-like coulisses, rolled out from the edges of the canvas, are derived from conventional formulas for the European

3. Reproduced in Parry 1988, fig. 42. Durand erroneously describes the two mountains as Chocorua and Mount Washington: "two of the majestic brotherhood of the White Mountains, the loftiest in all the eastern half of North America" (Parry 1988, 69).

Picturesque. A more immediate source for Cole's composition is found in a well-known view, *Lake Nemi* by the late-eighteenth-century British painter Richard Wilson, which was doubtless known to the artist through engravings.[4] More important than these derivations are the radically innovative elements of Cole's dramatic canvas. In the center of the painting alternating planes of light and dark animate the pictorial space, lending a heightened ambient to the scene. More emotively charged than contemporary scenes inspired by picturesque aesthetics, Cole's work contains a dramatic foreground, selectively lighted to reveal the notional travelers. By way of strengthening the emotional effects of the canvas, the stark silhouette of a foreground tree writhes in anthropomorphic spasms while leading the viewer's eye toward the distant mountains. Finally, the natural elements of earth, water, and sky are dramatically conjoined to invest the narrative with the quality of some deep and ineffable mystery.

27. Thomas Cole, Lake Winnepesaukee, *1827. Oil on canvas, 24½ in. x 34½ in. Courtesy of the Albany Institute of History and Art.*

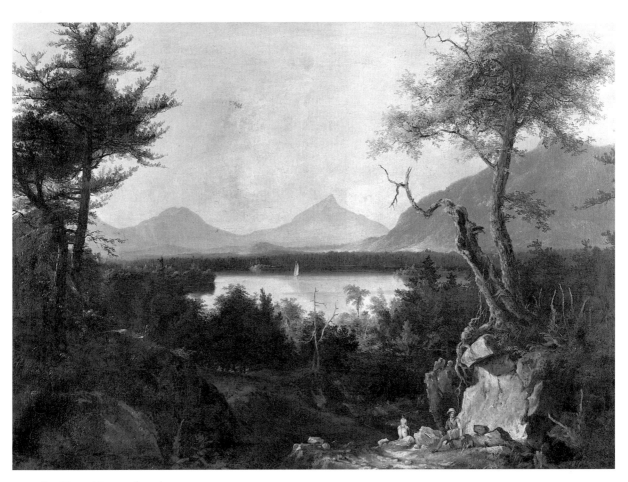

4. See Constable 1953, fig. 93b.

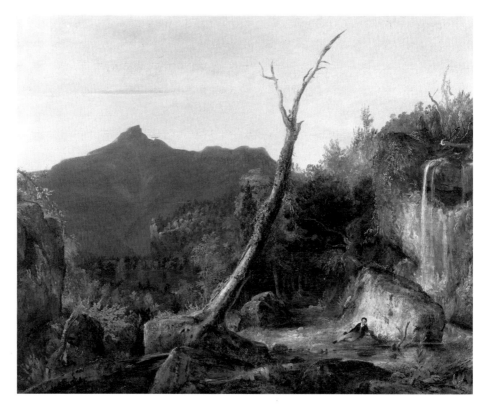

28. *Thomas Cole,* Autumn Landscape (Mount Chocorua), *ca. 1827. Oil on canvas, 38 in. x 48 in. Courtesy of Kennedy Galleries, New York.*

The gloomy aura of *Lake Winnepesaukee* yields to one of outright morbidity in the remarkable landscape entitled *Autumn Landscape (Mount Chocorua)* (fig. 28), probably executed at the same time. In this work the artist locates his figurative persona at the lower right of the composition in a pose that traditionally denotes melancholy. Neither wholly self-absorbed nor totally unaware of the viewer, the reclining figure also serves to enlist the spectator's empathy with the experience of the painting. By returning our gaze, the artist implicates the observer in the content of the painting and, by extension, in the artist's vantage without and within the canvas. The resulting image of a romantic artist ruminating upon an eighteenth-century legend, still speaks evocatively to the modern observer.

The solitary figure, no longer a conventional figure of *staffage* but a significant component of the view, is depicted in the role of an artist-wanderer.[5] Denoting the creative self immersed in the infinity of nature, the self-reflexive figure of the painter contemplates America's mythic past as well as his role as an integral subject of the painting.[6] Enframing the artist, a chaos of rocks, trees, and water further adumbrates

5. For an excellent study of the poetics of the peripatetic walker from Wordsworth to Thoreau, see Wallace 1993.

6. For a discussion of this theme see Lipp 1987 (122–45). For the waterfall as *vanitas* symbol, see Wiegand 1971 (89).

the elegiac mood of the painting. By way of signifying his intentions for *Autumn Landscape*, Cole noted in his journal: "It was not for pictures that I ascended the mountain [Chocorua], but for ideas—for conceptions" (Erwin 1990, 28).

In this important early painting it was through the legend of Chocorua that the artist most forcefully asserted the capacity of the American landscape to fulfill the imperatives of European "associational theory." Claiming that aesthetic value resides less in the object represented than in the mind of the beholder, the doctrine of Associationism was inherently inimical to an America lacking a perceived history. In this connection, Cole's effort to elevate the wilderness to a state of aesthetic respectability was grounded in a conscious effort to discover accessible myths in Native American history.

The figure of the artist, indulging in the "somber pleasure of a melancholy heart," establishes the dominant mood of the view. Situated beneath a waterfall ("the voice of the landscape"), which weeps evocatively into the scene, he confronts the spectator rather than communing with the surrounding spectacle of nature. Embodying in his represented persona the "delightful horror" central to the experience of the sublime, the artist-wanderer serves as the viewer's emotional surrogate. At the center of the composition a starkly symbolic tree bifurcates the scene into light and dark, near and far, human and nonhuman.[7] Above the desolate foreground looms the summit of Mount Chocorua bathed in a lingering twilight. As if recalling Wordsworth's verses from *Tintern Abbey* (1798) ("The sounding cataract haunted me like a passion: the tall rock, the mountain, and the deep and gloomy wood"), Cole shaped one of his most resonant images of the American landscape as embodied history. A natural *memento mori*, this moralistic canvas was destined to impart to an informed viewer an awareness of the American past as nativist and tragic. In deploying the image of Mount Chocorua and the mythic aura of its attendant legend, Cole fashioned a work bearing a heavy freight of "poetical association."

By way of a seemingly extended verbal discourse with Cole's painting, the fireside poet John Greenleaf Whittier, versifying a decade later, commented on "that grim citadel of nature." The poet's favorite mountain, it was equally the natural museum where "God's great pictures hung." For Whittier nothing "had a deeper meaning / Than the great presence of the awful mountains / Glorified by the sunset" (Whittier 1904).

Mount Chocorua, as a prime locus of sublimity, cast its darkening shadow over much of the romantic period. When Professor Charles Dana of Dartmouth College attempted, shortly after the exhibition of Cole's celebrated narrative, to

7. For the theme of solitude in American art, see Glanz 1978 (12–13).

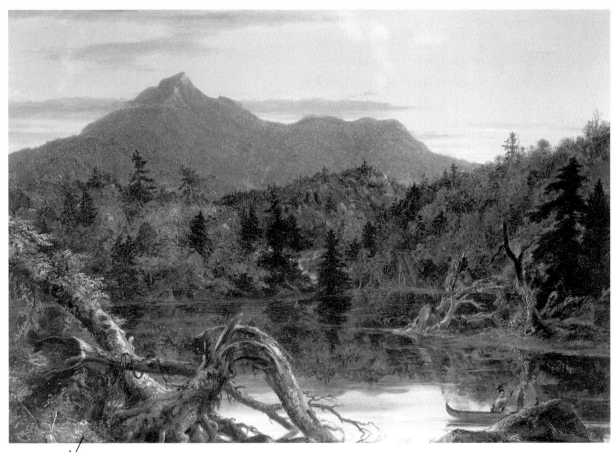

29. *Thomas Cole,* Autumn Twilight, View of Corway Peak, *1834. Oil on canvas, 14 in. x 19½ in. Courtesy of The New-York Historical Society.*

account for the death of cattle in the region through the presence of excess lime in the water, it was, at best, a feeble attempt by science to undermine the mythic power of the legend (Mayo 1946, 31–56).

A few years later Cole's attitude toward the idea of the mountain underwent a major transformation. Two paintings created for the wealthy New York patron Luman Reed in 1834 provide evidence of this revised perspective. The first, entitled *Autumn Twilight, View of Corway Peak* (fig. 29), represents the familiar profile of the peak together with a rather fanciful view of Chocorua Lake. The dominant symbolic tree of the earlier view has collapsed into the water, a victim of time, myth, and nature. At the lower right, the *genius loci,* the Abenaki chieftain Chocorua, resurrected for the fictive occasion, paddles a canoe upon the placid body of water. Transforming history into histrionics, Cole reduplicates the mountain, the blazing autumn foliage and the resplendent twilight in the reflecting surface of the limpid lake. This display of nature's vivid representation of itself to itself lends Cole's canvas its imaginative force as well as its nativist content. As the mirror of nature, the lake functions as a locus for literal and figurative reflection upon the primal American wilderness.

The surface of the painting, dense, viscous, heavily pigmented, is covered with the visible gesture of Cole's brush, the painterly trace imposed by the artist between the spectator and the illusory space of the painting. For Cole, the deliberate evidence of his brushwork represented both a physical and an emotional intercession with the content of the work, the active, "painterly" surfaces communicating his emotional involvement in the recreation of the landscape and its expressive content.

Cole's nostalgic reprise of Chocorua and his mountain was doubtless intended to represent the primal American wilderness prior to the incursions of Europeans, the recreation of a vanished golden age. "A 'real' landscape cast in the past tense" (Wallach 1981, 98), *Autumn Twilight* reverts to a mythic time when the first Americans lived in harmony with nature. Such pictorial restoration of the land and its inhabitants to the presumed origins has been interpreted by Alan Wallach as an attempt to escape from the discordant reality of the present by retreat into the ideal of the wild (1981, 94). A fundamentally conservative project, this retrospective historicism informed many of Cole's early works in both the Catskills and the White Mountains.

For Cole, at this juncture of his career, Mount Chocorua frequently served as a cultural template for a variety of narrative contexts. Recycled through his fertile imagination, the constituent parts of the scene (mountain, water, trees, *staffage*) could be reassembled to affirm the present or to retrieve the past. This recurrent appropriation of the legendary mountain for aesthetic and/or ideational purposes can also be viewed as an anticipation of the respective serial images of Mont Saint Victoire and Mount Katahdin by such modern artistic luminaries as Paul Cézanne and Marsden Hartley.

A pendant work, identical in size and intended from its inception to be viewed in a dialectical relationship to *Autumn Twilight, Corway Peak,* is entitled *Summer Twilight, a Recollection of a Scene in New England* (fig. 30). Replacing the Indian with a woodsman and displacing the blasted tree with a man-made stump, Cole depicted the antipode of wilderness, the domesticated landscape. Representing the "improvements" of culture, the second canvas substitutes for the mythic past the agrarian present and for the wilderness panorama the depiction of a cultivated world. Tilled lands, curving paths, a tranquil farm house, and a radiant body of water are adduced to provide an image of pastoral harmony. In the immediate foreground a yeoman-farmer, bearing an axe, observes radiating shafts of light emanating from the setting sun. For Cole, such celestial display generally denoted the "highest sublime . . . the eternal, the infinite . . . the throne of the Almighty" (Noble 1964, 282). The temporal progression from wilderness to agrarianism inscribed within these contrasting paintings possibly reflected Cole's reluctant

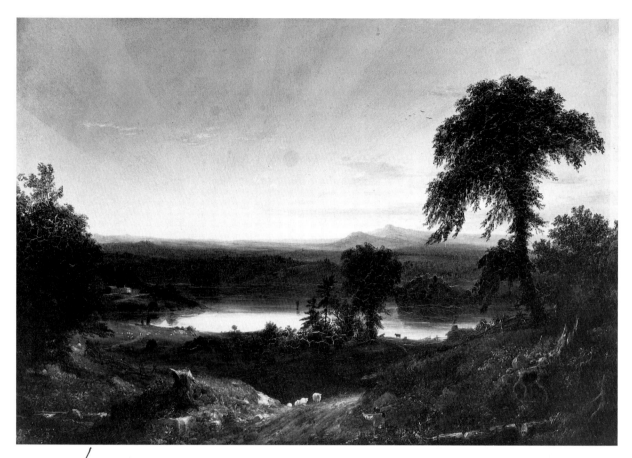

30. *Thomas Cole*, Summer Twilight, a Recollection of a Scene in New England, *1834. Oil on wood panel, 13½ in. x 19½ in. Courtesy of The New-York Historical Society.*

acceptance of the inevitable triumph of culture over nature. Claiming in his *Essay on American Scenery* that "American associations are not so much of the past as the present and the future," he juxtaposed seasonally autumn with summer (in metaphoric terms, death with life), and the historic past with the pastoral present (McCoubrey 1965, 108).

In contrasting the primordial wilderness of Mount Chocorua with the "quieter spirit" of rural husbandry, Cole reluctantly renounced "the stern sublimity of the wild." For Cole the dilemma of American nature (in Barbara Novak's celebrated formulation—nature as poetry and property, culture and commodity [1980, 171]) could only be resolved through an art that offered the consolation of a bucolic counterpoise to the inevitable processes of history. Indeed, at the exact moment the artist created this diptych, he was also working on *The Course of Empire*, a series of paintings for his patron Luman Reed, documenting the inexorable rise and fall of civilization.

A third Chocorua-related painting representing the frontier era in New Hampshire also mediates between the polarities of wilderness and cultivation. *The*

Hunter's Return of 1845 (fig. 31) depicts a pioneer family living in near proximity to Mount Chocorua. A log cabin and modest traces of cultivation provide a rustic setting for the returning hunters. A conscious reformulation of biblical representations of the Israelites in the Promised Land, Cole's composition invests the pioneering era (an intermediate stage between the savage and the fully domesticated) with the status of a rural Arcadia. As with the revisioned view of *Crawford Notch* (see fig. 18), Cole was striving to arrest the headlong rush of American history at this moment of minimal human interaction with the wilderness. Arguably, this confected equilibrium represented for the artist the optimal condition for human habitation of the White Mountains.

Art historian William Truettner has persuasively argued that Cole's New England frontier imagery also constituted a form of cultural resistance to the nation's westering, expansionist impulse. Substituting nostalgia for America's past for the imperatives of Manifest Destiny, Cole sought to preserve the White Mountains as an ideal retreat for myth and a refuge from the broader utilitarian thrust of his society (1991, 29).

31. Thomas Cole, The Hunter's Return, 1845. Oil on canvas, 40⅛ in. x 60½ in. Courtesy of the Amon Carter Museum, Fort Worth, Texas.

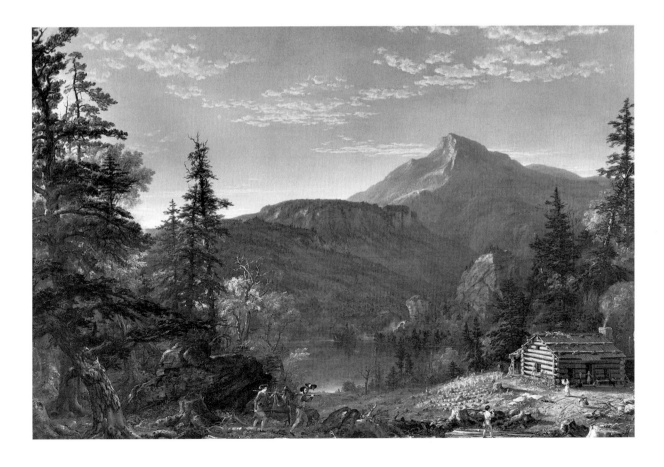

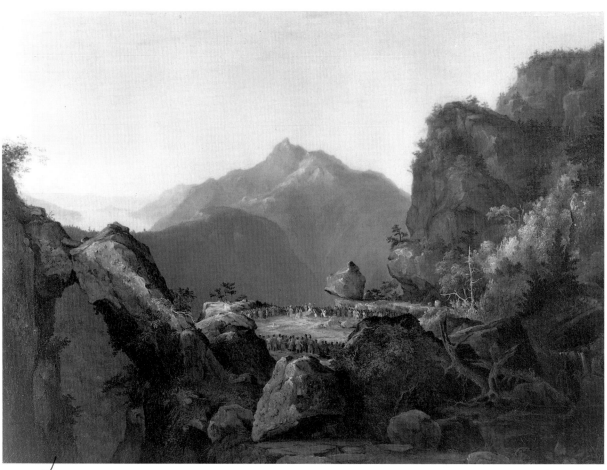

32. *Thomas Cole,*
Landscape Scene from
The Last of the Mohicans,
1827. Oil on canvas, 25 in. x
31 in. Courtesy of New York
State Historical Association.

Cole's obsession with the Chocorua legend carried over into the representation of many of his other Indian subjects. In a painting based on his friend James Fenimore Cooper's recently published novel *The Last of the Mohicans* (fig. 32), Cole employed the profile of Mount Chocorua as the setting for the confrontation between whites and Native Americans. Depicting the famous passage from the concluding chapter in which Cora, the representative of maidenly Christian virtue, pleads with the ancient Delaware Tanemund to spare Alice and Heyward, Cole locates the event improbably in the White Mountains. Although the locus of Cooper's narrative was near Lake George in the Adirondacks, Cole reflexively substituted Mount Chocorua as the setting for the action. In addition, he visually translated Chocorua's rock from the summit of the mountain into a precariously balanced boulder located above the circle of Indians. This bit of lithic and pictorial legerdemain caused Cole's literal-minded patron Robert Gilmore to criticize the artist by observing that "the rock teetering on its pivot is scarcely balanced enough" (Parry 1988, 64). Referring to the many mysterious "erratics" found throughout New England, Gilmore was drawing attention to a geologic phenomenon that

greatly interested the romantics well before the theory of glaciation was widely understood.

One of the artist's most resonant uses of the Chocorua-trope was as the setting for the recently discovered *Garden of Eden* (plate 3). This resplendent canvas was painted in 1828 as a pendant to the better-known *Expulsion from Paradise* (Boston, Museum of Fine Arts) and was exhibited at the National Academy of Design in 1831. Employing a modified Claudian formula, Cole created an emblematic image of Eden as the White Mountain Intervale. With its darkened foreground, park-like middle distance, centrally placed waterfall, and climax mountain summit, Cole shaped an image that strongly influenced several later nineteenth-century landscape paintings of the "garden of the world." Impacting both compositionally and ideationally such diverse and celebrated works as Frederick Edwin Church's *Heart of the Andes* (1863) and Albert Bierstadt's *The Rocky Mountains* (1863), Cole's seminal scheme provided a paradigm for the Adamic American wilderness. So authoritative was Cole's sequential image of the garden, and so pervasively spiritualized its intended meaning, that the painting was engraved as the frontispiece for Gray and Bowen's Bible published at Boston in 1831.

Striving to make visible John Ruskin's assertion that "the best image which the world can give of Paradise is the shape . . . of a great Alp, with its purple rocks and eternal snows above." (Starr King 1859, 1), Cole defined an epiphanic vision of natural glory for his romantic contemporaries. In a verbal reprise of Ruskin's views, the artist avowed in his *Essay on American Scenery* that "We are still in Eden, the wall that shuts us out of the garden is our own ignorance and folly" (McCoubrey 1965, 109).

A symbol of national innocence, *Garden of Eden* also reminded viewers of the British philosopher John Locke's dictum that "in the beginning all the world was America." As if present at the Creation, the observer sees through the eyes of the first parents the splendors of Paradise. The depicted awakening to nature of the American Adam (and Eve), here understood as a metaphor for "nature's nation," is viewed through an arched opening in the trees, a primal forest cathedral. Tropical flora such as orchids and palm trees frame the revelatory moment of wonder and discovery.

In 1839 Cole made his third and final trip to the White Mountains, revisiting such familiar sites as Mount Chocorua and the Crawford Notch. A painting of 1844 entitled *Corway Peak, New Hampshire* (fig. 33) depicts the familiar mountain as a virgin wilderness together with the presence of Indians perched on a rocky ledge in the middle distance. A densely pigmented surface of strident autumn hues suggests the organic flux of nature moving in harmonious accord with the rhythms and patterns of her native inhabitants. A further series of views from the following years

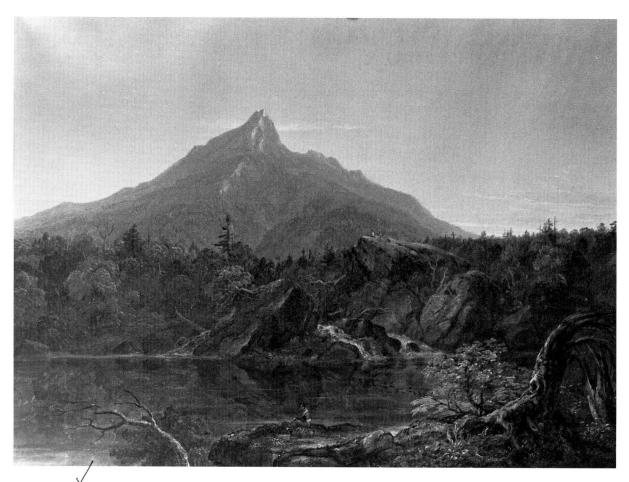

33. *Thomas Cole, Corway Peak, New Hampshire, 1844. Oil on canvas, 18 in. x 24 in. Courtesy of the Maier Museum of Art, Randolph-Macon Women's College, Lynchburg, Virginia.*

incorporates the feared and beloved mountain within the convention of mid-century pastoralism. A painting of 1845, entitled *The Old Mill at Sunset*, employs Chocorua as the backdrop for a bucolic scene of grazing cows, a placid lake, and children gathering flowers within a cultivated foreground. *The Hunter's Return* of the same year depicts the mountain, receding in space and time, distantly presiding over a scene intermediary between the states of wilderness and cultivation. A foreground composed of a rustic log cabin, a modest garden, man-made stumps and returning hunters, laden with game, further imbricates the region with the frontier myth. A final work, *Home in the Woods* of 1847, executed the year before the artist's death, reprises the frontier theme while depicting continued cultivation of the wilderness. In this luminous composition, Mount Chocorua no longer dominates the human protagonists and their activities, but is recessed well into the background, a quasi-absent signifier of the once potent mountain. Bathing the scene in a golden, elegiac light, the artist created a "wishful continuum with the classical world, as if America could stop dead in its tracks and remain a never-changing virgilian paradise" (Truettner 1991, 29, fig. 20). For Cole, Chocorua served both at the beginning and

at the end of his career as a symbolic mountain, a place where the artist explored the broad spectrum of American mythologies as he sought to create a distinctive cultural identity for the nation. Surely no other mountain in the history of American art—with the notable exception of Mount Katahdin—served so well, nor was so well served by a landscape painter.

In terms of the broader history of American art, no mountain has figured more prominently in the representation of the national landscape. Without exception, Chocorua has been more frequently depicted than any other peak (though New Hampshire's Mount Monadnock possesses the dubious honor of being the most frequently climbed). More picturesque than Mount Washington (Starr King), and bearing a larger body of legend than any summit in the White Mountains (Henry James), Chocorua functioned as a crystallized paradigm for both mountain gloom and mountain glory.

For Asher Durand the mountain still bore as late as midcentury much of the freight of meaning imparted by Cole. More actualized than Cole's mythic vistas, Durand's view of Chocorua (fig. 34) nonetheless depicts a wilderness untouched by

34. Asher Brown Durand, Chocorua Peak, 1855. Oil on canvas, 44¼ in. x 60 in. Courtesy of Museum of Art, Rhode Island School of Design, gift of Rhode Island Art Association.

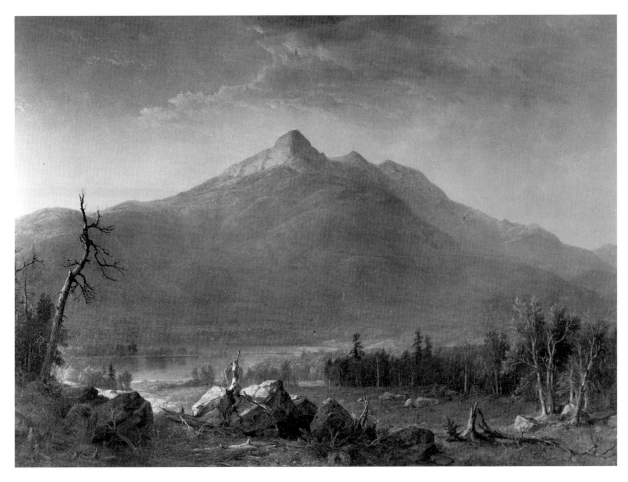

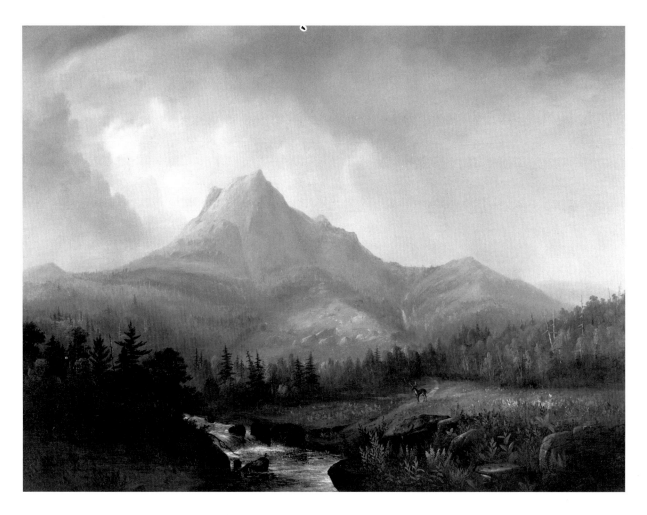

35. *Samuel Griggs*, Mt. Chocorua, *1857. Oil on canvas. Private collection.*

the axe of civilization. Although the region was heavily populated by midcentury, Durand's painting remains a nostalgic recreation of the mythic past. An imaginative recovery of lost wilderness, Durand's *Mount Chocorua* discourses with art, history, and the persistent dream of American exceptionalism.

An intriguing painting somewhat dubiously attributed to Samuel Griggs and dated 1857 (fig. 35) conveys even more emphatically the ethos of a pictorially recreated wilderness. Dark and turbulent, the large canvas boldly envisions the mountain as a natural theater of the American sublime. With its extruded summit, boiling atmospherics, and chaotic foreground, the work anticipates the pictorial operatics of such renowned western artists as Albert Bierstadt and Thomas Moran. Adhering to an established literary convention, Griggs depicted a tumultuous sea of clouds replicating in the sky above the material shape of the mountain. This conceit is encountered in verbal form, for example, in Thomas Starr King's empurpled description of "the two Chocoruas": "One is a rocky, desolate, craggy-

peak substance—the other is the wraith of the proud and lonely shape above" (1859, 140–41). Nearly a century later the poet Wallace Stevens, engaging in a poetic dialogue with the cultural aura of Mount Chocorua, referred to its "prodigious shadow" as a means of exploring his own artistic relationship to the mountain. By way of further analogy with Griggs's painting, Mount Chocorua remained for Henry David Thoreau, as late as 1858 and despite contrary evidence, "the wildest and most imposing of all White Mountain peaks" (Howarth 1982, 232).

These wistful and imaginative pictorial and literary treatments of the mountain stand in marked contrast, however, to most midcentury images of Chocorua. For example, the works of Aaron Draper Shattuck, David Johnson, and John Frederick Kensett (cf. fig. 40)—to mention but a few of the hundreds of painters who were drawn to the site—depict the mountain in conformity with decidedly more sober realist canons of art. The deliberate horizontal format of their canvases together with the inclusion of farms, fields, and flocks bring them into accord with the actual midcentury patterns of habitation and agriculture in the region.

The emblematic character of Mount Chocorua: pyramidal, isolated, rocky (Henry James referred to it as possessing the allure of a "minor Matterhorn"), and its status as the "only mountain whose peak is crowned with a legend" (Howarth 1982, 145) rendered it serviceable in a wide variety of painterly contexts. Under the pictorial aegis of Thomas Doughty, for example, the mountain was miraculously transposed to the Franconia Notch, where in a canvas of about 1830 it can be seen in improbable juxtaposition with the cliffs of Cannon Mountain and Echo Lake (fig. 36). Forming a veritable pastiche of White Mountain scenery, Doughty's painting cleverly redeploys the familiar topography in a fanciful collage of sky, water, and summits. These imaginative displacements were by no means confined to the early romantics. As late as 1857, when most American painters were largely committed to topographic accuracy, John White Allen Scott relocated Chocorua to the vicinity of Crawford Notch (fig. 37), effecting yet another protean cultural migration of the peak.

Viewed from the north, Chocorua offered a more benign aspect to most midcentury painters. An instructive example of this process of demystification is a painting by Benjamin Champney from about 1870 (fig. 38). In this softened canvas a river and a plain provide the foreground and middle distance for a composition that emphasizes a classic horizontal rather than the transcendent vertical disposition of mountain and sky. Loose, visible brush strokes together with the use of earthen hues and hazy atmospherics further divest the landscape of strong emotional resonance and suggest connections with contemporary French painting of

36. *Thomas Doughty,*
Sportsman by Lake, *ca.*
1830. Oil on canvas, 20 in. x
24½ in. Courtesy of the
Hood Museum of Art,
Dartmouth College.

37. *John White Allan Scott,*
In the Notch, *1857.*
Oil on canvas. Courtesy of
the New Hampshire
Historical Society.

the Barbizon School. In Champney's soft focus work sublimity yields to a kind of pictorial détente and a clear preference for the prosaic and mundane over the dramatic and phenomenal.

Viewed from the distant Intervale at North Conway, Chocorua offered a still more welcoming face to the pastoral sensibilities of the late century. Alfred Thompson Bricher's *Mount Chocorua and Moat Mountain from Intervale* (fig. 39) of ca. 1870, for example, employs an extended horizontal format to achieve a balanced and planar composition suffused with the effects of clarified lighting. This emergent interest in light, color, and atmospherics, which has been variously described under such art historical rubrics as aerial luminism or atmospheric luminism, began to compete with the older paradigm of climax scenery during the middle decades of the nineteenth century. With its emphasis on "space as a container of colored air," the luminist aesthetic in its various manifestations stressed a quietistic ideal of nature—rather than the more active imperatives of nineteenth-century narrative scenery. Emphasizing stasis rather than flux, luminism has been defined as a visual analogue to transcendentalism (Novak 1969), pantheism (Weiss 1987), and, most recently, the feminine principle of culture (Miller 1993). In each of these accounts

38. Benjamin Champney, Mt. Chocorua, New Hampshire, ca. 1870. Oil on canvas, 12 in. x 18 in. Courtesy of the Museum of Fine Arts, Boston. Reproduced with permission. © 2000 by the Museum of Fine Arts. All Rights Reserved.

light as the dominant aesthetic element is considered a *simulacrum Dei*, a manifestation of the presence of the divine in the world.

In stressing light over form and eliminating the foreground device of *repoussoir* and bracketing trees, Bricher eschewed the usual picturesque conventions of enframement. Rather, he permitted the landscape forms to extend laterally off-canvas, thereby divesting the scenery of much of its potential for "climax." This unprepossessing imagery was generally characteristic of the midcentury and may also reflect the structures and practices of early landscape photography. No longer perceived as a sublime wilderness but rather as a place conducive to human cultivation, the subject of Bricher's canvas can best be described as a landscape of expediency. In present environmentalist terms, *Mount Chocorua and Moat Mountain from Intervale* embodies a conservationist rather than a preservationist ethic. Agrarian usage rather than the ideal of primal wilderness, the aesthetics of the beautiful rather than the sublime, inform this utopian vision.

Among the earliest and finest examples of north country luminism is John Frederick Kensett's *October Day in the White Mountains* of 1854 (fig. 40). Imposing both atmospheric clarity and compositional planarity on the depiction of the fabled mountain, Kensett imparted lateral balance and symmetry to the scene. White farm houses, cultivated fields, and a bridge located parallel to the picture plane are conjoined to produce a vision of rural harmony. Relying upon the capacity of natural light to evoke supernatural mysteries, the painter suffused the land-

39. Alfred Thompson Bricher, Mount Chocorua and Moat Mountain from Intervale, *ca. 1870. Oil on canvas, 8½ in. x 16 in. Collection of Charles and Gloria Vogel.*

scape with a shimmering glow of atmosphere intimating an ideal world. Kensett's static view, like Bricher's later works, contrasts sharply with the earlier White Mountain views where active narrative content was often conjoined with phenomenal landscape forms.

The concentrated emphasis on light found in the works of Bricher and Kensett corresponds to an emerging philosophical and empirical awareness of the role of sight in the appreciation and understanding of mountains.[8] As explicated, for example, in Thomas Starr King's nearly contemporaneous guide book *The White Hills*, vision entails both knowledge and sensitivity; emphasis was further placed on the role of the "cultured and reverent eye" as the principal faculty for interpreting landscapes. Sight, according to the author, "is the chief physical sign of the royalty of man"; learning to see "one of the chief objects of education and life." Acutely sensitive to the role of light in the apprehension of nature, Starr King also described the times of day when certain mountains are best viewed: "Thus the mountains are

40. John F. Kensett, October Day in the White Mountains, ca. 1854. Oil on canvas, 31⅜ in. x 48⅜ in. Courtesy of Cleveland Museum of Art, 2000, John L. Severance Fund and gifts of various donors.

8. Starr King was an avid reader of Ruskin and the art journal *The Crayon*, from which he derived his views on the role of light in perception. For an excellent account of the role of *The Crayon* in promulgating Ruskin's doctrine of light, see Grzesiak 1993 (12).

41. *Jasper F. Cropsey, Mt. Chocorua and Railroad Train, New Hampshire, 1869. Oil on canvas, 20 in. x 33 in. Diplomatic Reception Rooms, Department of State.*

ever-changing. They are never two days the same. The varying airs of summer, the angles at which—the light strikes them, give different general character to the landscapes" (1859, 18).

In addition to describing the physics and metaphysics of light, Starr King also argued for diligence and constancy in the pursuit of truth to nature. A follower of John Ruskin, he claimed that artistic beauty is "founded on fact. The man who sees the most beauty in the landscape deals with the facts as demonstrably as if he were engaged all day in dipping buckets of water or shoveling sand or felling birches" (1859, 21).

Despite such persistent efforts by artists and writers to reformulate the aesthetics of the landscape, an aura of sublime mystery continued to be associated with Mount Chocorua. As a hotel was never constructed on its summit, the mountain retained much of its legendary status throughout the later nineteenth century. As one midcentury observer remarked: "No 'Mountain House' perched on these tremendous battlements allures the traveler hither to mock the majesty of nature with the insipidities of fashion" ("A Tour" 1852, 11).

In this connection, all the more intriguing is Jasper Cropsey's *Mount Chocorua and Railroad Train, New Hampshire* (fig. 41) of 1869. This unorthodox view contrasts the spectacle of a train bisecting the landscape with the profile of the fabled mountain.

The energy and dynamism of the machine are juxtaposed with the permanence and stability of nature. In the foreground the figures of boaters provide scale for the scene as well as a veiled discourse on more traditional modes of locomotion. What appears at first glance to be a collision between the opposing institutions of wilderness and technology is in point of fact a synthesis of what the cultural historian Leo Marx described as the two great nineteenth-century "kingdoms of force" (1964, 82). In the contemporaneous formulation of Ralph Waldo Emerson: "Nature loves the gliding train of cars like she loves her own." Viewed as less an intrusion upon nature than an instrument of modern energies, the train was easily reconciled in the romantic imagination with the idea of wilderness. Through an alchemical transformation in the American mind, the curse of Chocorua, like the terrors of the Notch, yielded to a vision of technological progress in the years after the Civil War. As the expedient landscape of the late century emerged, the mountain, like Crawford Notch, was divested of much of its mythic aura. In reluctant acknowledgment of this utilitarian shift, the Reverend Thomas Starr King deplored "the failure of nature" in a versified lament: "the last vibration of the red man's requiem exchanged for syllables significant of cotton mill and rail car" (1859, 149).

42. *John Marin*, Chocorua
in Blue, Green, and
Yellow, *1926. Watercolor;*
16¾ in. x 20 in. © 2000 by
the Estate of John
Marin/Artists Rights
Society (ARS), New York.

6

John Marin's Chocorua and the Poetry of Wallace Stevens

Now, I, Chocorua, speak of this shadow as
A human thing. It is an eminence,
But of nothing, trash of sleep that will disappear
With the special things of night, little by little,
In day's constellation, and yet remain, yet be . . .

—Wallace Stevens, "Chocorua to Its Neighbor," 1933

ONLY DURING the 1920s and 1930s did a major American painter return to Mount Chocorua for inspiration. John Marin's numerous watercolors of the mountain are among the most challenging and engaging American landscapes of the first half of the twentieth century. Employing the language of modern expression: active brushwork, strident coloration, frames within frames and cubist lines of force, Marin sought to make his forms cohere both in space and on the surface of the design. Oscillating between abstraction and representation, Marin's view of Chocorua (fig. 42) leads a pictorial double life, both as a vehicle of significant form and as a referent to the older landscape tradition. Shifting from form to force, Marin subsumed the mountain into the pictorial energies of his painting.

In this complex aesthetic and ideational enterprise, his work also contains striking analogies with Wallace Stevens's poem *Chocorua to Its Neighbor*, published in 1933.[1] Both the poem and the painting confront the dual problematics of beauty and narrative in the modern world as they strive to displace the material realm with the higher reality of art. Stevens's aspiration to write "the poem that took the place of a mountain" parallels Marin's desire to make an autonomous, self-contained aesthetic object at once reliant upon, yet fully independent of, the external world. In a still

1. See Pearce 1979 for an extended discussion of the poem.

further connection, both artists strove to reconcile "myth making" with modern aesthetic experience. By relating the forms of his painting to the imperative of the internal structure of the composition, Marin deliberately subverted the idea of landscape as scenery. Nature, like art, was fundamentally conceived as a process. In this project he created a pictorial equivalent to Stevens's poetic strategy. For both the painter and the poet the mountain "was more than an external majesty." Rather, it was the raw material from which their self-reflexive art was shaped. Like the verses of Wallace Stevens, the abstractions of Marin, hermetic and self-sufficient, allude through a process of resemblance to the play of mind on reality, while eventuating in the "supreme fiction" of the work of art. Central to this project were the effects of imaginative reciprocity between place and perception. To this end Marin observed: "First you make your bow to the Landscape. Then you wait and if and when the Landscape bows to you, then and not until then, can you paint the Landscape" (Marin 1970, 154).

Tilting the perspective and shifting the point of view, Marin created a fluctuating image of natural forces and forms that also served as a metaphoric projection of his own artistic struggles. Whereas most nineteenth-century images of Chocorua strove to attain compositional stability, Marin set the mountains in motion, subjecting them to a kaleidoscopic reshuffling that destabilized the point of view of the spectator. Viewed simultaneously from several contrasting angles, Marin's view of Chocorua, for example, unfolds in an extended perceptual process that transcends the spatial and temporal limits of conventional realism. In his writings the artist viewed mountains "as formed by weights pushing and pulling . . . fighting and being fought against" (Marin 1970, 110). A similar dynamism informs his pictorial system as the fabled mountain is subjected to a revised modernist order.

Although the art of Marin and Stevens represents the most significant confluence of the Chocorua theme in American culture, another early modernist fusion of poetry and painting occurs in the oeuvre of e. e. cummings. Throughout the first half of the twentieth century, cummings frequently summered at his grandfather's farm at the base of Mount Chocorua. Styling himself both "poet and painter," cummings, after a brief flirtation with painterly abstraction, turned increasingly to naturalistic representations of the landscape. Such early watercolors as *Landscape with Stormy Sky* (plate 4), executed in what the artist called his "spontaneous style," offer an intensely subjective and expressive reading of the mountain. Bright colors, applied in transparent washes, intimate the artist's deeply felt emotions for a place beloved since childhood. A poem from the mid-1930s ("when faces called flowers float out of the ground") forms a verbal *paragone* to this image. The

43. *e. e. cummings,*
View from Joy Farm,
1941. Oil on canvas.
Private collection.

poem's repeated anthropomorphic refrain, "yes the mountains are dancing togeth-er," suggests a perceived exuberance that is mirrored in the artist's active brushwork and vibrant coloration. The expressionist aesthetics and intense subjectivity of both the poem and the painting situate these works among the foremost products of early American modernism.

A later oil painting, *View from Joy Farm* (fig. 43) of 1941, is a less vital and original work and closely relies on one of Paul Cézanne's canonic post-impressionist views of Mont St. Victoire.[2] The distant summit, enframed by a foreground tree, affords a decidedly derivative look when contrasted with the painterly exuberance of the "spontaneous style." Cummings's turn from personal expressionism to an academic dependence on the history of art also reflects the emergence of "regionalist" aes-thetics during the period and the widespread rejection of early modernist abstrac-tion. Paradoxically, cummings's poetry at this time was becoming increasingly experimental as his painting became more grounded in convention. For this reason cummings has generally been more esteemed by critics and historians for his vers-es than for his oils and watercolors.

2. Compare with Schapiro 1952, fig. 37.

44. *Frank Stella, Cho-*
corua I, 1965–66. Acrylic
on canvas, 120 in. x 128 in.
Courtesy of the Los Angeles
County Museum of Art.

7

Frank Stella, Chocorua I

It is everything that a New Hampshire mountain should be.
It bears the name of an Indian chief. It is invested with traditional
and poetic interest. In form it is massive and symmetrical.

—Thomas Starr King, *The White Hills*, 1859

*I*N 1966 the celebrated painter Frank Stella created a series of shaped canvases under the high modernist rubric "Irregular Polygons." Based upon recollections from the artist's youth, especially camping trips with his father to the White Mountains, the paintings marked a significant turning point in his career. The general pictorial affect of these works is the tension created by interpenetrating geometric shapes. *Chocorua I* (fig. 44), for example, juxtaposes a gray rectangle with a tan isosceles triangle. The triangle is fortified by a band of white. Where this band intersects and penetrates the rectangle it is "cushioned" by a contiguous pink band. Defining the reciprocal pressures exerted by these shapes upon one another, the bands soften the transitions visually and structurally. Finally, the dominant hues of *Chocorua I*, gray and tan, recall the artist's better known monochrome "black paintings" of the late 1950s.

While Stella, one of the major practitioners of non-representational abstraction, would clearly reject any attempt to ascribe narrative content to his paintings ("What you see is what you get"), the temptation nonetheless persists to project meaning onto them. Is there not some allusion embedded in the title of the painting that encourages, or at least allows, for speculation as to the narrative implications of these works? Does not the structure of the canvas, a triangle rising above a rectangle, suggest the pyramidal summit of Chocorua surging over the fabled lake?[1] The somber hues likewise elicit associations with the tragic legend of the Indian

1. The Russian theorist-painter Vassily Kandinsky, whose *Concerning the Spiritual in Art* was first published in 1914, considered the mountain/triangle/pyramid form a geometric symbol for spiritual enlightenment (20). The triangle was adopted by numerous early transcendentalist-modernists, including Lawren Harris, John Marin, and Marsden Hartley, to denote spirituality.

chief, much as the titles of Stella's "black paintings" (*Die Fahne Hoch, The Marriage of Reason and Squalor*) are not fully separable from the artist's morbid chromatic schemes.

These considerations aside, Stella's use of the Chocorua trope suggests that the mountain had retained its cultural charisma even during an era of canonical formalism. The artist's work, which is, according to the critic Michael Fried, "the most radically illusive and irreducibly ambiguous in the history of modernism" (1965, 134), nonetheless will continue to invite readings of content unless the artist's titles are considered to be utterly perverse or arbitrary.

8

Mount Washington

AN ICON OF PLACE

The second greatest show on earth.

—P. T. Barnum

O N JULY 31, 1820, Phillip Carrigain, attorney general for New Hampshire, guided by the legendary Ethan Allen Crawford, ascended the highest peaks of the White Mountains. With the exception of Mount Washington, already named by Belknap, he christened them successively, according to height, after presidents Adams, Jefferson, Monroe, and Madison. Running out of presidents, Carrigain named the last and least for Benjamin Franklin and Henry Clay.

Seven years later, following an itinerary laid out by his patron Daniel Wadsworth, Thomas Cole stood before the western slopes of the Presidential Range. From a large glacial mound known as the "Giant's Grave,"[1] he made sketches for the magisterial canvas today found in the Wadsworth Atheneum (fig. 45), the collection for which it was originally commissioned. A wide panoramic view of Mount Washington and the southern peaks, Cole's painting is the earliest known depiction of the vast sweep of the western slopes of the Presidential Range. It is, moreover, the first American landscape painting embodying a conception of grandeur that aspires to the epic. In the foreground an axe-bearing woodsman is literally overshadowed by a large American elm that surges heavenward through the broken trunk of a blasted tree and links the sky with the earth. An alternately lighted and darkened path leads sharply into the middle distance where two wanderers,

1. Starr King (1859, 228) cites the legend of a torch-bearing Indian "maniac" who stood on the giant's grave and proclaimed: "The great spirit whispered in my ear / No pale face shall take deep root here." Starr King notes the fact that all the hotels established on the site burned down. Pondering this circumstance he asks: "Were these fires kindled by the dusky prophet's torch?" John Greenleaf Whittier's early poem "Agiochook" (1837) develops a similar tragic theme of Indians and settlers (Whittier 1904).

45. *Thomas Cole,* View in the White Mountains, *1827. Oil on canvas, 25½ in. x 35 in. Courtesy of the Wadsworth Athenaeum, Hartford, Connecticut, bequest of Daniel Wadsworth.*

traveling in the direction of wilderness, lead the spectator's eye toward the brightly illumined middle distance of the Amonoosuc Ravine. Drawing upon Matthew 7:13–14 ("narrow is the way, which leadeth unto life, and few there be that find it"), Cole animates the landscape with only three figures. In this recessional journey the spectator is guided through the *selva oscura* toward a radiant plateau at the base of a snow-clad mountain that forms the climax of the composition. Among the earliest sequential landscapes in American painting, Cole's *View in the White Mountains* leads the viewer on a spatio-temporal journey that strongly intimates both pilgrimage and spiritual transcendence.[2] Tilting the perspective and deepening the space, Cole fashioned a strongly conceptualized image of natural splendor that is simultaneously a convincingly accurate transcription of place.

An extant oil sketch (fig. 46) reveals the considerable degree of transformation that occurred in Cole's visual thinking between his initial response to the site and

2. For a study of the literary metaphor of "life-as-journey" see Roppen and Sommer 1964.

the finished canvas. In the preliminary conception, gathering storm clouds and a dark foreground filled with blasted stumps and errant boulders impart a conventionally turbulent mood to the scene. Drawing upon the fashionable formulas of literary and pictorial gothicism, Cole treated the mountains as a locus of stress and anxiety. In the revised canvas a brilliant aura of light illuminating the summit of Mount Washington disperses the mood of gloom. At the apex of the composition a hovering halo of clouds ("the smoke of a continual sacrifice") replicates the pyramidal summit of New England's highest peak. Eschewing *Sturm und Drang* for balance and stasis, Cole's *View in the White Mountains* embodies the positive ideals of what has been described as "Christianized naturalism."[3] Representing a moment of visionary contact with the eternal, Cole's painting synthesizes art and nature to form a reverential icon of romantic pantheism. By way of confirming his intention, Cole noted in his revelatory essay on the virtues of American scenery, "The wilderness is yet a fitting place to speak of God" (McCoubrey 1965, 100).

The earliest of the artist's numinous, transcendental landscapes, Cole's *View in the White Mountains* articulates a pantheistic belief in the presence of the divine in

46. Thomas Cole, Storm Near Mt. Washington, 1827. Oil on canvas, 10 in. x 14 in. Courtesy of Yale University Art Gallery, Battell-Stoeckel Trust.

3. For a discussion of the "gothick" and Christian sublime, see Novak 1971 (64–73).

nature. In this seminal work, the wilderness is equated with religious ground and mountains are understood as forms of divine architecture superior to anything made by man.

In a poem written about the time of the painting, Cole enunciated his belief in the divine symbolism of mountains:

To Mount Washington

Hail Monarch of a thousand giant hills!
Who settest proudly on the earth thy throne
Crowned with the clouds and the lightenings. Hail!
Vast monument of power that God hath reared
Upon the lowly earth to conquer time
And measure our eternity—what sage
So wise can tell when first thy dark rude top
Pierc'd the blue heavens and with the sun midway—
The season—hour—when thou shalt melt away
And vanish like the cloudy mists thou art now nursing?
When the all powerful hand of God shall crush
Thy pond'rous rocks, and cast the dust
Upon the changeful and unresting winds?
Not one: Man's vaunted works since thou wert reared
Have risen and crumbled—oblivious night
Hath blotted empires out. And mighty things
Have perish'd like a breath that only dying lives—

(Cole 1972)

Alternating in the space of a single canvas the polarities of light/dark, calm/turmoil, depth/height, advance/retreat, Cole created a landscape of opposites denoting spiritual transcendence. Deployed in this allegorical manner, the painting's chiaroscuro lighting serves as both a natural phenomenon and a metaphor for a spiritual journey, elevating the view from topography to theology. The painting's deliberate structure of duality denotes, as has recently been suggested, the idea of pilgrimage from the mundane to the sacred realm.[4] Cole, an avid reader of John Bunyan's *Pilgrim's Progress*, sought by means of the landscape's deep recessional

4. See Moore 1994 (142–43) for numerous contemporary references to the divine significance of mountains and the idea of pilgrimage.

space, penetrated by the straight path of moral rectitude, to convey the idea of ascension toward higher and hallowed ground.

A definition of pilgrimage by the psychologists Victor and Edith Turner affords added insight into Cole's canvas: "A pilgrim is someone who divests himself of the mundane concomitants of religion . . . to confront in a special 'far milieu' the basic elements and structures of his faith in their unshielded, virgin radiance" (1978, 15). Consistent with this line of thought, the snow on Mount Washington—albeit "unrealistic" for summer—can be understood to symbolize purity, while the summit of the mountain, located at the apex of the composition, figures as the goal of a journey initiated in the foreground. A pictorial pilgrimage through space, intimating both the voyage of life and spiritual odyssey, the structure of *View in the White Mountains* also informs such serial works as Cole's *Voyage of Life*, as well as many of the paintings of the artist's celebrated pupil Frederick Edwin Church. One of Cole's many admirers and followers, Albert Bierstadt, shaped numerous "continental landscapes" of the American West that depend upon the artist's paradigmatic formula for pilgrimage and transcendence. John Frederick Kensett's *The White Mountains—Mount Washington* (see fig. 72)—the most important American landscape of the mid–nineteenth century—also relies upon Cole's sequential composition and its implicit signification of renewal in nature.

In addition to conveying ideas of transcendence, Mount Washington, both as image and reality, was further understood by contemporaries to symbolize liberty and the virtues of the American republic. Associated with both revolutionary energies and the authority of the founding fathers, New Hampshire's Presidential Range was invested by artists and writers alike with a freight of patriotic national meaning.[5] Conflating altitude with beatitude and summits with sovereignty, Cole confected the spectacle of a *sacro monte* embodying spiritual transcendence and patriotic fervor.

Despite these multiple aspirations to a "higher landscape," Cole's *View of the White Mountains* remains resolutely topographic, a recognizable portrait of place. At once phenomenal and spiritual, the canvas represents a synthesis of the profane and the sacred. The artist's determined naturalization of the allegorical impulse, a process that might be termed transcendental realism, works at several levels to reconcile the apparent distinction between "things and thoughts."

For all of Cole's apparent fidelity to the site, many of the artist's patrons had little

5. See Miller 1993 (268–74) for an excellent account of the patriotic symbolism associated with Mount Washington.

47. *Anonymous*, The Broad and Narrow Way, *n.d. Lithograph published by Marshall, Morgan and Scott Ltd. Courtesy of the University of London, the Warburg Institute.*

sympathy with his aspirations to sacrilize and politicize the real. In a letter of December 4, 1827, Daniel Wadsworth expressed his consternation at the extent of Cole's artistic license: "Where in nature," he asked, "might one find the setting for *View of the White Mountains?*" Expressing a preference for fact over fantasy, Wadsworth continued to interrogate the artist and his canvas: "Is the scene of the mountain from near Crawford's house, or where and how far west of the Notch?" (Clark 1975, 94). Throughout his career Cole frequently encountered his patrons' preference for topography over theology and a persisting resistance to his invocations of the ideal over the real. As with most nineteenth-century cultural audiences,

Cole's clients were diversified. Daniel Wadsworth, for example, might express indifference or even hostility to an allegorical reading of landscape, but Cole's friend and biographer, Louis Legrand Noble, was openly receptive to the artist's symbolizing faculty. In providing a model for hundreds of Hudson River School paintings, the artist's vision of Mount Washington is both a recognizable image of place and an icon of romantic nature reverence, a painted link between the material and the spiritual world. A pictorial analogue to one of the artist's favorite texts, John Bunyan's *Pilgrim's Progress*, *View of the White Mountains* is best understood as the paradigmatic transcendental landscape of the early romantic period in America.

A popular graphic parallel to Cole's allegory is provided by a mid–nineteenth century English print illustrating the age-old choice between good and evil (fig. 47). The broad path leading to a stormy realm at the left is contrasted with the narrow way of righteousness. Traversed by several bridges, the path of virtue ascends to the summit of Mount Sion. The Eye of the Lord and the Rainbow of the Covenant confer blessing upon the landscape of righteousness. Employing a recognizable American landscape in lieu of the symbolism of the English print, Cole fashioned a related ascent to virtue through the sacred topography of the White Mountain wilderness.[6]

Shortly after the completion of Cole's influential work, the Portsmouth, New Hampshire, painter Charles Codman created a similar, albeit more constricted, view of the Presidentials and the Amonoosuc Ravine (fig. 48). Employing a dark palette, Codman dramatized and animated the site with the addition of turgid atmospherics and stark, enframing trees. In addition, Codman's canvas is topographically more accurate than Cole's composition. In eliminating the snow-covered summit and blunting the Presidential peaks, the New England painter was more faithful to the site than the Knickerbocker Cole. A bridge traversing the Amonoosuc River, however, is an imaginative device that was often connected with the symbolism for aspiration in European romantic painting.[7] While the mountain denotes power and transcendence, the bridge was associated allegorically with rites of passage and the pilgrimage of life.

When the English topographic illustrator William Henry Bartlett visited America in 1836–37, he brought with him the prevailing European canon of scenic value. Following an itinerary that took him as far west as Niagara and as far south as the Natural Bridge in Virginia, Bartlett was commissioned by the London pub-

6. For an interesting discussion of images of "The Broad and Narrow Way," see Warnke 1995 (115–26 and figs. 107–17).

7. See Holcomb 1974 (31–58). For Codman, see Felker 1990 (61–86).

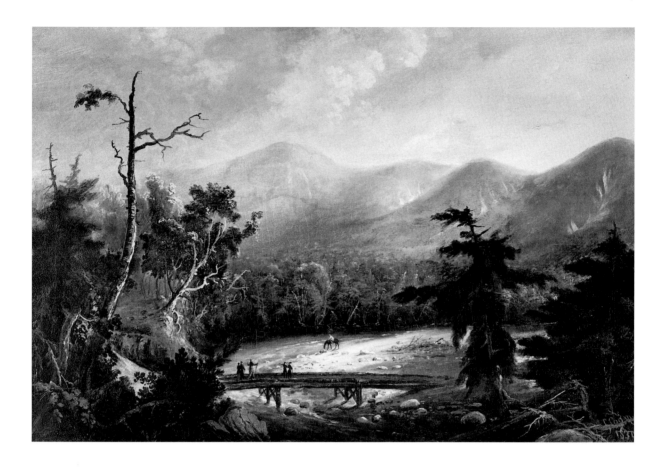

48. Charles Codman, Footbridge in the Wilderness, 1830. Oil on canvas, 25¼ in. x 38½ in. Courtesy of the Portland Museum of Art, Maine.

lisher George Virtue to make landscape drawings for the first comprehensive European book on American nature. Of the 119 scenes illustrating *American Scenery*, twelve are of the White Mountains, second in number only to the Hudson River. As the cult of American wilderness expanded, Bartlett's White Mountain views served to popularize the region for an international as well as a national audience.

The author of the text, Nathaniel Parker Willis of New York, defined the nation's wilderness in the language of romantic singularity: "Either nature has wrought a bolder hand in America, or the effect of long, continued cultivation of scenery, as exemplified in Europe, is greater than is usually supposed. Certain it is that the rivers, the forests, the unshorn mountain-sides and unbridged chasms of that vast country are of a character peculiar to America alone. It contains a lavish and large featured sublimity quite dissimilar to the picturesque of all other countries." In concluding his eulogy on American nature, Willis invoked the trope of the New World Eden: "It strikes the European traveler, at the first burst of scenery of America on his eye, that the New World of Columbus is also a new world from the hand of the Creator" (1839, 3).

Bartlett's illustration of the Presidential Range (fig. 49) represents an apparent conflation of the imagery of the American landscapists Cole and Codman (figs. 45 and 48). Retaining the extended heights and atmospherics of the former, Bartlett also included the pilgrim's bridge. Shafts of light illumine the summit of Mount Washington, the abode of divinity, providing a resplendent aura for the scene. In addition, "clouds of rapture" envelop the perpetually snow-clad summits. Although Cole disparaged Bartlett (describing him in Constable's term of opprobrium as a mere "manufacturer of images"), Bartlett's engravings helped to create an international cachet for the White Mountains as the "Switzerland of America" and a privileged locus of divinity in the new world.[8]

The publication of William Oakes's *Scenery of the White Mountains* in Boston in 1848 marks another important turning point in the cultural history of the White Mountains. A deluxe folio volume containing drawings by Isaac Sprague (the friend and associate of John James Audubon) and Godfrey Frankenstein, Oakes's *Scenery*, lithographed by the firm of J. H. Bufford in Boston, is the first American

49. W. H. Bartlett, View of Mt. Washington, *illustration for Nathaniel P. Willis,* American Scenery, *London, G. P. Vertue, 1838–39. Courtesy of Dartmouth College Library.*

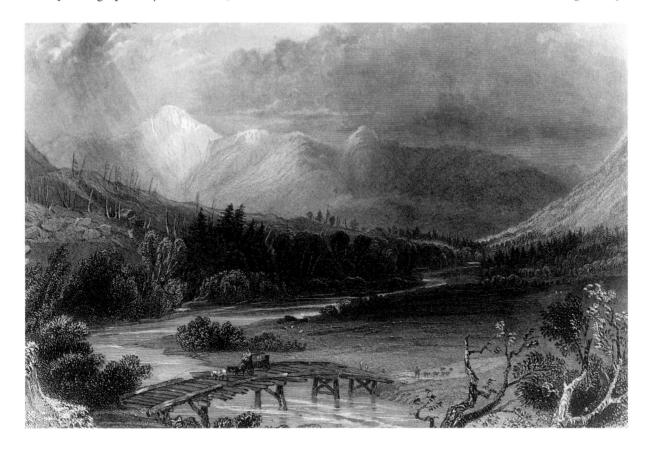

8. See Arnot Art Gallery 1966.

publication devoted exclusively to the White Mountains in which text and image are conjoined to honor the landscape. Among the foremost botanists of the age, Oakes was one of the first scientists to view the White Mountains both as a theater in which the unfolding drama of creation was occurring and as a field for scientific study (Oakes Gulf on the flank of Mount Washington is named after him). His descriptions oscillate between objective analysis of scientific facts and rhapsodic sermons on divine providence: "Mountains are no less monuments of the goodness and wisdom, than of the power and glory of God, their great creator" (1848, 2).

Like many of his contemporaries (Tuckerman, Bigelow, Boott, Huntington, Agassiz, etc.) a scientist-cum-theologian, Oakes carefully described the alpine flora and arctic tundra encountered on the highland plateaus of the Presidential Range, while simultaneously viewing the mountains as evidence of God's handiwork.

The imagery accompanying Oakes's text is, however, less reflective of the spirit of the age or the intent of the author. The splendid full-page illustrations by Isaac Sprague, as seen for example in *The White Mountains from the Giant's Grave, near the Mount Washington House* (fig. 50), are unusually sophisticated designs that depart

50. John Henry Bufford, after I. Sprague, The White Mountains from the Giant's Grave, near the Mount Washington House, *1848. Lithograph, 8⅜ in. x 13½ in. Courtesy of the Hood Museum of Art, Dartmouth College.*

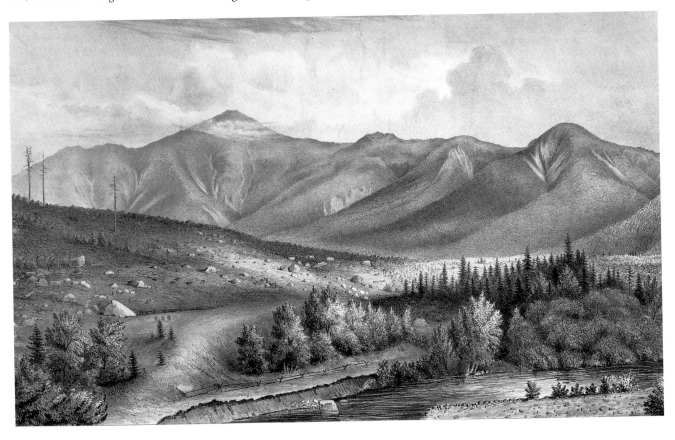

from inherited convention. Informed less by the rhetoric of sublimity than by the imperatives of an emerging midcentury realism, Sprague's renderings of White Mountain scenery appear highly actualized and devoid of the usual associative symbolisms so often invoked by Oakes. His factual yet softly lyrical drawings focus upon appearances rather than formulas for the evocation of spirituality. In all likelihood Sprague's emergent pictorial realism also reflects, in addition to the influence of Audubon, the growing interest in photography that had first been employed in the White Mountains at almost the same moment.[9] As such, Sprague's images fortify the scientific approach of the text while generally eschewing the more overt pantheistic effusions encountered in Oakes's writing.

Where N. P. Willis, the author of *American Scenery*, had elevated Mount Washington to over seven thousand feet with snow during "nine, ten, or eleven months," Oakes places its height within three feet of present reckoning and acknowledged that the summit is "well below the regions of perpetual snow." Among his many interesting observations, Oakes alludes to the slides of 1826 as accounting for the ravaged face of the ravines and interpreted the burnt foreground seen in Sprague's lithograph as the result of deliberate conflagrations made to create potash. This historical and social account stands in marked contrast to previous imaginative writings about the White Mountains. A comparison of Sprague's view of the western slopes with those of Cole and Bartlett reinforces these observations. In Sprague's view, site-specific realism displaces pictorial hyperbole and other customary romantic effusions.

The Oakes-Sprague collaboration afforded the White Mountains richly detailed verbal and pictorial descriptions of the region as well as a wider national audience. The synthesis of fact and imagination encountered in the writing of Oakes further reflects the transcendentalist vision of facts flowering into metaphysical truths. Despite Oakes's verbal efforts to perpetuate the transcendent meaning of nature, however, Sprague's illustrations, taken in isolation and without the supporting verbiage, significantly contribute to the demystification of the mountain landscape.

9. In "White Mountain Notes," Frederick Tuckerman (1926, 295) quotes Thomas Hill, president of Harvard: "If one would recall particular scenes, he must have recourse to the descriptive pen of Mr. Oakes and the daguerrotyping pencil of Mr. Sprague. . . . A Botanist could herbalize in his foregrounds, a geologist theorize on his hillsides. He draws landscapes with minute accuracy, and they therefore have value as portraits far above that of the beautiful idealized landscapes which other artists give of the same spots."

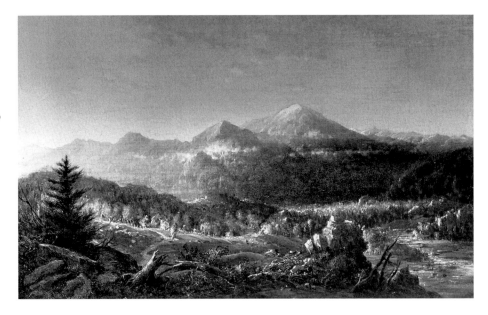

51. George Loring Brown,
The Crown of New
England, *1868. Oil on
canvas, 14⅞ in. x 24⅛ in.
Courtesy of the Hood
Museum of Art, Dartmouth
College.*

As a corollary to Oakes's scientism, many painters after midcentury brought a greater degree of naturalism to the representation of the White Mountains. Although the visionary ideal dominated most depictions, both verbal and literary, not all artists found gods in granite. George Loring Brown's celebrated canvas *The Crown of New England* (presently unlocated), painted in 1860, for example, was, according to critical accounts, less charged with transcendent meaning than earlier images of the western slopes although its mammoth size (approximately 8' x 6') afforded a new scale for White Mountain views. Represented from the north and west, Brown's scene eschewed the customary vantage from the Giant's Grave. Instead the artist represented the view from Jefferson Highlands, including the full sweep of the Presidential Range with Mount Washington regally dominating the lesser northern peaks. Commissioned as a pendant for a similarly scaled view of New York City presented to the Prince of Wales (later Edward VII) by the Congregational minister Henry Ward Beecher and a group of American businessmen, *The Crown of New England* rivaled the mammoth canvases of Church and Bierstadt currently in fashion. As an antipode of the city, Brown's view of the Presidentials engaged in a pictorial dialogue with the pendant vision of urban culture. The title of the canvas, moreover, suggests royal rather than democratic associations, and appropriately enough, the painting entered the collection at Windsor Castle soon after its execution. Although this celebrated work has since been lost, the composition is known through a smaller probatory oil sketch (fig. 51). The royal provenance of Brown's painting further suggests the degree and extent of international celebrity enjoyed by the White Mountains during the nineteenth century.

Additionally, several White Mountain paintings by Thomas Cole and Jasper Cropsey, to name but two members of the Hudson River School abroad, were painted in London (from prior on-site sketches) and exhibited at the Royal Academy.[10]

In 1886 the New Hampshire painter Edward Hill's *Presidential Range from Jefferson Highlands* (fig. 52) also depicted the mountains from a revised physical as well as cultural perspective. Conflating the discrete traditions of landscape tourism with rural genre, Hill fashioned an engaging social drama in the mountains. In the left foreground of the canvas a farmer stands beside several sharply receding cords of wood "put up" for the coming winter. Passively observing the transit of tourist coaches, he is contrasted with the figures of strolling vacationers in the right foreground. A perambulating nurse and a fashionably dressed couple represent "flatlanders" who (then as now) bemuse and confound the hill folk. The drama of opposites is played out before the broad sweep of the high peaks, which forms the backdrop for a social dialectic still operative in the north country today.

Another topical view of the western slopes by the little-known painter Gamaliel Beaman (fig. 53) depicts Mount Washington (flanked to the north by Mounts Clay and Jefferson) from Manns Hill near Littleton. Painted in the late 1860s with rich coloration and energetic brushwork, this canvas is the earliest to depict the summit house on Mount Washington. This mountain hostel, which opened in July 1852, had among its first visitors Jefferson Davis, the future leader of the Southern seces-

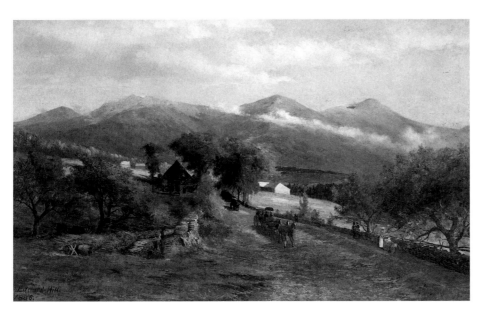

52. Edward Hill, The Presidential Range from Jefferson Highlands, *1886. Oil on canvas. Courtesy of the New Hampshire Historical Society.*

10. For Cropsey's London sojourn see Talbot 1972 (121).

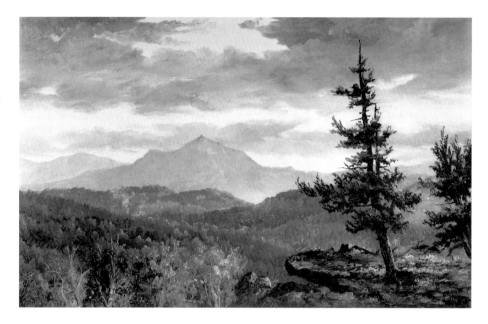

53. Gamaliel W. Beaman,
Mount Washington
from Manns Hill,
*1865–70. Oil on canvas, 13¼
in. x 12½ in. Courtesy of the
Hood Museum of Art,
Dartmouth College.*

sion. Beaman's view is unusual both for its unique vantage and for the heavy impasto of pigment employed to build up the surface of the painting. This striking facture, which asserts that the canvas is primarily a confected aesthetic object before it is a replica of a mountain, was seldom employed during the period for a subject as charged with associations as Mount Washington. Beaman, however, appears in undertaking this grand vista to have perceived nothing more ideologically charged in the landscape than a high mountain capped by a tourist hotel.

Homer Dodge Martin's *White Mountains: Mount Madison and Mount Adams from Randolph Hill* (fig. 54), dating from the middle to late 1870s, affords still another idiosyncratic view of the Presidentials. Executed in the softened tonalist mode of the late nineteenth century, Martin's deliberately aestheticized canvas interposes a veil of softened atmosphere between the viewer and the mountains. Heavy layerings of paint produce a densely pigmented surface, which affirms rather than denies the conditions of the picture's own making. Pictorial unity is imparted to the scene by a conscious subordination of natural detail to an overall impression, as the more traditional discursive meanings associated with the mountain are sacrificed to the evocation of an ambient mood. Few of the conventional narrative associations of fear and exultation, as distinct from the process of making art, are elicited by this highly subjective painting. Anxiety, transcendence, and social history are largely erased from Martin's vaporous mountain world. Beyond the reach and aspiration of earthly pilgrims, his high peaks exist in an ethereal realm of painterly transubstantiation.

In addition, the artist's elevated viewpoint distances the viewer and provides no

immediate ingress into the picture. With no visible threshold for the painting, the spectator is suspended in space contemplating the distant mountain but no longer capable of relating to it vicariously. The further suppression of a recognizable middle ground elides the structure of the image into the proximate and far and renders it less immediate to a viewer's actual experience. The tractions engendered by this new structure transform the landscape into a place of aesthetic delight but no longer a space capable of penetration. As such, the view exists in an indeterminate relationship to the spectator's notional view of the world, and the painting is released from the necessity to transcend its own condition as illusion. Derived from the moment, yet lifted into eternity, *White Mountains: Mount Madison and Mount Adams from Randolph Hill* creates a firm barrier between the viewer and the subject that can be bridged only through mind and emotion.

Martin's highly personalized vision precipitated a crisis of representation in the art of nature. Oscillating between the broader ideology of place and the artist's idiosyncratic response to it, the painting functioned as both an outer and an inner landscape. More grounded in private emotion than public spectacle, Martin's canvas strove, in the words of a contemporary critic, to "express the inexpressible" (Martin 1904, 21).

Stylistically, the artist's tonalist image lies somewhere between the finished Hudson River School manner and the *plein-air* practices of the impressionists. Painted in the studio over charcoal sketches made in the field, it represents a transition between the two dominant modes of nineteenth-century facture: the conceptual and the perceptual, the ideal and the real.

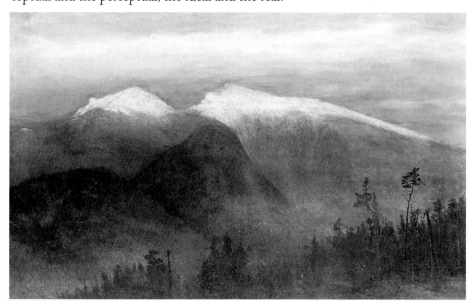

54. Homer Dodge Martin, White Mountains: Mount Madison and Mount Adams from Randolph Hill, 1870–80. Oil on canvas, 30 in. x 50¼ in. Courtesy of the Metropolitan Museum of Art, New York, gift of William T. Evans, 1891.

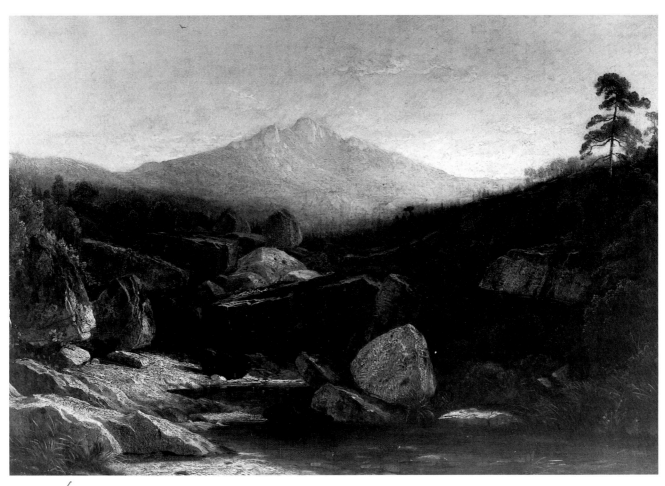

55. *Thomas Doughty,*
Tuckerman Ravine, *ca.*
1830. Oil on canvas, 18 in. x
27 in. Courtesy of the Allen
Art Museum, Oberlin
College.

9

The Eastern Slopes

A howling wilderness does not howl;
it is the imagination of the traveller that does the howling.

—Henry David Thoreau

URING the period when Cole and Codman were fashioning their canonic paintings of the western slopes of the Presidential Range, the landscapist Thomas Doughty visited the wild and unpopulated eastern side of Mount Washington. The artist's *Tuckerman Ravine* (fig. 55), painted about 1830, is among the most radically innovative early images of the White Mountains. A pictorial domain of untrammeled wilderness, the putative view of Mount Washington from Pinkham Notch provides an instructive companion to Cole's contemporaneous view of the Western Slopes (see fig. 45). With its pilgrim-wanderers, winding paths, and numinous ambiance, Cole's work employs the pictorial rhetoric of a sequential landscape of transcendence. In Doughty's view, Mount Washington appears remote and inaccessible, rising beyond a boulder-strewn foreground. Neither figures seeking to penetrate the wilderness nor paths leading into a coherent middle distance provide access to the distant summit. Finding no figural surrogates in the painting, the spectator confronts the vast otherness of nature without the customary pictorial mediations of picturesque *staffage* and spatial *repoussoir*. Nature herself, wild and autonomous, rather than human interaction with nature, emerges as the subject of this unconventional painting.

Among the earliest American landscapes totally devoid of human occupants, Doughty's painting represents a primal state of wilderness, prior to the incursions of civilization. Eliminating the middle distance, the artist contrasts a dark and forbidding foreground with a distant peak. In basing his composition on such paradigmatic romantic works as Caspar David Friedrich's *Watzmann* (see fig. 5), Doughty deployed large erratic boulders in the immediate foreground. Mountains in miniature, they serve as barriers to human ingress into the space of the painting. As has recently been suggested, however, the rocky stream bed also intimates (in the

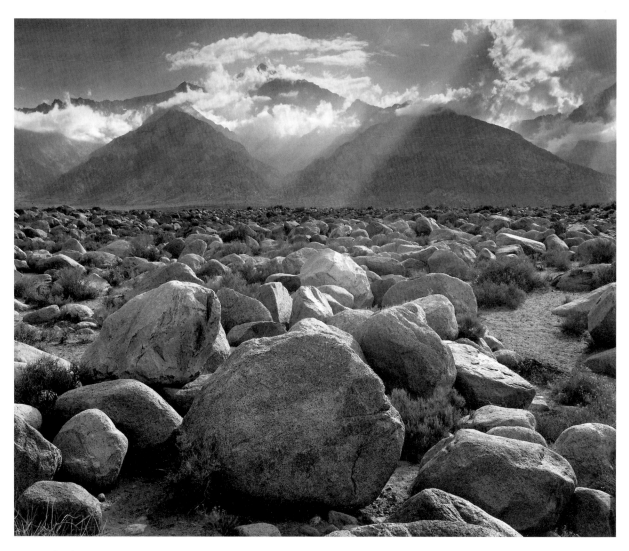

56. *Ansel Adams,* Mount Williamson, the Sierra Nevada, from Manzanar, California, *1945. Courtesy of the Trustees of The Ansel Adams Publishing Rights Trust.*

iconography of European Romanticism) the pilgrim's tortuous path and the theme of Christian salvation.[1] An alternative to Cole's deeply recessional views, Doughty's binary scheme of foreground/distant peak operates at a different level of spectator empathy. Visionary transcendence is achieved through implicitly optical rather than physical means. This inherited paradigm also found fertile ground in America, where it has continued to inform the national vision of wilderness. For example, Ansel Adams's famous photograph of Mount Williamson (fig. 56), a celebrated Sierra Club icon, is deliberately grounded in this duplex structure of proximate and distant, small and large, accessible and inaccessible.

1. See the excellent study by Joni L. Kinsey (1990).

10

Summit Views

THE LANDSCAPE AS PLEASURE AND ADVERSITY

The Mountains are more grand and inspiring when we stand at the proper distance and look at them, than when we look from them.

—Thomas Starr King, *The White Hills*, 1860

PANORAMIC VISTAS from the summits of mountains are relatively uncommon in American art. The bird's-eye view favored by Europeans, which privileges the observer, occurs less frequently in the iconography of American landscape than the contrasting worm's-eye view. Required by their low vantage to look up at the works of God, the nation's painters were more intent upon contemplating the realm of divinity than gazing earthward toward the domain of man.[1] From first to last the "reverential" rather than the "magisterial" gaze was preferred by White Mountain painters as a means of bearing witness to God's creation. By way of added appeal, American artists were also spared the arduous labor of climbing White Mountain peaks in order to gain vantages upon the lowlands.

The prospect view, which came into vogue in Europe during the late Renaissance, did not occur with any frequency in America until Thomas Cole began about 1825 to make sketches from the summits of the Catskills and the White Mountains. Having climbed Red Hill near Lake Winnepesaukee in 1827 and Mounts Washington and Chocorua in 1828, Cole produced at least two summit views known today only through engravings (Parry 1988, figs. 57 and 80).[2]

Recent art historical studies of the panoramic vista in American painting have attempted to associate this visual paradigm with modern poststructuralist theories

1. Henry T. Tuckerman observed: "the very immensity of the prospect renders it too vague for the limner; it inspires the imagination more than it satisfies the eye" ([1852] 1967, 15).

2. Too late for inclusion here is the recent "discovery" in a private collection of a previously unknown summit view by Cole entitled *View from near the Summit of Mount Washington*, dated 1828. The painting is currently on long-term loan to the Portland Museum of Art.

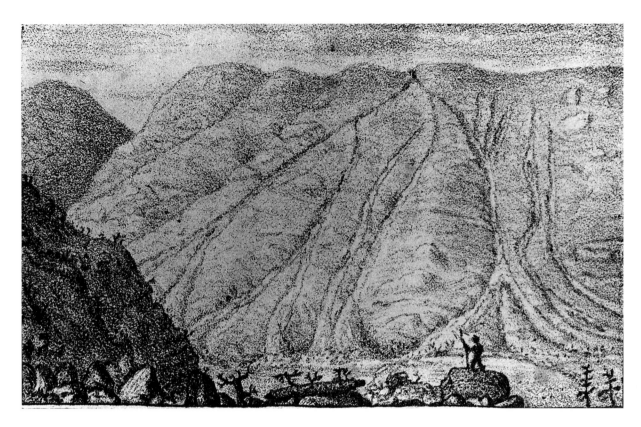

57. *Unknown artist, after a sketch by Daniel Wadsworth,* Avalanches in the White Mountains. *Lithograph. Illustration for Theodore Dwight,* Sketches of Scenery and Manners in the United States, *New York, 1829. Courtesy of Dartmouth College Library.*

of power and control. Invoking Michel Foucault's "eye of power," Allan Wallach, for example, has argued that the totalizing vision afforded by the summit view is instrumentally linked to the rise of landscape tourism (1981). Conversely, Albert Boime has interpreted the "magisterial gaze" in the light of America's western expansion during the period of Manifest Destiny (1991). As neither of these accounts adequately explains Cole's early ascents of Mounts Chocorua and Washington, it is instructive to look elsewhere for the artist's motivation. The recollection that Cole ascended Mount Chocorua "not for pictures . . . but for ideas, for conceptions" doubtless affords firmer insight into the artist's intentions than do poststructuralist accounts of tourism and ideology.

Prior to Cole's Petrarchan exertions of 1827–28, his patron Daniel Wadsworth probably executed the earliest known panoramic view from a White Mountain summit. A crude lithograph entitled "Avalanches in the White Mountains" (fig. 57), illustrating Theodore Dwight's *Sketches of Scenery and Manners in the United States,* provides, according to the author, "a correct idea of the singular appearance of the avalanches and was made by a gentleman distinguished for his taste and accuracy who visited the spot a few months after the catastrophe" (1829, 69). As this statement corresponds with the circumstances of Wadsworth's visit to the Notch in 1826

and, given the evidence of other attributed drawings, there can be little doubt concerning the identity of the draughtsman. Silhouetted against the ravaged face of Mount Willey, a diminutive mountain climber, alpenstock in hand, contemplates the paths of the avalanche and the pleasurable vertigo of the sublime. Witness to the vast and terrible spectacle of the mountain world, the solitary climber beholds the ravaged face of Mount Willey, the site of the slide. Altogether this modest scene represents one of the earliest summit views in American art as well as the first depiction of alpinism or recreational mountain climbing. By contrast, Cole's apparent reluctance to represent summit views doubtless signifies the affective nature of the low vantage point, which induced wonder and meditation, as opposed to the panorama, which the artist considered too "map-like" (Clark 1975, 92).

Cole's general aversion to heights was not shared by the English topographic illustrator William Henry Bartlett, who apparently climbed the Presidentials in 1836 in order to make sketches for the well-known British publication *American Scenery*. The scene entitled *View from Mount Washington* (fig. 58) is typical of Bartlett's convivial European outlook of the mountains as playgrounds. Replacing the solitary climber with an active party of hikers, Bartlett depicted a scene of genial

58. Unknown artist, after a drawing by William H. Bartlett, View from Mount Washington. *Engraving. Illustration for Nathaniel P. Willis,* American Scenery, *London, 1839. Courtesy of Dartmouth College Library.*

59. *Victor De Grailly,*
Picnic at Mount
Jefferson, *ca. 1845. Oil on
canvas, 21⅜ in. x 28⅞ in.
Courtesy of the Hood
Museum of Art,
Dartmouth College.*

human recreation amidst the mountain splendor. In lieu of the pictured visage of all-threatening nature, the English illustrator envisioned a scene of benevolent mountain glory. By contrast with Cole's astringent and inhospitable *View from Mount Washington*, Bartlett's summit is populated with congenial and gregarious hikers. The Englishman's convivial outlook (contrasted with the preferred American vision of solitude) inflected the high country with the sensibility of the European picturesque.[3]

Further evidence of the continental love of heights is provided by the French painter Victor De Grailly's *Picnic at Mount Jefferson* (fig. 59), which was derived from another of Bartlett's White Mountain views. This oil painting was produced in about 1845 in Paris, where the artist had established an industry making oil paintings of American scenery based on the Englishman's prints. Whether intended for American tourists (much as the variants of Walter Keene's wide-eyed children

3. Of the 119 Bartlett engravings, 22 are of the Hudson and 12 of the White Mountains, making the latter second in interest, appeal, and significance only to the great river.

found on Montmartre today) or a European audience, De Grailly's numerous paintings of White Mountain scenery were created without the benefit of having visited America. This English and French vogue for American scenery, however, was persistently informed by European academic conventions of mountain recreation. At a time, for example, when few women had ventured onto the summits of the Presidentials, Bartlett (followed by De Grailly) populated them with recreating tourists, including pink-parasoled women in urban dress carrying bulging picnic baskets. In this critical regard Bartlett anticipated by a generation the "feminization" (vide supra) of the White Mountains by American artists during the last quarter of the nineteenth century. Indeed, it was not before the post–Civil War tourist views of Winslow Homer that well-dressed ladies were allowed to inhabit the pictured summits of the Presidentials with any frequency.

Among the earliest professional American artists to depict summit views in the White Mountains were Godfrey Frankenstein and Russell Smith, both of whom visited the Presidentials between 1845 and 1850. Russell Smith's *Mount Franklin, Sept. 17, 1848* (fig. 60) affords a chilling view of the southern peaks from the vantage

60. Russell Smith, Mt. Franklin, Sept. 17, 1848. Oil on canvas, 24 in. x 36 in. Courtesy of Kennedy Galleries, New York.

61. J. H. Bufford, Mount Washington, over Tuckerman Ravine, *after* G. N. Frankenstein, 1848. Lithograph. Courtesy of Dartmouth College Library.

of a traveler somewhere along the famed Crawford path.[4] Swirling clouds, gigantic boulders and rime-iced rock formations provide a typical American ambiance of desolation and of isolation, a marked antithesis to the pictorial blandishments of the European recreational view. Discoursing at some probable level with Bartlett's amiable scenery, Smith depicted the Presidentials as a hostile and uninviting landscape. The dismounted traveler, dwarfed by the immensity of the mountains,93

4. For Smith see Lewis 1956.

62. *Charles Octavius Cole,*
Imperial Knob and
Gorge: White
Mountains of New
Hampshire, *1853. Oil on
canvas, 44¾ in. x 36⅛ in.
Courtesy of the Brooklyn
Museum.*

inhabits a world conceptually far removed from the Englishman's alpine playground.

Godfrey Frankenstein's *Mount Washington, over Tuckerman Ravine* (fig. 61) provides another stark and discordant view of the high country. Presumably lost, but known from a lithographic copy reproduced in Oakes's *Scenery of the White Mountains* (1848), Frankenstein's painting of the famous Ravine, surmounted by the cone of Mount Washington, is configured from the vantage of the opposing ridge of Boott Spur. The vertiginous view developed by the artist creates an aura of alien-

ating otherness. Frankenstein's lurid vision of the high country is characteristically American and again contrasts with the more benevolent mountain scenery of Europeans. Curiously, this unique lithograph, which suppresses detail in the interest of evoking a somber atmosphere, departs significantly from Isaac Sprague's disinterestedly scientific images found in the same publication.

Another striking view of one of the great cirques of the eastern slopes of the Presidentials is entitled *Imperial Knob and Gorge: White Mountains of New Hampshire* (fig. 62) by Charles Octavius Cole, a little-known painter from Portland, Maine. Signed and dated 1853, this large canvas affords a curious enigma for anyone familiar with the region. Suggestively akin to Frankenstein's *Mount Washington, over Tuckerman Ravine,* Cole's painting is more likely than not derived from the canonic view found in *Scenery of the White Mountain.* The putative site of the painting, Imperial Knob and Gorge, is wholly fictitious, having been invented perhaps to disguise the artist's probable source.[5] As this impressive canvas indicates, the industry of manufacturing oil paintings from White Mountain print sources was by no means the exclusive practice of Parisians.

An interesting variant on the theme of American solitude versus European conviviality is created by the Franco-American artist Régis Gignoux. A beaux-arts trained painter, Gignoux came to America in 1840 and rapidly acquired the rudiments of the Hudson River School style. Gignoux's large-scaled canvas *White Mountain Landscape* (plate 5) of the mid-1860s gives every appearance of belonging to the native American school. In point of fact, Gignoux's view of one of the major gulfs of the Presidential Range (the exact locale cannot be identified) was doubtless inspired, both in its size and facture, by the epic landscapes of Frederick Edwin Church and Albert Bierstadt. These grandiose visions of American scenery captured the public imagination during the 1860s and 1870s before succumbing (together with the reputations of their creators) before the tide of French aesthetics that washed over American art in the last decades of the century. Paradoxically, Gignoux's perfervid vision of the American landscape owes everything to the national school and little, if anything, to the artist's own French heritage.

Edward Moran, the lesser-known brother of the celebrated western painter Thomas Moran, also employed the grand manner in his depictions of the White Mountains. His *Halfway Up Mount Washington* (fig. 63) of 1868 is an example of the atmospheric operatics produced by the Turner-inspired school of painters who

5. No map or guide book of the White Mountains refers to an Imperial Knob. Perhaps this usage, like George Loring Brown's *Crown of New England,* was intended to evoke antidemocratic sentiments.

depicted the American West and other exotic locales such as the Arctic and South America during the later nineteenth century.[6] Moran's dramatic canvas employs the customary pictorial rhetoric of the marvelous and spectacular while investing the site with added resonances of the gothic sublime. Within a year of the completion of this melodramatic work, the cog railroad, one of the wonders of the age, ascended to the summit of Mount Washington, completing the conquest of New England's highest peak by machine technology. In light of this circumstance, it is tempting to view Moran's painting in consort with Thomas Hill's *White Mountain Notch—Morning after the Willey Slide* (see plate 2) as parallel responses to a mythic landscape in the process of being transformed by the technics of the Industrial Revolution, a final ritualized spasm of the natural sublime on the eve of its certain extirpation.

With the appearance in 1869 of the cog railroad on the slopes of Mount Washington, the high country became accessible to tourists of every conceivable stripe. Such locations as Lakes of the Clouds and Tuckerman Ravine, previously attained by dint of shank's mare, or most often an actual mare, were now easily frequented by the wider public. In order to accommodate this popular audience, a new type of artist emerged whose works were destined primarily for tourists. More

63. Edward Moran, Halfway Up Mt. Washington, 1868. Oil on canvas, 30 in. x 50 in. Private collection. Photograph courtesy of Spanierman Gallery, LLC, New York.

6. Compare with Kinsey 1992.

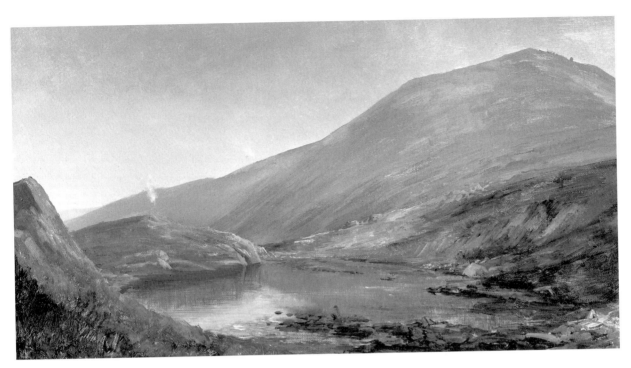

64. *Edward Hill,* Mount Washington from Lakes of the Clouds, *ca. 1890. Oil on canvas, 9½ in. x 15¼ in. Collection of Mr. and Mrs. Arthur Wood.*

interested in the recreational experience of natural curiosities than in the presence of the divine in nature, these tourist artists depicted landscape "singularities," for the gratification of their fashionable clientele.

A gifted representative of this newer genre of painter is Edward Hill (1843–1923) who affiliated himself during his career with several of the grand tourist hotels, including the Profile House, the Glen House, the Waumbek Hotel, and the Flume House.[7] Setting up his studio in one of the establishments during the summer season, Hill painted countless inexpensive "souvenir" views of the region. A canvas entitled *Mount Washington from Lakes of the Clouds* (fig. 64) of 1890 is characteristic of Hill's touristic vision. Drawing upon the celebrity of the site (which Nathaniel Hawthorne had described in *The Great Carbuncle* as "an enchanted lake"), the artist depicted the high mountain pond as a singular feature of the landscape rather than as a part of a larger panoramic vista (Hawthorne 1946, 55).[8] Rapidly executed in a broad painterly style, Hill's canvas eschews the detailed particulars of most previous White Mountain views. Employing a limited palette, the artist created what amounts to an abbreviated sketch of a popular site. As an economic necessity Hill's

7. For the career of Edward Hill, see Plymouth State College Art Gallery 1985. See also McGrath 1989.

8. In Hawthorne's moralistic tale *The Great Carbuncle*, Lakes of the Clouds is the site of the mythic gemstone sought by the story's diverse "pilgrims." A place of death and disfiguration, it served the author as a locus of literary gothicism.

"tourist touch" facilitated the production of hundreds of inexpensive paintings for the summer clientele. The summary facture of his work allowed for both rapid execution of the canvas and a fluent pictorial surface.[9]

Seldom wandering from the well-beaten tourist track, the artist placed no great demands on the spectator either imaginatively or intellectually. Rather, nature has been reduced to an agreeable commodity. Excerpted from a larger whole (i.e., climax scenery), Hill's view in *Lakes of the Clouds* reflects a more intimate sensibility, one seeking to stimulate the memory and desire of tourists in search of mementos of visits to singular or unusual locales.[10]

A souvenir view of *Snow Arch at Tuckerman Ravine* (fig. 65), dated 1884, is also typical of the natural oddities that intrigued Hill and his clientele. First discovered by

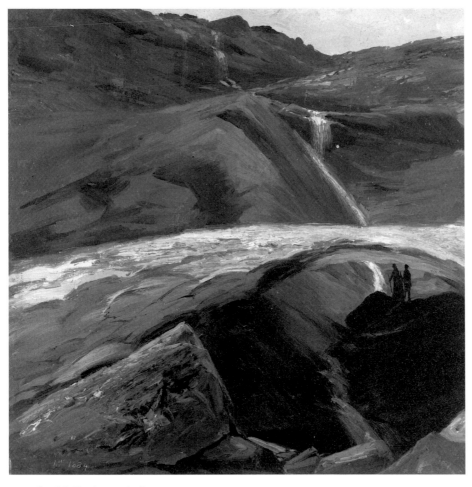

65. *Edward Hill,* Snow Arch at Tuckerman Ravine, *1884. Oil on canvas, 15 in. x 15 in. Courtesy of the Hood Museum of Art, Dartmouth College.*

9. See McGrath 1989 (47).

10. More likely than not, Hill painted the view from a stereograph taken by his friend the photographer Benjamin West Kilburn. See McGrath and MacAdam 1988 (82).

the famed mountain guide Ethan Allen Crawford in 1829, the curious snow formation was described in the florid rhetoric of the period:

> Such was the size of this empty space that a coach with six horses attached, might have been driven into it. . . . I did not go far into it . . . but it appeared to be of considerable length. It was a very hot day, and not far from this place, the little delicate mountain flowers were in bloom. . . . There seemed to be a contrast—snow in vast quantities and flowers just by—which wonderfully displays the presence and the power of an all-seeing and overruling God, who takes care of these little plants and causes them to put forth in due season. (Burt 1883, 188)

66. Albert Bierstadt, Tuckerman Ravine, 1869. Oil on paper. Private collection.

Beneath the broad span of the arch, Hill located two tourist pilgrims on a rocky pulpit casting their curious gaze upon nature's ephemeral architecture. Sketchily wrought, the composition affords no direct visual ingress to a notional observer;

rather, the spectator confronts the scene from an unspecified vantage as if suspended in space as a kind of disembodied eye. In supplying his audience with depictions of natural curiosities, Hill's work parallels journalistic accounts of these phenomena. For example, a writer in the art journal *The Crayon*, in describing the snow arch, invoked a quaint yet effective ecclesiastical metaphor: "There is in Tuckerman's Ravine a great altar of snow, ten feet high, twenty feet broad and seventy five feet long" (Anonymous 1857). Whether shaping his motif of the snow arch as an altar or as the vault of a natural cathedral, Hill also consciously employed similar popular journalistic rhetoric in conceiving of his tourist vision.

The Reverend Thomas Starr King, in an account entitled "A Dinner Party under the Snow Arch of Mount Washington" appearing in his famous guide book *The White Hills*, acknowledged that he was attracted to the site by a work of art. Citing Godfrey Frankenstein's view of Tuckerman Ravine reproduced in Oakes's *Scenery of the White Mountains* as his inspiration, Starr King set out to verify the accuracy of the scene. Dining on cheese and pie and drinking toasts from the ice melt of the arch, the Boston clergyman evocatively described the "crystal cave" as being of "exquisite gothic workmanship" (1859, 342–48).

A distantly related painting of Mount Washington's celebrated glacial cirque is Albert Bierstadt's oil study of the snow field at *Tuckerman Ravine* (fig. 66). Roughly sketched on paper, this work appears, however, to be more of an *aide-memoire* for an intended canvas than a tourist souvenir sketch. The vigorous Bierstadt spent several summers in the White Mountains and the view was probably executed in 1869 when he was visiting the Glen House while working on his magnum opus, *The Emerald Pool* (Anderson and Ferber 1991, fig. 33). In this connection the snow field at Tuckerman Ravine, together with its fabled arch, was considered the White Mountain equivalent of an alpine glacier, attracting visitors during most of the summer months. Both geological and mystical, the snow field served to remind visitors of the processes that had formed the divine architecture of the mountains.[11] Once again, the "Switzerland of America" afforded visitors approximations—both actual and imagined landscapes—of Europe's fabled Alps.

11. For a discussion of the spiritual significance of glaciers, see Sheets 1985.

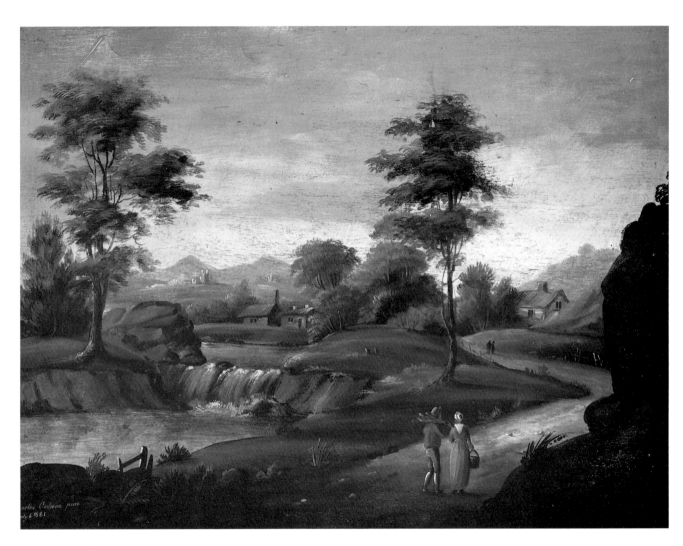

67. Charles Codman, View
of Twin Mountain, New
Hampshire, *1821. Private
collection.*

II

The Landscape of Desire

PAINTING AND THE AMERICAN BARBIZON

One who visits the Conway meadows sees the original of half the pictures that
have been shown in our art rooms the last two years. All our landscape painters
must try their hand at that perfect gem of New England scenery.

—Benjamin Willey, *Incidents in White Mountain History*, 1856

IN HER *History of the White Mountains*, Lucy Crawford recorded that on July 1,
1824, a guest stayed at their inn at Fabyans and "took some beautiful sketches
of the hills and likewise of the Notch" (1978, 66). While this artist-visitor has
not been identified, one likely candidate is Portland, Maine, painter Charles
Codman. Codman's *View of Twin Mountain, New Hampshire* (fig. 67), signed and
dated July 6, 1821, is the earliest extant painting of the White Mountain region.[1] The
composition, however, is so insistently formulaic that the work bears no clear
resemblance to its putative site, the small settlement located above the northern
entrance to Crawford Notch. In a rigidly conventionalized manner, foreground
staffage traverse a curving path. Enframing trees, a limpid pond, and distant moun-
tains are further conjoined to achieve an artfully picturesque composition. The ser-
pentine path, carrying the spectator's eye into the middle distance, facilitates (as in
European precedents) entry into a pastoral landscape. The academically derived
color scheme ranging from brown to green in the foreground and middle distance
to a distant blue horizon, creates the customary chromatic recession into depth.
Grounded conceptually more in the landscape paradigms derived from the muse-
um rather than any direct transcription from the site, Codman's painting is more
emphatically a product of culture than of nature.

Another possible candidate for Lucy Crawford's artist-in-residence is Ports-

1. For Codman's career see Felker 1990.

68. *J. S. Blunt*, View of the Saco, *1826. Oil on canvas. Courtesy of the New Hampshire Historical Society.*

mouth, New Hampshire, painter John Shelburne Blunt. A self-taught artist who is known by a half-dozen works, Blunt's *View of the Saco* (fig. 68), dated 1826, also predates Thomas Cole's better-known visits to the White Mountains.[2] Also determined by the conventions of the "picturesque," Blunt's canvas is strongly indebted to inherited sources, possibly British prints (fig. 69) or such native graphic portfolios as Joshua Shaw's *Picturesque Views of American Scenery* of 1821.[3] While the painting's winding river might be identified as the Saco, its village as North Conway, and its distant summits as Moat Mountain and Chocorua, the view is so resolutely schematic that it could serve as generic scenery for almost any region of the Northeast. In conformity with "picturesque" conventions, a curving path and river (the Hogarthian "line of beauty") directs the viewer's gaze through the bucolic landforms. The small figures riding into the landscape and traversing the bridge are also derived from the academic *staffage* populating conventionalized English landscape views.

2. See Little 1948 (772–74).
3. See Nygren 1986, 46 and plate 461.

A recent study by British geographers Stephen Daniels, Susanne Seymour, and Charles Watkins argues that the theme of Britain as a nation is "imagined in and through its river scenery," a claim that reinforces the conviction that Codman's and Blunt's riverine confections are more concerned with the bucolics of pastoral England than with the sublimities of the White Mountains (1998, 157).

By way of marked contrast to these derivative formulas, Thomas Cole's pen-and-ink drawing inscribed "Near Conway, New Hampshire" of 1827 (fig. 70) is so site-specific that Mount Washington is easily discernible near the center of the composition. Drawing less upon established pastoral convention, Cole populated his landscape with a seated wanderer and minimal signs of habitation. While Cole did not employ this sketch for any known paintings, it served as the basis for an engraved illustration in John Howard Hinton's *History and Topography of the United States*, published in London in 1832. The earliest deluxe quarto volume to use engravings of American scenery, Hinton's illustration *The White Mountains* ("drawn on the spot and engraved on steel expressly for this volume") is derived from Cole's drawing (Parry 1988, 78).

For the next twenty years no important artists visited the Conway Valley. In his memoirs, Intervale native Samuel D. Thompson mentions "an artist by profession" who stayed at the family inn sometime during the 1830s. According to his account,

69. Unknown engraver, "View from the Terrace at Oat-Lands" from A New Display of the Beauties of England, *vol. 1. London, 1776. Courtesy of the Society for the Preservation of New England Antiquities.*

70. Thomas Cole, Near Conway, New Hampshire, 1827. Pen and ink. Courtesy of the Museum of Fine Arts, Boston. Gift of Maxim Karolik. Reproduced with permission. © by the Museum of Fine Arts. All Rights Reserved.

the guest became so enraptured with the region that his "stay was extended into days, weeks, and months and the summer was gone and autumn came before he could think of going to his city home" (MacAdam 1988, 22). The artist returned the following summer, and Thompson noted, "from that small beginning came the start which has ripened and grown into its present dimensions, yes to [that] landscape artist more than to any other one influence is due the present prosperity of North Conway" (MacAdam 1988, 22). A possible candidate for this prophetic and influential artist is the Boston painter Alvan Fisher.

A painting entitled *Crossing the Saco River, Conway, NH* (fig. 71) of 1845 is the earliest dated view of the Presidential Range from the Intervale at North Conway. The commanding presence of Mount Washington, at the center of the composition, is balanced by a large foreground boulder. Mounted travelers, emerging from darkness into light, are depicted in the act of fording a broad river. The earliest representation of the eastern slopes to include tourists, Fisher's canvas envisions the landscape as a benign Edenic wilderness. As in many of Fisher's paintings, the scene is overlaid with an atmospheric veil of golden light that elicits a mood of reverie. An aura of tranquility, produced by limpid light and autumnal color, further informs

the scene as the gleaming mountain, the tranquil river, and the verdant banks are deployed to form a place of pictured delights.

During the second half of the nineteenth century more paintings were made of the privileged precinct of the Intervale than of any other site in the White Mountains. In June 1850 three young artists, recently returned to America from European study, "discovered" the village of North Conway and declared it the most beautiful place on earth, "even more picturesque than the Alps" (Champney 1900, 102). Benjamin Champney, John Casilear, and John F. Kensett were enchanted by the village and the broad elm-dotted fields leading to the slopes of the Presidentials. "We had seen grander, higher mountains in Switzerland," Champney avowed, "but not often so much beauty and artistic picturesqueness brought together in one valley" (1900, 103). In addition the artists especially appreciated the clear morning light, undiffused by dense forests or narrow mountain chasms, that afforded a sharp clarity to forms and invited working out of doors. Black flies, apparently, were less frequent visitors to the broad Intervale than to other regions of the White

71. Alvan Fisher, Crossing the Saco River, Conway, N.H., 1845. Oil on canvas, 27½ in. x 39¾ in. Courtesy of Indiana University Art Museum.

Mountains, or so it was claimed. Many years later Champney compared the "reconnaissance" of the Intervale to a military invasion (1893, 6).

All that summer Kensett made sketches for a panoramic canvas that was completed in his New York studio during winter 1851. When it was exhibited, *The White Mountains—Mount Washington* (fig. 72) was widely acknowledged as the signature painting of the region and ultimately became one of the most celebrated landscapes of the period. Purchased by the American Art Union, it was engraved by James Smillie (fig. 73) for circulation to over thirteen thousand subscribers. Representing a fusion of man and nature, Kensett's image held special meaning for midcentury America. As a vision of an ideal society—an Arcadian middle ground between city and wilderness—the painting honored the landscape while promoting social harmony. With its deliberate synthesis of the cultivated and the wild, Kensett's painting evoked for his urban contemporaries a new model of man-in-nature. Envisioning the White Mountains as a paradigmatic national landscape, all regions of the country were subsumed by the painting's overarching ambition to promote religious, political, and social harmony. In erasing all vestiges of discordant reality, the artist created a perfected world of white houses, verdant fields, winding streams,

72. *John F. Kensett*, The White Mountains— Mount Washington, *1851. Courtesy of Wellesley College Museum of Art.*

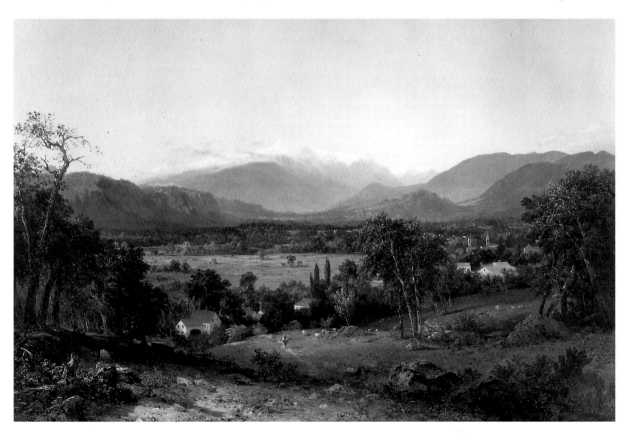

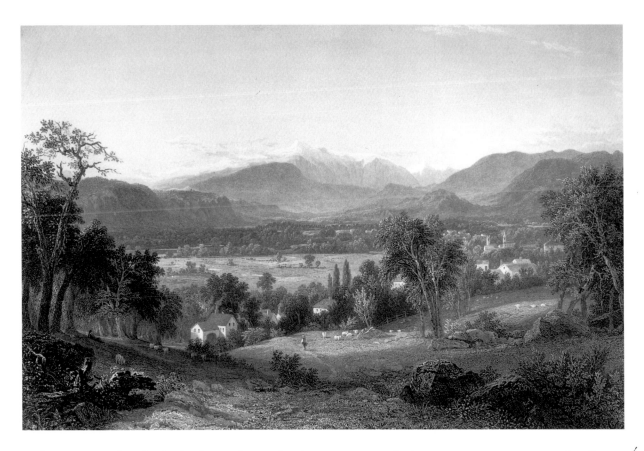

and snow-capped peaks. In this benevolent realm the spectator overlooks a sequentially organized village set before a verdant valley enframed by low-lying hills. Towers of the church and the academy rise above the white frame houses, signifying the presence of religion, learning, and domestic values at the threshold of nature's wonderland.[4] Through the funnel-like aperture of civilization, the viewer's gaze is directed through the green Intervale to the base of snow-clad Mount Washington. In the happy formulation of Angela Miller, "the distant sublime is approached through the avenue of the picturesque" (Miller 1993, 272). In this work of deliberate synthesis, the agrarian ideal is fused with its antipode, the American wilderness, to form the quintessential "middle landscape" of the American scene (Miller 1993, 13–14). Depicting the wide, verdant Intervale from the elevated perspective of Sunset Hill, the painting carries the viewer's eye through the main street of North Conway, along paths to the foothills, before climaxing at the snow-covered summit of Mount Washington. Man, a privileged occupant of this Edenic garden, is neither a visitor nor an intruder. Rather the solitary figure entering into

73. James David Smillie, after John Frederick Kensett, Mt. Washington from Sunset Hill, N. Conway, *n.d. Engraving. Courtesy of the Hood Museum of Art, Dartmouth College.*

4. Compare with Driscoll 1985 (66–70).

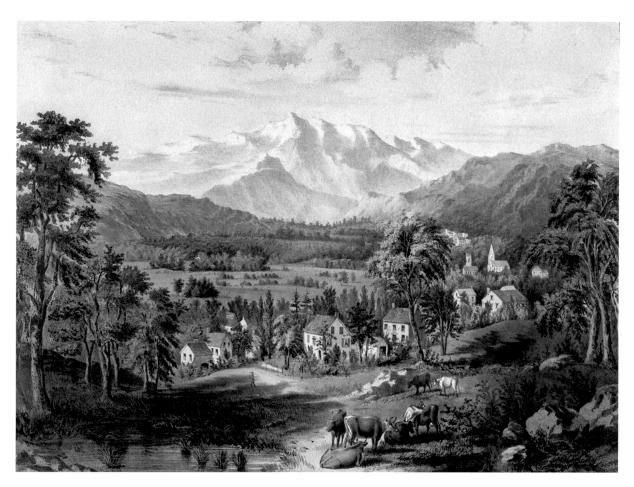

74. *Nathaniel Currier and James Ives, from a design by Fanny Palmer,* Mount Washington and the White Mountains, from the Valley of Conway, *1860. Lithograph on paper, 21½ in. x 26¾ in. Courtesy of the Hood Museum of Art, Dartmouth College.*

the landscape along a well-traveled path undergoes transfiguration into a pilgrim on the path of life.

An apt description of his friend's painting was provided by Champney, who claimed that the Intervale was "the bare ideal of a certain kind of scenery—a combination of the wild and the cultivated, the bold and the graceful. . . . The inhabitants are sober—pious—well disposed and have all gone to church" (Driscoll 1985, 67).

This newly formulated harmony of opposites adroitly conjoined Jeffersonian agrarianism with the romantic ideal of freedom in the wild. In addition the painting sought to arrest on canvas the unpredictable processes of history through the creation of a visual utopia. In equating the industry of agriculture with national prosperity, Kensett's pictorial cultivation of the land paradoxically celebrated the pastoral ideal at a moment of rapidly increasing industrialization. In providing a visual stay against the encroaching threat of technology, Kensett shaped the most celebrated White Mountain landscape of the era. As a nationalist icon, the artist's pictorial recovery of the agrarian paradise provided both security against the threat

of modern dissolutions and a means of controlling history through the idealism of the agrarian myth.

Paraphrased a few years later by Frances (Fanny) Palmer for a well-known Currier and Ives lithograph, (fig. 74), the view found its way onto the walls of thousands of American homes. Owing to its wide dissemination, as well as the special appeal that it held for the period, *The White Mountains—Mount Washington* became the best-known American landscape of the immediate pre–Civil War era. A New England scene with grand national associations, it established a new model for the representation of American nature. By virtue of its acquisition and dissemination through the American Art Union, the painting also became a literal commodity. Awarded to the winner of the monthly Art Union lottery, the canvas (together with its diffuse graphic progeny) firmly established the celebrity of North Conway in the popular imagination. The ultimate commercial exploitation of the region is surely not unrelated to this early transaction, the contemporary orgy of consumerism deriving at some perverse level from the past century's love of mountain scenery.

In his memoirs Champney appositely noted that the painting served as a form of advertisement for North Conway: "Thus the fine picture became widely known and interested artists and others in our mountain scenery. So much so that the next season many artists followed in our wake bringing friends and lovers of mountain scenery with them" (1900, 103).

As noted elsewhere, the picturesque landscape formula employed by Kensett is derived from the seventeenth-century French master Claude Lorrain. Classically balanced, the Claudian scheme was intended to present pastoral truths in an Arcadian setting. Commenting on the European "look" of the site, Henry David Thoreau observed on a visit to the White Mountains in July 1858 that the Intervale "is quite unlike New Hampshire generally . . . and suggests a superior culture" (Howarth 1982, 236).

While the Smillie engraving for the American Art Union represents a faithful copy of the original oil, the Currier and Ives lithograph derived from the same source is paradoxically more domesticated and more mountainous. The relative prominence given to the town of North Conway by the designer, and the dramatic treatment of Mount Washington, has the effect of emphasizing the divide between wilderness and cultivation. Destined for the walls of the houses of middle-class homeowners, the Currier and Ives print stressed the cleavage between the wild and the inhabited landscape, rather than Kensett's condominium of man and nature.

Benjamin Champney also painted the canonic view of the Intervale on several occasions but none of his canvases achieved the national celebrity of Kensett's

picture. A classic sketch of the site (fig. 75) was employed, however, to illustrate George P. Bond's 1853 map of the White Mountains and slightly later to serve as the frontispiece for Benjamin Willey's 1856 text *Incidents in White Mountain History*. Willey, a lineal descendent of the ill-fated martyrs of the Crawford Notch, provided a lively anecdotal account of pioneer life in the region. His enraptured description of the view from North Conway also affords a strong verbal analogue to Champney's image: "One feels in standing on that green plain, with the music of the Saco in his ears, hemmed in by the broken lines of the guardian ridges and looking up to the distant summit of Mount Washington, that he is not in any county of New Hampshire, not in any namable latitude of this rugged earth, but in the world of pure beauty—the *adytum* of the temple where God is to be worshipped, as the infinite Artist, in Joy" (Willey 1856, 120).

Writing from North Conway in 1855, Asher Durand gave utterance to similar sentiment in his renowned "Letters on Landscape Painting": "In the White Mountains there are passages of the sublime and the beautiful . . . and for those who have the physical strength and mental energy to confront the former amidst the deep chasms and frowning precipices . . . the simple truth would be enough to convey the full idea. . . . But to one like myself, unqualified to penetrate the 'untrodden ways' . . . the beautiful aspect of the White Mountain scenery is by far the predominant feature" (McCoubrey 1965, 111). Durand's preference for the blandish-

75. O. Wallis, after Benjamin Champney, Mount Washington from North Conway, *1853. Lithograph. Courtesy of the New Hampshire Historical Society.*

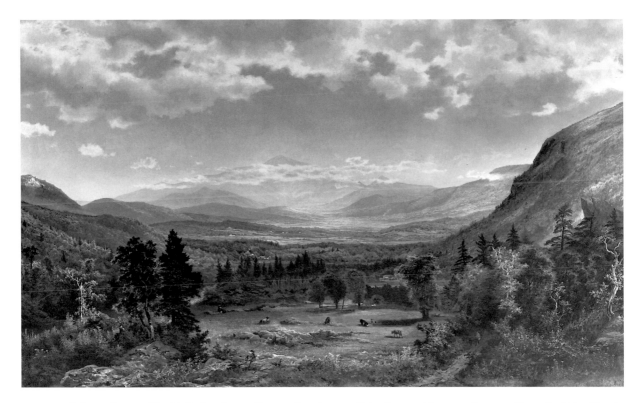

ments of the cultivated "middle landscape" over the rigors of the "untrodden way" served further to situate North Conway in the touristic consciousness of the age.

Another significant variant on Kensett's paradigmatic scheme is found in the Dutch immigrant Alexander Wust's *Mount Washington, New Hampshire* (fig. 76) painted sometime during the 1860s. A colossal canvas, over seven feet wide, Wust's epic view imparts an almost "western" inflection to the scenery. Derived from the pictorial theatrics of such artists of the American frontier as Albert Bierstadt, Wust's view eliminates the village of North Conway, and erases the pastoral foreground in the interest of evoking a wilder and more operatic vision of the sublime.

Yet another pictorial emendation of the standard view was provided by Portland, Maine, painter Harrison Bird Brown, whose *View of Mount Washington* of 1866 (fig. 77) further stresses the priority of nature over culture and the ultimate triumph of wilderness over the works of man. The presence of a dilapidated mill house in the middle distance lends an air of nostalgia to the scene. As both a "ruin" and a signifier of obsolescent technology, the mill served as a memento mori, a reference to the passage of time and the futility of man's endeavors in the face of enduring nature. Restoring the land to the status of wilderness, regenerative nature supersedes the vestigial remnants of its former exploitation. In the right foreground a new growth forest further denotes the processes of succession, signifying the con-

76. Alexander Wust [Dutch 1837–1876], Mount Washington, New Hampshire, *ca. 1865. Oil on canvas, 52 in. x 86 in. Private collection.*

77. *Harrison Bird Brown,
View of Mount
Washington, 1866. Oil on
canvas, 25 in. x 42⅛ in.
Courtesy of the Portland
Museum of Art, Maine, gift
of Mrs. Louis L. Hills, Jr.,
in memory of Mrs. Louis L.
Hills, Sr., and Mr. Louis L.
Hills, Jr.*

viction of the age in the infinite capacity of nature to restore herself in the face of depredation. In this regard Brown's juxtaposition of decaying architecture and resurgent geology discourses with numerous British and American Pre-Raphaelite formulas for mountain scenery.[5]

Sanford Gifford's *Mount Washington from the Saco River* (fig. 78) provides another pictorial solution to the possibilities posed by the conjunction of fields, streams, and mountains viewed from the Conway Intervale. Employing a horizontal format that emphasizes a lateral extension of space rather than movement into depth, Gifford focused upon light, watery reflections and the evocation of a limpid atmosphere. Stillness and silence reign in Gifford's light-filled Intervale, where formerly picturesque aesthetics had dominated the depiction of the region. Unifying the scene through subtle tonal harmonies, the artist invoked the midcentury aesthetic of luminism. Better suited to coastal and lake scenes than mountains, luminism was, however, occasionally employed for White Mountain views. This shift from picturesque form to atmospheric stillness invited the spectator to enter the scene in a meditative state and to internalize emotionally the theatrics of the sublime.

The considerable diversity of artistic styles present in America in the post–Civil War decades is further evidenced by Charles Herbert Moore's meticulously

5. Compare with Rosenblum 1975 (67).

detailed drawing of Mount Washington, entitled *White Mountains* (fig. 79). One of numerous studies that the artist made of the mountain between 1869 and 1870, Moore's obsessive and microscopic vision contrasts vividly with the fluid, atmospheric treatment of Gifford. A member of the American Pre-Raphaelite brotherhood (the Association for the Advancement of Truth in Art), Moore was among

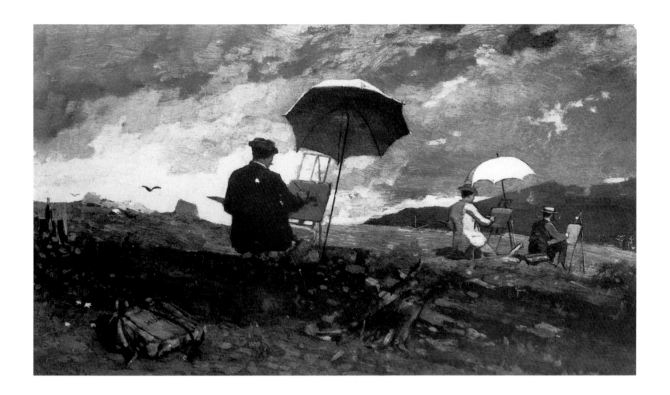

80. *Winslow Homer,*
Artists Sketching in the
White Mountains, *1868.*
Oil on panel, 9½ in. x 15⅞
in. Courtesy of the Portland
Museum of Art, Maine,
bequest of Charles Shipman
Payson.

the better-known followers of the aesthetic doctrines of English critic and philosopher John Ruskin. Devoted to site-specific documentation, the Pre-Raphaelites' goal was to render nature "in such a way that the poet, the naturalist, and the geologist might have taken large pleasure from it" (Ferber and Gerdts 1985, 200). Central to the Pre-Raphaelite aesthetic was a tightly controlled and carefully rendered manner of realism together with a firm rejection of the compositional formulas and painterly facture of the Hudson River School. Both groups, however, were united in their commitment to the "earnest loving study of God's work of nature" (Ferber and Gerdts 1985, 34).

Winslow Homer's *Artists Sketching in the White Mountains* (fig. 80) was probably painted at North Conway, where the artist resided for several weeks during the summer of 1868. According to apocryphal legend, one of the sketching artists is Homer Dodge Martin, a friend of Homer's who was among the earliest American painters to adopt the Barbizon style of landscape.[6] A more recent interpretation views Winslow Homer as the central figure in the composition sketching the landscape before an easel. A knapsack at the lower left bearing the artist's signature, and a wine bottle placed on a stump, provide a subtext for the narrative of painters in

6. See Tatham 1966.

the outdoor studio.[7] The ideal of artistic community suggested by Homer's painting corresponds to contemporary accounts of North Conway, the nation's first artist's colony, as an "American Barbizon." In his memoirs, Benjamin Champney celebrated the region in terms redolent of Homer's painting: "North Conway at one time became almost as famous as Barbizon and the Forest of Fontainbleau after Millet, Rousseau and Diaz had set the fashion. Dozens of umbrellas were dotted about under which sat artists from all sections of the country" (1900, 160).

With familiar hyperbole (while also employing a characteristically turgid literary metaphor), the Reverend Thomas Starr King celebrated the Intervale as a "large nocturnal poem in the landscape." In comparing the God-given array of landforms with the syntax of language deployed by the poet, Starr King claimed that the "scattered vocabulary of light, tint, and form" is nowhere more artistically integrated than at North Conway, where land "is lifted into landscape" (1859, 180). In such empurpled "drawing with words" Starr King sought to elicit for his readership both the aesthetic and the spiritual qualities of the site, which he designated "a little quotation from Arcadia, or a suburb of Paradise" (1859, 180). Homer's painting was surely intended to document this spiritualized context even if it did not accord fully with the artist's own sensibilities toward nature and landscape painting.

As America's first art colony, North Conway also developed as a center for the propagation of New England's wider claim to national cultural hegemony. Commodifying the landscape through paintings, artists of varied stripes inscribed the White Mountains as a locus of New England exceptionalism. With works of art serving—to cite Benjamin Champney's prescient metaphor—as "advertisements" for the region, travel writers were also busily touting the virtues of the surrounding landscape for touristic delectation and instruction. The artist Thomas Addison Richards, writing in *Appleton's Illustrated Hand Book of American Travel* in 1857, acknowledged an almost incestuous connection between landscape painting and landscape tourism: "Conway valley," he averred, "is a delightful place for artistic study, and for summer residences; and within a few years past, it has been a favorite resort of American landscapists, and has grown to be a veritable 'watering place,' in the great numbers of tourists who not only pass, but linger within its borders"

7. Nicolai Cikovsky, Jr., argues that Homer's canvas is a satirical critique of landscape painting: "the three artists seated one on top of the other on a heavily shorn, stump-filled mountainside, polluting themselves and nature by the bottle and its contents . . . subversively mock and call into question the sacred and solemn enterprise that Durand enjoined upon American artists" (1995, 73). In addition to misconstruing the actual site of the painting, the Intervale, a valley floor rather than a mountainside, the author also overlooks Homer's mission on behalf of *Harper's Weekly* and *Appleton's Journal* to document activities in the White Mountains for articles on summer tourism.

81. George Inness, Saco Ford: Conway Meadows, *1876. Oil on canvas, 37⅞ in. x 62⅞ in. Courtesy of Mount Holyoke College Art Museum, South Hadley, Massachusetts.*

(Appleton 1857, 91–92). "Sisters under the skin," art and tourism were intimately connected in the cultural imagination of the era.

George Inness's *Saco Ford: Conway Meadows* of 1876 (fig. 81) provides an instructive closure for the series of panoramic views of the Intervale. Composed from a relatively high vantage, Inness's view affords a radically revised study of weather and atmospherics at the expense of conventional scenery. Obscured by turbulent cloud cover, the mountains are suggested but not unveiled, a known presence that is, however, absent from the painting. In his study of the artist, Nicolai Cikovsky observed the uniqueness of Inness's White Mountain landscapes: "In the summer of 1875, which he spent in the White Mountains of New Hampshire painting with great intensity and almost serially, he began to make some of the most magnificently expressive landscapes he had ever done" (Cikovsky and Quick 1985, 30). Turning from "natural monuments to natural moments," he reenvisioned the Saco River valley as a locus, *inter alia,* for the study of climate and weather.[8] In so doing Inness subverted the traditional pictorial canon by focusing on natural processes and their capacity to evoke emotions, rather than the more conventional affects of scenery. The dominance of weather over form destabilizes the scenery, offering an image of flux and transience in place of the traditional emblematic vision of nature. Lacking the stable fixities of a Cole or a Kensett, Inness's fugitive image introduces such ephemeral contingencies as climate into the broader public perception of the

8. Drake provides a literary analogue to Inness's climatics: "At the mountains the first look of everyone is directed to the heavens, not in silent adoration or holy meditation, but in earnest scrutiny of the weather" (1882, 155).

White Mountains. Claiming that "the subject is nothing" and that the purpose of art is to elicit emotion rather than to instruct, Inness posited flux and "becoming" as significant pictorial values. Despite his persistent and conventional belief in the capacity of nature to evoke spiritual truths, Inness was more concerned with recording optical impressions than in creating icons of transcendence. In substituting perceptual for cerebral values, he also converted the artist as mediator between art and reality into a recorder of his subjective responses to nature. For this reason viewers were induced to perceive the canvas as first a painting by Inness before it was understood as a representation of the Intervale. Persuaded by the protomodernist conviction that an artist must first serve his unique genius before the conventions of popular taste, Inness shaped a radically new vision of the old landscape. Substituting for the grand vista insight into the artist's soul and mood, he became concerned "not with the imitation of things but with the reproduction of emotion" (Cikovsky and Quick 1985, 146).

From the present vantage the decade of the 1870s can be understood as a period in which the romantic ideal of American nature began to erode. By internalizing the landscape, artists like Inness deflected nature away from the sublime vista toward the modernist imperative of art for art's sake. Having exhausted the cultural possibilities of wilderness, artists in the post–Civil War era began to explore the opposing image of culture.

A case in point is Frank H. Shapleigh's *Mount Washington and Walker's Pond from an Old Barn in Conway, N.H.* (fig. 82), dated 1885. Shapleigh's signature image, a view of a mountain from a barn interior, enjoyed considerable vogue during the last

82. Frank H. Shapleigh, Mount Washington and Walker's Pond from an Old Barn in Conway, N.H., *1885. Oil on canvas, 10 in. x 16 in. Courtesy of the Hood Museum of Art, Dartmouth College.*

quarter of the nineteenth century. Contrasting enclosure with the freedom of the wild, Shapleigh's scheme produced an inverted relationship between the polarities of nature and culture. Deploying the conventional genre-derived structure of a view of a barn interior, the artist enframed nature with the accessories of cultivation. At another level the barn, together with the accretion of farm implements and domesticated animals, was probably intended to denote agrarian simplicity, a symbolic interior space suggesting shelter and stability. This "interiorization" of sensibility has also been interpreted as a response to the urbanization and industrialization of America in the post–Civil War years.[9] For many Americans, seeing "New England-ly" became a means of assuaging the fears of an anxious present with the security of the agrarian past.

9. See Betsky 1985 (241–56).

12

Moat Mountain

THE LANDSCAPE OF ACCOMMODATION

[Moat Mountain] is a constant source of study and pleasure. In truth, Moat Mountain is perhaps quite as interesting as Mount Washington and its lofty brothers, which are seen at a greater distance.

—Benjamin Champney

ONE OF THE uncontested masterpieces of White Mountain art is Albert Bierstadt's *View of Moat Mountain, Intervale* (plate 6), painted in 1869. A resolutely realistic view of the prominent peak situated on the western boundary of the Intervale, Bierstadt's canvas has been instructively compared with the landscape photographs of his well-known brothers Charles and Edward (Lipke and Grime 1973, 20–31). The wide angle, sharp definition, deeply recessive space, and persuasive illusion of reality of the painting bear a striking resemblance to the three-dimensional effects achieved by the contemporaneous stereographic camera.[1] Overlaid with naturalistic hues of green, gray, and ochre, *View of Moat Mountain* is a canonic work of nineteenth-century "photographic realism." In capturing the quality of what Henry James described as New England's "strong silver light, all simplifying and ennobling," Bierstadt further transformed the luminist obsession with light into an aesthetic bordering on hyper-realism.

Opposed both in feeling and effect to Bierstadt's truth-to-nature landscape is Jasper Cropsey's nearly contemporaneous *Winter Landscape, North Conway, N.H.* (fig. 83). Cropsey's view of the Moats, composed from a northern vantage, is one of the rare winter scenes of the White Mountains executed during the nineteenth century. Because the region's major painters (with the notable exception of Benjamin Champney) typically retreated to their urban studios in winter, snow scenes seldom

1. See Lindquist-Cock 1970 (376).

83. *Jasper F. Cropsey, Winter Landscape, North Conway, N.H., 1859. Oil on canvas, 10¼ in. x 16½ in. Private Collection.*

figured in the iconography of the seasons. Winter, moreover, was not considered an "ideal" time when the divine was most clearly manifest in the natural world. At best the season was considered a period for rest and relaxation, leisure and the visiting of friends (Gidley and Lawson-Pebbles 1989, 167). Significantly, winter was also understood as the period of the death of nature, albeit containing the potential for life.

For the most part genre painters rather than landscape artists depicted the activities of the winter season, as a means of providing a sense of homey, rustic well-being for urban America. It was doubtless the precedent of New England genre painting that encouraged Cropsey to humanize his winter landscape by the inclusion of a woodsman and a rustic homestead. Another possible meaning for Cropsey's unusual landscape resides in the widely held conviction that New England's moral and physical superiority to the rest of the nation was confirmed by the ability of her residents to survive winter's rigorous climate. Harsh, snowy winters, it was claimed by regional apologists, further demonstrated the moral superiority of the northern states to the degenerate south (Gidley and Lawson-Pebbles 1989, 171). Of still further interest is the prophetic nature of Cropsey's snowy landscape in anticipating the ascendant modern perception of the White Mountains as a winter playground rather than a summer showcase.

Another striking view of Moat Mountain is Aaron Draper Shattuck's *Haying Scene Near Moat Mountain, Conway* of 1859 (fig. 84). Loosely painted in the emergent style of the French Barbizon School, Shattuck's work is also atypical for including signs of rural labor. For the most part, White Mountain artists ignored the actual industry of agriculture, preferring instead to represent its fruits, harvested fields, or grazing flocks. Shattuck's depiction of haying was doubtless inspired by the French Barbizon practice of representing agricultural work as a social and political antidote to city life. The new focus on process, both climactic and agricultural, that informs Shattuck's view further reflects the prosaic and mundane subjects that came into vogue during the last quarter of the century.

Gazing eastward from North Conway's Intervale, painters were afforded a grand (and balanced) spectacle of the soaring pyramid of Kearsarge North. The mid-nineteenth-century painting attributed to Charles Octavius Cole entitled *Mount Kiarsarge* (fig. 85) is a highly conceptualized view of the mountain that Starr King described as "a charming pyramid" (1859, 151). Based on the engraved title page of William Gage's well-known 1875 White Mountain guidebook *Switzerland of*

84. Aaron D. Shattuck, Haying Scene Near Moat Mountain, Conway, 1859. Oil on cardboard, 9¼ in. x 14 in. Private collection.

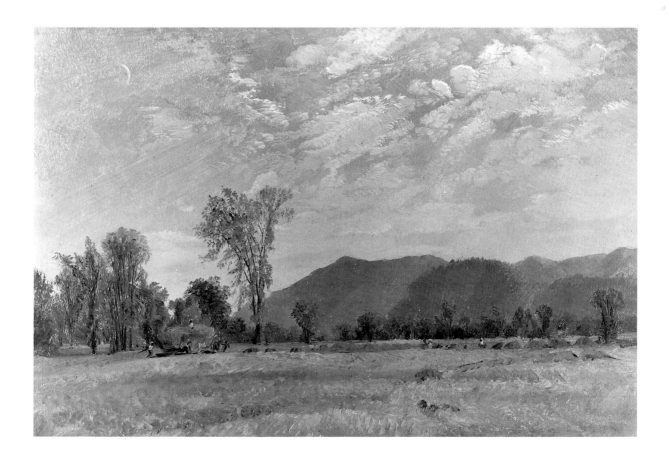

America, this work is another example of a painting derived from a popular print source. The starkly dead symbolic tree (improbably migrated from Thomas Cole's *Autumn Landscape* of 1827 [see fig. 28] into this bizarre pastiche) marks another instance of the rapport between high culture and the artifacts of tourism.

Although depictions of agriculture were uncommon in paintings of the White Mountains, a rare occasion for the representation of labor is encountered in Samuel Lancaster Gerry's view of Mount Kearsarge North, *Landscape with Cows and Ploughman* (fig. 86). This unusual canvas is exceptional not only for its enclosed foreground but for the relative insignificance imparted to the distant mountain summit. The ploughman, working the fields of the middle distance, also appears as incidental *staffage* for a confected formulaic composition. In short, his view of Kearsarge North is largely a picture about other pictures. Based on the model of

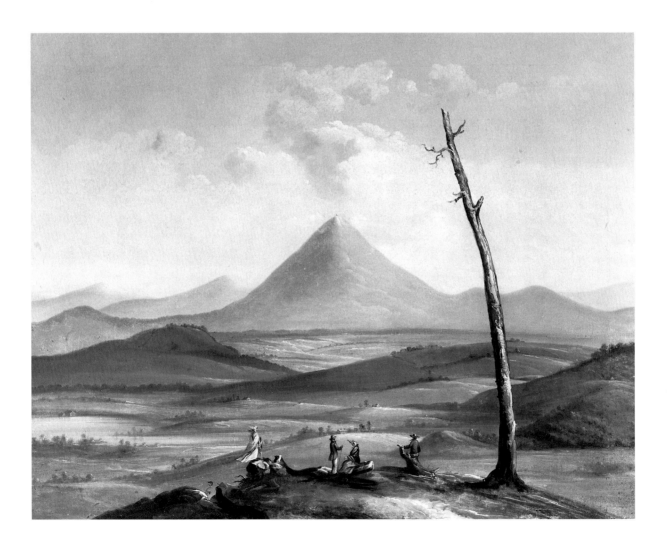

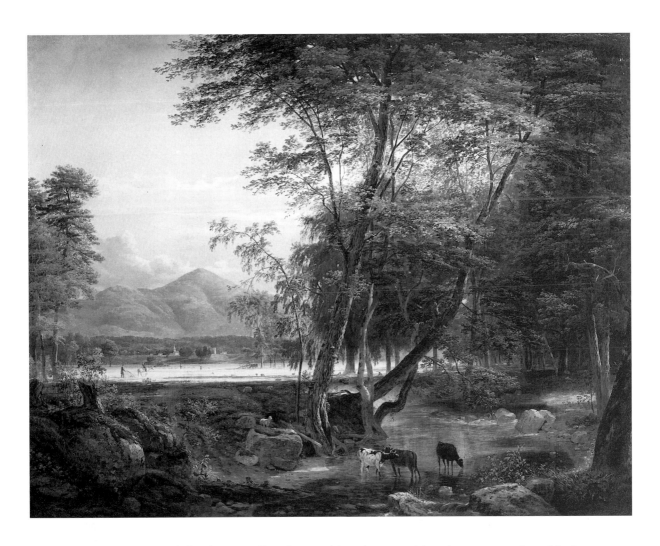

seventeenth century Dutch landscapes, Gerry's open/closed composition departs from the normative picturesque and sublime formulas of the period. In deliberately invoking the structure of Netherlandish landscape painting, Gerry invested the representation of the White Mountains with the compositional weight of a tradition distant in both time and place.

86. Samuel L. Gerry, Landscape with Cows and Ploughman, 1852. Oil on canvas, 40⅛ in. x 52⅛ in. Courtesy of the High Museum of Art, Atlanta, Georgia, acquired in honor of Mrs. Ronald W. Hartley, president of the Members Guild, 1978–79, in memory of her mother, Frances Haven Beers.

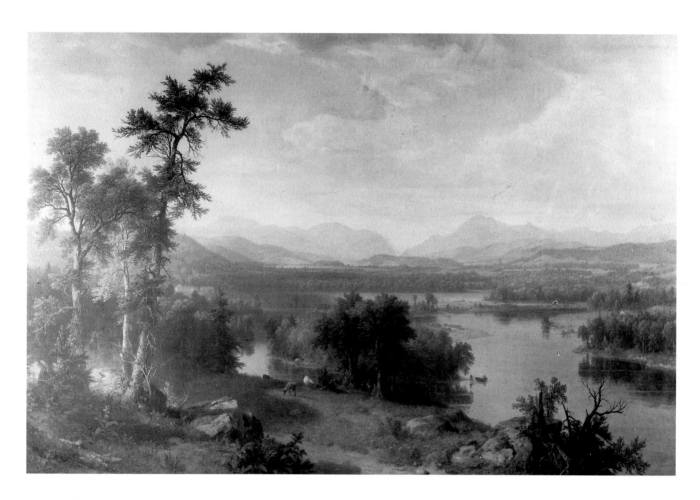

87. Asher Brown Durand,
White Mountain
Scenery, Franconia
Notch, N.H., *1857. Oil on
canvas. Courtesy of The
New-York Historical
Society.*

13

Franconia Notch

THE MORALIZED LANDSCAPE
AND "QUARRIES OF TRUTH"

This has nothing of the desolate grandeur of the other Notch. The elements do not seem to have chosen this for a battle ground.

—Thomas Cole, 1828

WHEN Asher Durand completed a large canvas in 1857 entitled *White Mountain Scenery, Franconia Notch, N.H.* (fig. 87) he proffered a conceptual, compositional and, at still another level, social alternative to Kensett's famed *Mount Washington*, painted six years earlier. Configured in accord with a series of diagonal recessions into space, Durand's view climaxes in a void rather than a mass. With a number of sight lines converging on it, the inverted triangle of space of Franconia Notch (the antipode of a pyramidal mountain summit) constitutes the focal point of the composition, a space governed by the absence rather than the presence of form. Painted on commission for the New York collector Robert L. Stuart, the deep panorama represents the confluence of the Franconia range and the wide Pemigewasset River Valley. Durand's canvas, illumined by the softened light typically favored by the painter, provides another version of the normative midcentury synthesis of the wild with the cultivated. In a letter of June 2, 1857, Stuart wrote to Durand expressing his contentment with the work: "Enclosed please find my check for thirteen hundred dollars. Very much pleased with the painting, I have made the check for more than I mentioned to you" (Koke 1982, 345).

Celebrating a putative rapport between the artist and the Franconia region, a *plein-air* sketch for Durand's landscape is included on the easel in Daniel Huntington's well-known portrait of the artist at work in his outdoor studio (fig. 88). In this engaging canvas, with its painting within a painting, Durand is portrayed in the pursuit of his professed "lowly imitation of God's handiwork." In this

88. Daniel Huntington,
Asher Brown Durand,
1887. Oil on canvas,
56⅛ in. x 44 in. Courtesy
of the Century Association,
New York.

connection, Huntington's painting functions both as a portrait of his friend Durand and as a form of homage to the Franconia region, while marking, incidentally, an emergent rivalry with North Conway as a center of art and tourism. Although the painter Charles Lanman had noted on a trip through the Notch in the mid-1840s that "the wild beauties of this Notch, unknown to fame, are charming beyond compare" (Lanman 1844, 215), by midcentury Franconia was laying claim to the status of rival art colony to North Conway.

An article in *Harper's New Monthly Magazine* for June 1852, for example, extolled the beauties of Franconia Notch, claiming that it is "infinitely more picturesque" than the Mount Washington valley lying further to the east. The writer concluded, however, with the familiar lament that Franconia was not "linked with mighty incident" or "clothed with the sacred vestment of traditionary lore. Its magnificent grandeur and picturesque beauty so fitted to figure in Indian romance or settler's legend is sadly deficient in the hallowing charm of historic or poetic association" ("A Tour" 1852, 11).

To counter this purported deficiency, Franconia's most determined advocate, Daniel Huntington, observed in *The Crayon*:

> I find it indeed a very agreeable and desirable place for landscape study.
> . . . the Pemigewasset River which winds through the valley is some-
> what like the Saco in the vicinity of Conway. . . . The valley is narrower
> than that of the Saco and is quite different in the character of its half-
> wooded hill-sides. . . . The hotel kept by Sandborn . . . is very neat and
> comfortable, and the host and hostess are obliging. The charges for
> board are moderate. (Huntington 1855)

Durand, however, reported in *The Crayon* for October 1855: "it rains all the time and the wind is terrible up here."

Huntington's attempt to exploit the celebrity of Durand (by midcentury the acknowledged leader of the American landscape school) for purposes of extolling the virtues of the Pemigewasset Valley, was but one aspect of an emerging rivalry between Franconia and the artist colony at North Conway. "Poppy Oil," writing in *The Crayon* for October 1856, for example, argued for the superiority of Campton over North Conway owing to "the total absence of the fashionable watering-place air."[1]

A terse riposte was published in the next issue under the authorship of "Mummy": "But to compare the narrow valley in which West Campton is deposited with . . . the court of Mount Washington. . . . How could anybody be so rash! Where are their ledges—where their grey and solemn Mote—their Kiarsarge for climbing—their distances like those around Dinsmore's?" (1856). In his famous guidebook to the White Mountains, the Reverend Starr King described the beauties of both sites but cautiously chose not to "mingle in the dispute" (1859, 90).

On another level the Franconia mountains were understood to embody ideals of

1. See also Richards (1856, 93) for another essay written from West Campton.

freedom and peace. A Civil War poem by John Greenleaf Whittier, for example, entitled *Franconia from the Pemigewasset* from the series *Mountain Pictures* viewed the Notch from a characteristic New England perspective:

> So, let me hope, the battle storm that beats
> The land with hail and fire may pass away
> With its spent thunders at the break of day
> Like last night's clouds and leave as it retreats
> A greener earth and fairer sky behind
> Blown crystal clear by freedom's Northern wind.
> (1904)

For Whittier, Franconia Notch served as a beacon for national unity, a symbol of freedom transfigured by political events (Leary 1962, 274).[2]

2. See McGrath 1993 (9–10) for an interpretation of Sanford Gifford's 1863 *Whiteface Mountain from Lake Placid* (National Museum of American Art, Washington, D.C.) as "John Brown's Mountain" and a refuge from the strife of the Civil War.

14

The Lakes

I long for wildness . . .
Woods where the woodthrush forever sings,
Where the hours are early morning ones,
And the dew is on the grass,
And the day is forever unproven—
A New Hampshire everlasting and unfallen.

—Henry David Thoreau

HEN Cole visited the Franconia region in 1828 he noted in his diary his feelings in regard to two discrete bodies of water found in the heart of the Notch:

> They have such an aspect of deep seclusion, of utter and unbroken soli-
> tude, that when standing on their brink a lonely traveler, I was over-
> whelmed with an emotion of the sublime, such as I have rarely felt. It
> was not that the jagged precipices were lofty, that the encircling woods
> were of the dimmest shade, or that the waters were profoundly deep;
> but that over all, rocks, woods and water, brooded the spirit of repose,
> and the silent energy of nature stirred the soul to the inmost depths.
> (McCoubrey 1965, 104)

On another occasion he commented on their unusual topography: "There are two lakes situated in a wild mountain gorge called Franconia Notch. . . . They lie with-in a few hundred feet of each other, but are remarkable as having no communica-tion—one being the source the wild Amonoosuck, the other of the Pemigewasset" (Erwin 1990, 32).

For all of the passion and precision invested in these verbal landscapes, Cole did not depict the Franconia lakes in any of his known paintings, preferring instead the historically and mythically more resonant sites of the Notch, Lake Winnepesaukee, and Mounts Chocorua and Washington. Early canvases by Alvan Fisher and

Thomas Doughty, however, display highly imaginative treatments of the Franconia lakes. Fisher's *Indians Crossing a Frozen Lake* of 1845 (fig. 89) is a fanciful confection that is nonetheless based on recognizable topographic features of the Notch, including Echo Lake and Eagle Cliff. A winter scene, unusual for the period, Fisher's view constitutes another fictive effort to evoke the look of the primal American wilderness. As an imaginative act of recovery, the artist's nostalgic invocation of the past can also be viewed as a lament for what had been lost. Aboriginal natives, presumably as primitive and wild as the setting itself, populate the landscape. Nature's noblemen in winter's wonderland, they behave like "civilized" spectators reflecting upon the beauty of the site. Rather than enlivening the landscapes through their "natural actions," they contemplate nature as if it were a picture. This curious transformation of the "native" by the imposition of the convention of European spectatorship subverts the customary role of "natural man" in the landscape generally accorded to Indians.

Thomas Doughty's *Rowing on a Mountain Lake* of about 1835 (plate 7) is another attempt to instantiate the ideal of wilderness for purposes of reflection and self-renewal. A paradigmatic example of numerous White Mountain paintings grounded in the theme of solitude, the canvas depicts a boatman engaged in a meditative

dialogue with nature. Sky and water denote flux and stillness respectively while the distant face of Cannon Mountain, conveniently displaced from its location in actuality, beckons the voyager like a shining and distant beacon. The mirror-still lake functions as the conventional typology for the "Eye of Heaven." A dead tree, stark reminder of both human and nature's mortality, serves as a visual barrier or gate, capable of blocking or inviting entry into the picture. A wisp of smoke from a campfire alludes to the transience of life or, alternatively, to a kind of natural incense suffusing the sacred precinct of the temple of nature. In this lyric image Doughty employs a full gamut of romantic symbols, as well as references to the four elements, to suggest a voyage into the ineffable mysteries of nature. Fusing the terrestrial with the divine, he created one of the most revelatory images of the Franconia lakes from the era of romanticism.

Significantly, it was the unique combination of water and mountains as vehicles for speculation about human destiny that made Franconia Notch especially appealing to nineteenth-century painters. Within a generation of these early cultural incursions, however, the region had been transformed into a resort, replete with hotels and trains.

Albert Bierstadt's *Lake at Franconia Notch, White Mountains* of 1863 (fig. 90), however, also remains committed to the preservation of the ideal of wilderness in the face of the actualities of contemporary tourism. Silent and primordial, Echo Lake emerges as a stark reminder of the region's glacial past. A solitary deer, wild symbol

90. Albert Bierstadt, Lake at Franconia Notch, White Mountains, *1863. Oil on paper, 13½ in. x 19¼ in. Courtesy of the Newark Museum, New Jersey, gift of Dr. J. Ackerman Coles, 1926.*

of the nation's exceptionalism, is the sole inhabitant of the primal scene.[1] By the 1860s, however, as numerous paintings and photographs attest, the lakes had become the haunt of tourists rather than wild animals. Embedded in the amber of nostalgic vision, Bierstadt's canvas evokes the dream of an Eden unspoiled by hotels, trains, and boats. Animated by the presence of the deer (whose gaze becomes our gaze), the setting is constituted by the primal elements of air, earth, and water.

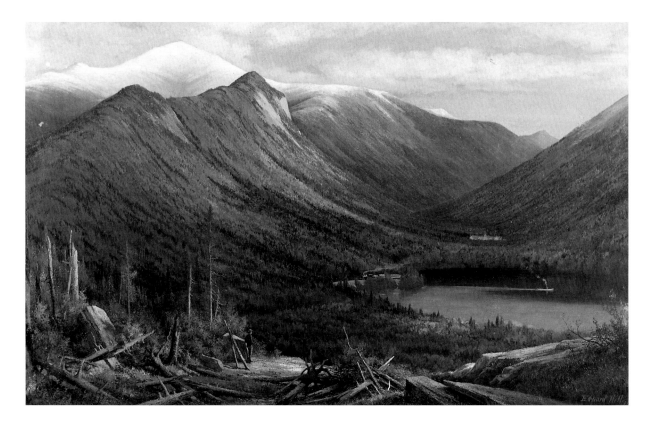

91. *Edward Hill,* Echo Lake from Artist's Ledge, *1887. Oil on canvas. Courtesy of the New Hampshire Historical Society.*

Edward Hill's *Echo Lake from Artist's Ledge* of 1887 (fig. 91) provides a striking alternative to these nostalgic images of the Franconia lakes. Standing upon a rocky stage, a solitary figure surveys a landscape transformed by the exigencies of tourism. Consciously devoid of the allure of mystery, history, or myth, Hill's view envisions the Notch as a domain of holiday pleasures, as a train traverses the once-virgin forests and a steamboat plies a lake. In the heart of the Notch, a large hotel provides

1. For American artists the wild deer generally functions as a symbol of freedom, the antithesis of the collared and enchained "King's stag" in English art. For the European tradition, see Bath 1992.

another focus of culture in the larger scenic surround. At the left of the canvas the snow-capped summit of Mount Lafayette is deliberately subordinated to these new energies by the gaze of the solitary figure, which falls upon the lake rather than the mountain. Directing the viewer's attention to the logistics of tourism rather than the majesty of mountain scenery, the figure contemplates a landscape of pleasure and expediency rather than of metaphoric heights.

Hill's pictorial "boosterism," a meditative fusion of past, present, and the hoped-for future, contrasts with the normative wilderness iconography of White Mountain painting. A resident of New Hampshire, Hill welcomed the incursions of tourism (together with the resultant monied clientele) into the Notch.[2] Like many of the natives of the region today, Hill was prepared to sacrifice the wilderness to the hope and dream of prosperity. The "Land of Many Uses," the current motto and intended philosophy of the United States Forest Service, custodians of the White Mountain National Forest, is given prophetic articulation in Hill's painting.

2. A typical "flatlander" response is found in Samuel Adams Drake's guidebook *The Heart of the White Mountains:* "Although one may make the journey from the Profile House to Bethlehem with greater ease and rapidity by the railway recently erected along the side of the Franconia range, preference will unquestionably be given to the old way. . . . I have nothing to say against the locomotive, but then I should not like to go through the gallery of the Louvre behind one" (1882, 248).

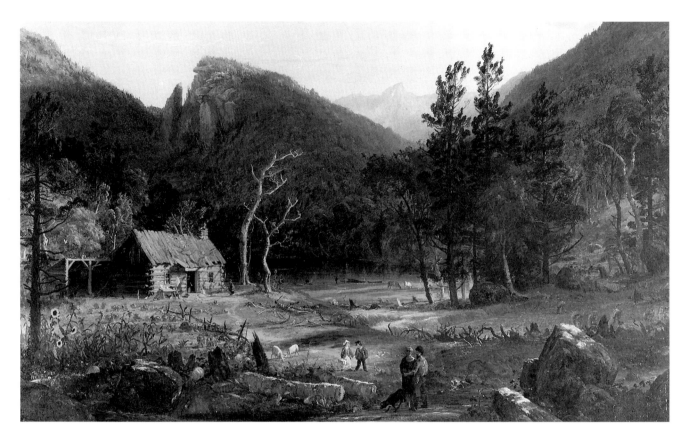

92. Jasper F. Cropsey, Eagle
Cliff, Franconia Notch,
New Hampshire, *1858.*
Canvas backed by panel, 24
in. x 39 in. Courtesy of the
North Carolina Museum
of Art, Raleigh, purchased
with funds from the State
of North Carolina.

15

The Eastern Frontier

The beautiful Franconia Notch, though far inferior to the Notch of the White Mountains in wild and gloomy grandeur, has many most agreeable and lasting attractions.

—William Oakes, *Scenery of the White Mountains*, 1848

THE CELEBRATION of the utilitarian present by the rural New Hampshire painter Edward Hill, was persistently countered by urban painters' conscious pictorial reversions to the region's mythic past. Arresting the actual trajectory of modern experience by historicizing the landscape, academic painters generally banished technology and the logistics of landscape tourism from the north country. Although no longer a tenable fiction by midcentury, the idea of untenanted wilderness or, alternatively, images of the pioneer past, were consistently invoked by artists to reconfigure the White Mountains into a condition of preindustrial innocence.

An early instance of such nostalgic pictorial musings is Thomas Cole's *The Hunter's Return* of 1845 (see fig. 31), which locates a pioneer family beneath the benign aegis of Mount Chocorua. Employing the conceit of a rustic log cabin (the antipode of the aristocratic European castle), Cole re-created the pioneer past to affirm the democratic present.[1] By reverting to the early history of settlement, Cole envisioned the self-reliant pioneer as protagonist for the exploration of the origins and promise of American democratic experience. A decade later, drawing upon Cole's precedent, Jasper Cropsey situated an identically imagined family of pioneers in the deep recesses of Franconia Notch. As a pictorial theme for reflection, the pioneer era functioned in a variety of roles in a painting entitled *Eagle Cliff, Franconia Notch, New Hampshire* of 1858 (fig. 92). A log cabin, growing crops, and grazing animals, together with a few members of the pioneer family, occupy the foreground of the composition. Presiding over the whole is the profile of the versatile and peri-

1. Compare with Truettner 1991 (30–36).

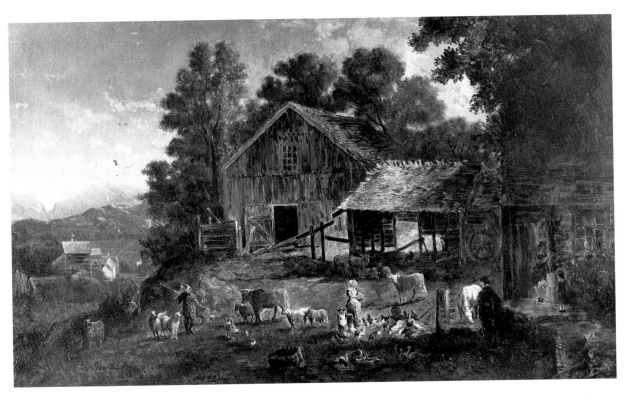

93. *George Loring Brown,*
Farmyard, West
Campton, New
Hampshire, *1870.*
Courtesy of Shelburne
Museum, Vermont.

patetic Mount Chocorua, removed from its actual topographic location, in order to provide the setting for wilderness yielding to the ideal of frontier husbandry. Not yet the "middle landscape" of the longed-for fusion of man and nature (the pastoral) but a historicized signifier of the frontier past, Cropsey's image functions to retrieve the perceived era of pioneer simplicity.

Another variant upon the theme of early habitation of the White Mountains is George Loring Brown's *Farmyard, West Campton, New Hampshire* of 1870 (fig. 93). The title is provided both by an inscription and by the distant but discernible view of the topography of Franconia Notch. The foreground is occupied by conventional signs of agrarian life (farmhouse, barn, animals, and milkmaid) as witnessed in numerous examples of nineteenth-century genre painting. Focusing more on rural husbandry than upon the face of nature, however, Brown fashioned a duplex image that mediates between the representational traditions of pure landscape and genre or scenes of everyday life. In addition, the artist imparted a distinctive European inflection to his canvas, clothing the farmers in picturesque costume and suffusing the setting with old-world charm. As in European genre paintings, the weathered buildings, acculturated by usage and habitation and bearing the weight of history, appear to be an extension of the land itself.

"Claude" Brown, best known in America for his epic canvas *The Crown of New*

England (see fig. 51), spent the better part of his career in Europe developing a style of rich glazing based on the Old Masters. The heavy brush-stroke and thick, painterly impastos of his facture, as well as the somber chromatic scheme of browns and greens, provide the look of deliberate artifice rather than the more illusionistic realism of the Hudson River School. A contemporaneous critic, in viewing one of Brown's works, noted that "we are almost frightened at the bold, fearless use of the brush," a reference to the artist's bravura manner of painting, derived from the practices of the seventeenth century ("Exhibition" 1861). The closed/open composition, receding sharply to the horizon, also imitates a baroque compositional formula. Brown, like many of his contemporaries, considered the White Mountains "the Switzerland of New England" and, in a letter, claimed that the region was unsurpassed for "waterfalls, rocks, trees, and mountains" (Fleming Museum 1973, 27). Of all White Mountain painters, Brown was arguably the most European in his sensibilities. The composite mode of "peasant-genre" employed by the artist for *Farmyard, West Campton* also carried a freight of nostalgia for the culture of the Old World as opposed to the newly minted look of the iconography of the American frontier.

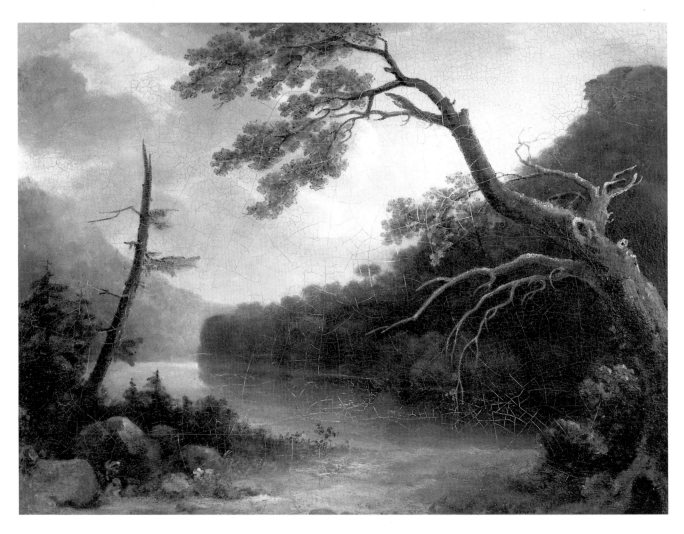

94. *Thomas Cole or Thomas Doughty or Alvan T. Fisher,* Profile Lake and Old Man of the Mountain, *ca. 1835. Oil on canvas, 17½ in. x 23½ in. Courtesy of the Hood Museum of Art, Dartmouth College.*

16

The Old Man of the Mountain

GODS IN GRANITE

I started! From the topmost peak of the loftiest of the summits a human yet God-like countenance was looking down upon me . . . and the unexpected manifestation of this superhuman presence was at once startling and sublime.

—*The Knickerbocker*, October 1852

THE MOST celebrated natural emblem in Franconia Notch (as well as the most anthropomorphized symbol of the White Mountains) was the Great Stone Face. Not discovered until 1805 and later immortalized in one of Nathaniel Hawthorne's famous twice-told tales, the Old Man came to be viewed as, among other things, an image of God seated in judgment of mankind.[1] Not only was this topos intimated by Hawthorne, but it was also rendered explicit in a suggestively titled novel, *Christus Judex* by Edward Roth, published in 1864. In this turgid Victorian narrative, the Old Man is compared to the image of the Supreme Judge in a Renaissance altarpiece (9).[2] For Hawthorne the Stone Face also functioned as an antidote to such unregenerative sites as the Notch. In his well-known short story, he referred to the granite visage as "a work of Nature in her mood of majestic playfulness" and the valley below "owed much of its fertility to this benign

1. For Hawthorne, the Old Man was also understood as a symbol of George Washington, the reluctant American messiah. The unveiling of Washington's colossal portrait bust at Mount Rushmore in 1930 completed this imperialistic transposition.

2. Right over the altar was a large painting, "containing one single figure. It did not represent the Crucifixion, as is generally the case with such pictures: on the contrary, the figure—of which I could distinctly see only the head—seemed to be sitting. But this head affected me most powerfully. It was the profile of a pale, noble countenance gazing sorrowfully yet immovably on some heart-rending sight. Oh, the sternness of that brow, though the eye was mild and the mouth gentle and loving! And the chin: it was the embodiment of inexorability: it told of strict justice, but no mercy . . . that was the beatified countenance of the Lord Christ" (Roth 1864, 9).

aspect that was continually beaming over it, illuminating the clouds, and infusing its tenderness into the sunshine" (1946, 292).

Among the earliest paintings containing the image of New Hampshire's granite deity is a view of Profile Lake with the Great Stone Face strangely marginalized in the upper right of the image (fig. 94). An expressive and writhing foreground tree creates a cross axis with the descending hillside, adding an element of mystery to the turbulent landscape. Informed by the pictorial rhetoric of the fashionable gothicism of the age, the painting possesses both stylistic and ideational connections with the early works of Thomas Cole, suggesting a date of around 1835. In his diary, for example, Cole noted that he felt "an awfulness in the deep solitude" of the Notch and that the "severe expression" of the stone deity was "too dreadful to look upon" (Noble 1964, 67). At present more precise analogies preclude a secure attribution of this important early work. A comparably morbid aura informs the early daguerreotype of Samuel Bemis (ca. 1840–41) entitled *Man in the Mountain* (fig. 95). Reversed on the copper plate, the Great Stone Face gazes sternly over the surrounding wilderness. Probably the earliest American photographic image of a natural geological formation, Bemis's daguerreotype remained in the artist's collection until 1980, when it was sold at auction.

95. Samuel Bemis, Man in the Mountain, *1840–41. Daguerreotype. Private collection.*

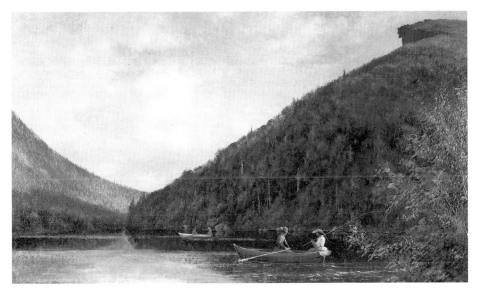

96. *George Wilson Cass, Profile Lake, ca. 1870. Oil on board, 7¾ in. x 13½ in. Unlocated. Photograph courtesy of The Old Print Shop, Inc., Kenneth M. Newman.*

A generation later, George Nelson Cass characteristically transformed the site of Profile Lake (fig. 96) into a realm of touristic pleasure. Boaters and anglers now occupy the privileged space devoted in the earlier canvas to the agonistic tree. Sublimely indifferent to Ruskin's injunctions against the "pathetic fallacy," the Great Stone Face gazes benignly upon the transformation of the Notch from howling wilderness to tourist playground.

Perhaps mindful of Thomas Starr King's description of the famous natural sculpture as "older than the Sphynx . . . [a] mighty angel sitting among the hills and enrobing himself in a cloud vesture" (1859, 113), Cass imparted an aura of other-worldly elevation to the stone visage. New Hampshire's Old Man of the Mountain served as an archetype for the emergent national landscape, especially in the American West, where faces in stone, both natural and manmade, began to emerge during the years after the Civil War.[3] The ultimate apotheosis of sculptural inter-cessions with mountain granite occurred during the 1920s and 1930s, when the artist Gutzon Borglum invoked the White Mountains' natural archetype to shape his remarkable vision of the imperatives of Manifest Destiny at Mount Rushmore in South Dakota. A human reenactment of the divine sculptor's original gesture, Borglum's pneumatic chisel shaped the epiphanic emblem of the fulfillment of American history.

3. Compare with Trenton 1983, fig. 72.

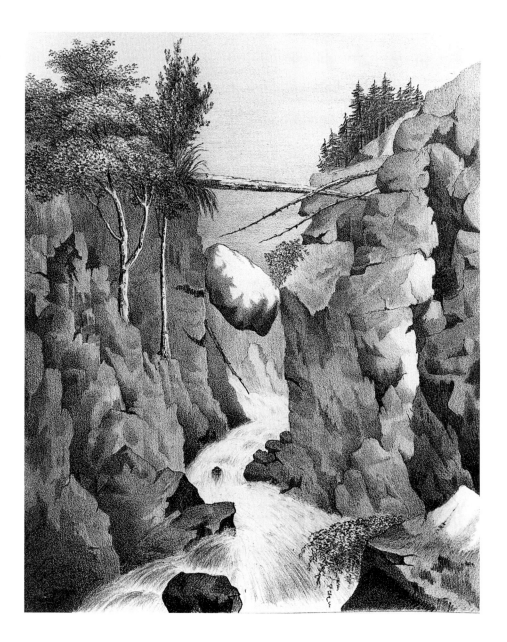

97. *J. Whitney,* Flume Franconia, *illustration for C. T. Jackson's* Final Report on the Geology and Mineralogy of the State of New Hampshire, *1844. Lithograph. Courtesy of Dartmouth College Library.*

17

The Flume

A SERMON IN STONE

When we see mountains crumbling before our very eyes, may we not
begin to doubt the stability of things that we are pleased to call eternal?

—Samuel Adams Drake, *The Heart of the White Mountains, Their Legend and Scenery,* 1882

PURPORTEDLY discovered by "Aunt" Jesse Guernsey when she was ninety-
three years old, the narrow chasm of the Flume with its gigantic suspended
boulder was both a natural curiosity and an object for metaphysical specu-
lation during much of the romantic period (Drake 1882, 227). The earliest repre-
sentation of this singular phenomenon appeared as an illustration for Charles T.
Jackson's *Final Report on the Geology and Mineralogy of the State of New Hampshire* pub-
lished in 1844 (fig. 97). This engaging lithograph stresses the wildness of the site
while depicting the boulder miraculously suspended between the walls of the
chasm. As a landscape "singularity," the Flume invited visitors to admire the awe-
some forces of nature that had deposited the enormous megalith in such a dramat-
ic context. At the same time the evident symbolism of a displaced rock, intimating
faith, resurrection, and redemption, deeply impressed the typological imagination
of nineteenth-century thinkers.[1]

Sometime during the 1860s Samuel Lancaster Gerry painted the Flume (plate
8) with an eye to the actualities of tourist experience as well as the symbolism of the
site. Animating Gerry's canvas is the figure of a solitary pilgrim, staff in hand,
ascending a wooden walkway located within the chasm. Less spatial and more ver-
tically disposed than the earlier lithograph, Gerry's image affords the site an aura of
solemnity associated with a natural cathedral.

1. Compare with Burt 1883. In his *Journals* Emerson takes note of the flume but offers no typo-
logical reading of its meaning: "I long sometimes to have mountains, ravines and flumes, like that in
Lincoln, New Hampshire, within reach of my eyes and feet; but the thickets of the forest and the
fatigue of the mountains are spared me and I go through Concord as through a park" (6:383).

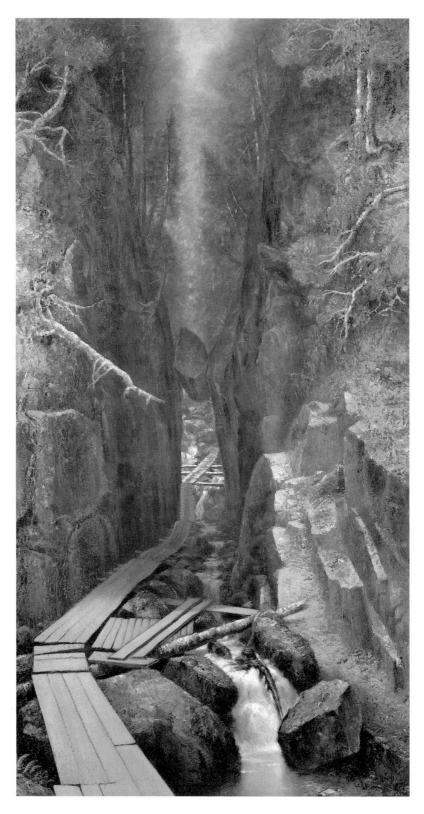

98. Ralph Albert Blakelock,
The Boulder and the
Flume, *1883. Oil on canvas,
54 in. x 28 in. Courtesy of
the Metropolitan Museum
of Art, gift of Mr. and Mrs.
Hugh J. Grant, 1974.*

Ralph Albert Blakelock's *The Boulder and the Flume* of about 1875 (fig. 98) provides an even more constricted view of the flume, as if the boulder were being crushed between vise-like walls. In this revised context, the walkway absorbs the viewer directly into the space of the painting, suggesting a rite of passage or a perilous trial akin to the literary conceit of the sword of Damocles,[2] or at another level, the arduous path of redemption. By the 1870s, however, the intense and private longings of the early romantics had devolved into more generalized spiritual clichés. Paying lip service to the symbolism of landscape as a meditation on the pilgrimage of life, Blakelock was probably less concerned with spiritual transcendence than with creating a marketable product for the tourist clientele.

In the spring of 1883 the greatest floods and avalanches in the White Mountains since 1826 wrenched the boulder loose from its moorings, drove it through the chasm, and shattered it into innumerable fragments. Relic hunters descended upon the site and carried off every fragment of rock that could be construed as having formed a part of the original boulder. The cover illustration for *Harper's Weekly* of July 14, 1883, depicts a lurid reenactment of the natural cataclysm (fig. 99). The accompanying verbal account of the flood was prefaced by an elegiac lament:

> The hundreds of visitors who this summer will visit the White Mountains will find some changes in one of the striking scenes in the picturesque and charming district that lies near Franconia Notch. The Eagle Cliff still towers up, the Great Stone Face still looks down, as if, in Hawthorne's words, an enormous Titan had sculptured his own likeness there. Echo Lake is still worthy of its name. The Basin still brims with its pellucid waters but the Flume has lost one of its wonders. ("The Recent Slide" 1883)[3]

A post-freshet painting by Edward Hill (fig. 100) depicts the Flume devoid of its most salient emblem. Depotentiated by the combination of nature and tourism, the artist's laconic image possesses none of the resonance formerly accruing to the site. Hill's canvas, unencumbered by transcendent meanings, represents the mundane actualities of place rather than the spiritual ideals of redemption, salvation, or

2. Compare with Starr King 1859 (124).

3. See also Slade 1895 (95): "The Flume has acquired some notoriety having been seen and described by a comparatively large number of visitors. It presented the same attractions which always marked the spot until the recent landslide, which has sadly marred the beauty of the surroundings and removed the huge boulder which was held suspended between the walls of the perpendicular cliffs,—a marvel to many."

99. W. H. Gibson, The
Fall of the Boulder. *Cover
illustration for* Harper's
Weekly, *July 14, 1883.
Courtesy of Dartmouth
College Library.*

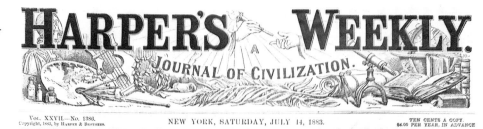

HARPER'S WEEKLY.

JOURNAL OF CIVILIZATION.

Vol. XXVII.—No. 1386.
Copyright, 1883, by Harper & Brothers.

NEW YORK, SATURDAY, JULY 14, 1883.

TEN CENTS A COPY.
$4.00 PER YEAR, IN ADVANCE.

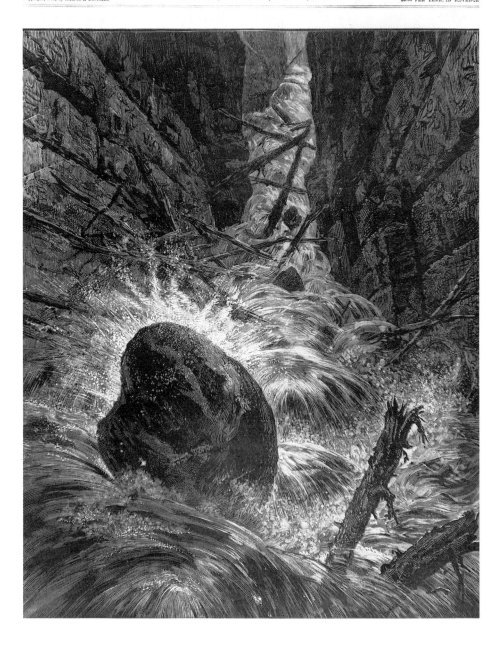

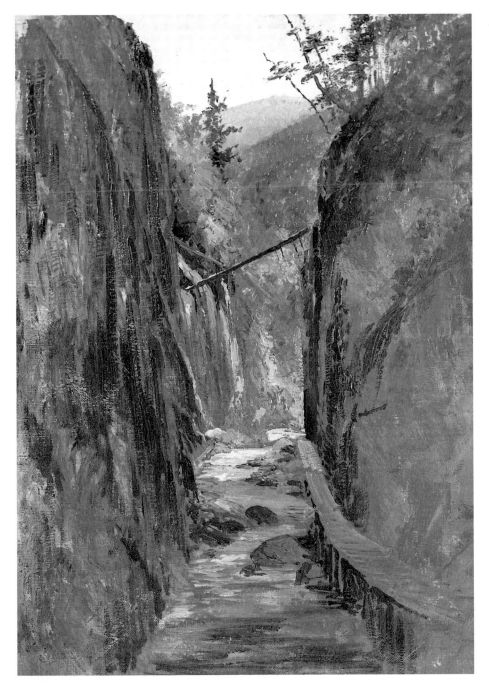

100. Edward Hill, The Flume, *n.d. Oil on canvas. Collection of Charles and Gloria Vogel.*

moral elevation. At best, the memory of the site's sacred resonance is evoked by the silent witness of this late-century image.

Another of the primary attractions of the region of the Flume was "The Pool," where the "natural and practical philosopher and geologist to the Franconia Mountains" delivered discourses upon the system of the earth. A late-century

101. Unknown engraver, Flume House, Franconia Notch, New Hampshire, ca. 1880. Engraving. Courtesy of the New Hampshire Historical Society.

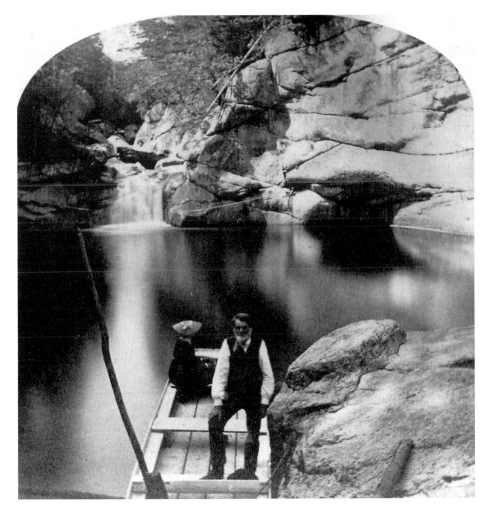

advertisement for the Flume House (fig. 101) delineates the accessible curiosities for tourists (Old Man, Flume, Pool) and in the roundel is seen the boat-borne "philosopher" gesturing towards cosmological symbols painted upon the rock walls of the Pool. One of Thomas Hill's oil paintings from the 1870s (plate 9) represents the bearded cosmographer rowing guests around the remarkable body of water formed near the headwaters of the Pemigewasset River. At the extreme right of the painting appears one of the cosmographic symbols inscribed upon the rock. Surviving stereographic views from the period (figs. 102 and 103) also show this celebrated lecturer posing with tourists in his bark or before the painted symbols, traces of which survive today.

Usually designated "The Man at the Pool," the philosopher was described as being "quite as much an object of interest as the Pool itself" (Roberts 1924, 12). John Merrill, as the philosopher was named, took up residence at the Pool in the mid-

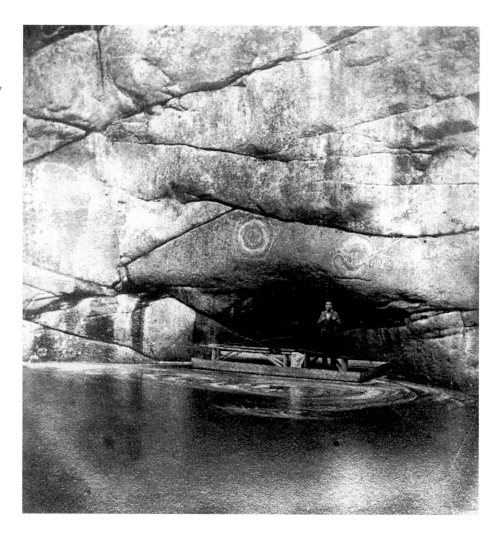

103. Unknown photographer, The Old Man of the Pool, ca. 1890. Stereograph. Courtesy of the New Hampshire Historical Society.

1850s, regaling visitors with his account of the earth as an inhabited hollow globe.[4] These views were expounded by Merrill in two publications and also were reported by most guidebooks of the period.[5] Starr King, doubtless offended by the philosopher's views, chose not to advertise his services, claiming that the Pool was

4. Merrill's views were expounded in two publications: *Cosmogony; or Thoughts on Philosophy* and *Lecture Delivered at the Flume House Parlor.* In the Flume House lecture he wrote: "On the subject of the Earth, I contend that at the north and south extremes there are open places letting air and space inside, for the Earth is a hollow globe" (1858). In *Cosmogony* he reiterated his theory in spectacularly mixed metaphoric terms: "[My theory] is now cast upon the waters of public opinion trusting that seed will fall into the minds of some and bring forth good fruit in due season" (1860).

5. The Reverend Guy Roberts, a later commentator on Merrill's views, wrote: "Mr. Merrill had a peculiar belief as to the world being flat, and edified all his passengers with an explanation of his theories by the aid of a large chart painted on the wall of the Pool at the right hand side of the cascade" (13).

"a gloomy, natural well in the forest." Seeking to dissuade visitors from frequenting the site, he commented, "If [the Pool] was hollowed out for Naiads, they must be of a very sullen temper, Nymphs of the Stygian order" (Starr King 1859, 125). Drawing upon Starr King's image, Samuel Adams Drake was more explicit about the *genius loci*, "the stranger, seeing an old man with a grey beard standing erect in a boat, has no other idea than he has arrived on the borders and is to be accosted by the ferryman of Hades" (Drake 1882, 226). The Reverend Julius Ward, however, was less comfortable with the prevailing mythology. In his transcendentalist-inspired guidebook of 1890, he emphatically undertook to deconstruct the Stygian metaphor: "The ferryman is not old Charon, ready to take you over the Styx, but a modern Charon who, for the last thirty years, has given all the summer visitors who had a shilling to spare a boat ride around the Pool and under the waterfall, and has thrown in a religious lecture on geology, spiritism and what not to all who were willing to listen to him. He is now beyond three score and ten and looks as venerable as one of the cliffs that enclose the Pool. He is a queer combination of the hermit and the prosperous Yankee" (179). Writing at the beginning of this century, Frederick Kilbourne completed the demystifying transaction, observing with ironic intent,

> From the Pool [the philosopher] carried away annually enough money to provide a comfortable living for the rest of the year. Indeed, it is said that the gratuities given him by tourists for paddling them over the Pool and for expounding for them his cosmogony were in the aggregate far from inconsiderable. While he was undoubtedly an oddity, it is hinted that there was method in his peculiarity, some of his notions and characteristics being assumed for their value in extracting money from visitors to this beauty spot. (1916, 262)

104. *Winckworth Allan
Gay,* Welch Mountain
from West Campton,
*1856. Oil on cardboard, 8¼
in. x 12 in. Courtesy of the
Brooklyn Museum, Dick S.
Ramsay Fund.*

18

The New Landscape

It is grand to be delivered from superstition, but not on the condition of losing the sentiment of the sacred, the mystic, the awful in the universe, of which superstition is either the immaturity or the disease. We do not necessarily gain in insight by banishing the special sacredness which a crude imagination concentrates upon parts of nature, but by discerning a nobler gentler sanctity. A purblind vision is cured, not when it sinks into utter darkness but when it receives more light.

—Thomas Starr King, *The White Hills*, 1859

RADICALLY divergent manner of depicting the White Mountains is encountered in Winckworth Allan Gay's *Welch Mountain from West Campton* (fig. 104). Painted in 1856, Gay's view of this little-known mountain rejects the visionary theatrics of traditional romantic landscape for the practice of a radically new aesthetic. Employing a subdued palette of earthy greens, grays, and blues, the artist suppresses detail with the goal of conveying a unified optical impression of nature. Evoking a single, momentary percept (as opposed to a sequential panoramic view), Gay's canvas affords a more closely studied approximation of ordinary reality than the hyperbolized landscapes of the previous decades.

Gay, as has recently been demonstrated, was the first American artist to study with the Fontainebleau painters near Paris, and *Welch Mountain* is considered the earliest Barbizon-inspired canvas painted in America (Craven 1981, 1224). Faithful to the site, as well as to the French aesthetic, Gay's view dispenses with the conventional narrative and framing elements of the picturesque and sublime formulas. Moreover, the theistic symbolism often imposed on White Mountain scenery has been suppressed with an eye to the evocation of an optically "accurate" view of the landscape. Subtle tonal gradations of a restricted chromatic scheme inform the view, which possesses no apparent aura of nature's traditional charisma. Romantic anthropomorphization (the "pathetic fallacy") of the landscape has yielded to a view of nature as separate and autonomous. In short, *Welch Mountain* conveys an

emphatic impression of place that is at once here and now, secularized and demystified, shorn of the conventional associations of religion and history. Divested of the visionary cultural baggage that imparted "higher meaning" to romantic landscapes, Gay's canvas is among the earliest deliberately secularized views of the period. Stressing the commonplace rather than the phenomenal, *Welch Mountain* is the product of a sensibility in search of aesthetic and scientific truth rather than spiritual meaning.

Because Gay was more concerned with registering a perceptual record of the site than potentiating the landscape, he no doubt consciously chose to depict a mountain with little or no associational meaning.[1] The suppression of the theatrics of the sublime implicit in Gay's painting anticipates a variety of late-century attitudes toward the White Mountains and the shift from the conceptual and symbolic to a more mundane view of nature.

Although he was a friend and traveling companion of Benjamin Champney, Gay was among those artists who preferred West Campton (and the company of Durand, Griggs, and George Loring Brown) to the Intervale. Paradoxically the North Conway painters Champney and Kensett, who were also in Paris in the 1840s, were less responsive to the Barbizon style and its displacement of spiritual meaning by the actuality of the commonplace.

1. Henry T. Tuckerman, in his biography of the artist, reiterated the conventional belief that "His pictures . . . by their truth, beauty, grandeur and loveliness would explain the strong feelings awakened in the minds of Hawthorne, Thoreau, Emerson and Dana" (1867, 563).

19

Work and Play

"You see the engine goes up behind, and in front down; and the car is simply pushed forward, or follows it."

"Suppose all these things break at once. What then? Where would we go?"

"That, madam, would depend upon what sort of life you had led."

—Samuel Adams Drake, *The Heart of the White Mountains*, 1882

SAMUEL Lancaster Gerry's *Whiteface in the White Mountains* (fig. 105), dated 1849, is a strikingly atypical painting for the middle decades of the century. In the first instance the painting represents a relatively obscure mountain in the Sandwich range and second, it provides a rare depiction of sports fishing in the region. The choice of Whiteface Mountain as topographic background for sporting activity was doubtless made by Gerry because (like Welch Mountain) it did not bear a heavy burden of prior association. The artist was thereby released from the pressure of more elevated narrative to focus on the theme of angling, which is conspicuously depicted in the foreground of the painting. Unlike such competing Eastern wilderness areas as the Adirondacks, the White Mountains were seldom considered a haven for sportsmen. Indeed, none of the important writers on the region (Starr King, Willey, Drake, etc.) focuses on fishing as a major attraction.[1] By and large, scenery rather than sport constituted the dominant thematic of the White Mountains for painters from such urban centers as Boston and New York.

By contrast, "native" painters like Edward Hill, a year-round resident of Littleton, New Hampshire, frequently depicted such common north country activities as hunting, fishing, and logging. Hill's *Ice Fishing* (fig. 106), for example, depicts an unfashionable subject during an even more unfashionable season. The appeal of this work lies in its relevance to the lives of regional inhabitants, rather than the urban "fishing fraternity," who by and large did not consider ice fishing a sporting

1. Asher Durand, reporting in *The Crayon*, complained that fishing in the White Mountains was overrated (1855).

activity. In the main, fishing for food was disdained by the cultivated fly-rod set of
the Izaak Walton League. President Grover Cleveland, for example, defined anglers
as only "those of us who fish in a fair well-bred and reasonable way" (Cooper 1986,
162). Clearly ice fishing with live bait and multiple lines would not have met with
presidential approval.

Likewise, the gray monochrome of the scene would not have held much attrac-
tion for an urban clientele accustomed to viewing nature in more alluring garb. In
this instance Hill's austere painting was presumably directed at a provincial audi-
ence familiar with the seasonal aesthetics, techniques, and rituals of ice fishing.

An even starker image of the White Mountains during the off-season is Hill's
Lumbering Camp in Winter (plate 10) of 1882. Eschewing the customary picturesque
anecdote for the benefit of city dwellers, Hill realized the bleakness and monotony

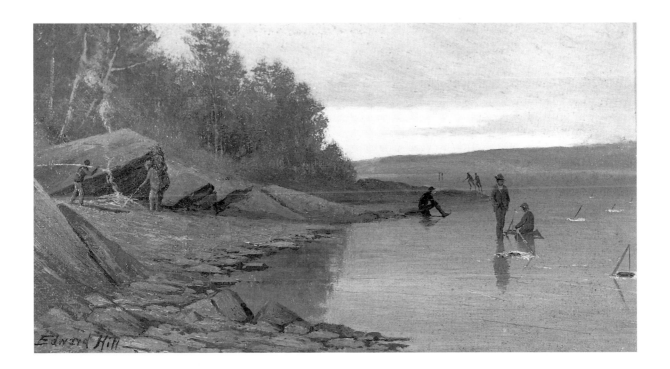

of winter as experienced by the indigenous working population of the north country. The artist's identification with this class, and with the hardship of surviving the long White Mountain winters, contrasts sharply with the more idealized visions shaped by urban artists. The psychological, social, and aesthetic divide between natives and summer tourists, here as elsewhere inscribed in Hill's work, is part of a dialectic that still informs hill country life in northern New England.

106. Edward Hill, Ice Fishing, *n.d. Oil on canvas. Collection of Charles and Gloria Vogel.*

107. Charles E. Beckett,
View of the Pleasant
Mountain House,
1852–1866. Oil on canvas;
24 x 34 in. Courtesy of the
Portland Museum of Art,
Maine, museum purchase
with a gift from Roger and
Katherine Woodman.

20

Tourism

A large proportion of the summer travellers in New Hampshire bolt the scenery, as a man, driven by work, bolts his dinner at a restaurant.

—Thomas Starr King, *The White Hills*, 1859

REPRESENTATIONS of the land, as distinct from the land itself, possess the advantage of being portable. As such, White Mountain paintings generally functioned to transmit the pseudo-experience of the region to distant urban centers and in the process to encode nature in an ordered representational system. Sites, depending upon their degree of celebrity, were hierarchically arranged according to predetermined canons of scenic value. One major consequence of this process was the further disassociation of the image from its underlying reality. Once detached from the world by the various processes of cultural reification (i.e., words and images), "nature" became susceptible to further exploitation both culturally and commercially.

The institution of landscape tourism, for example, has been defined as the application to life of lessons learned from art. Attracted in no small measure by artistic vision, tourists began to flock to the White Mountains in ever increasing numbers from the early 1850s onward. An illustrated article in *Harper's Monthly* for June 1852, for example, was among the first to extol the benefits of a vacation in the region. At almost the same moment, the completion of the Atlantic and Saint Lawrence Railroad (the Grand Trunk) with a station at Gorham (1851) transported travelers to within eight miles of Mount Washington.

The construction of the grand hotels to accommodate the ever-increasing numbers of visitors was another direct consequence of the improvement of travel to the White Mountains. While Horace Fabyan's Mount Washington House, an addition to Ethan Allen Crawford's original inn, is considered the earliest of the hotels, larger establishments were soon built in Franconia Notch (Flume and Profile Houses), in Pinkham Notch (Glen House), and on the summit of several of the

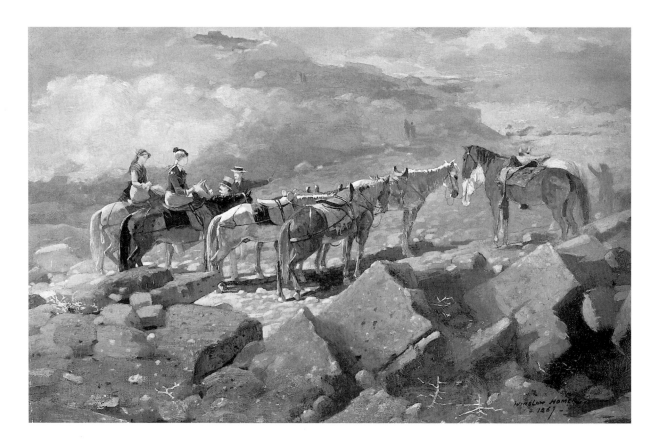

108. *Winslow Homer, Summit of Mount Washington, 1869. Oil on canvas, 16 in. x 24⅛ in. Courtesy of the Art Institute of Chicago, gift of Mrs. Richard E. Danielson and Mrs. Chauncey McCormick.*

major peaks.[1] The Tip Top House, for example, was erected on the summit of Mount Washington in 1853 and was quickly followed by the Pleasant Mountain House, the Lafayette House, and several other hostels on neighboring peaks. The little-known painter Charles E. Beckett's *View of the Pleasant Mountain House* of about 1855 (fig. 107) affords one of the earliest painted views of a summit hotel. Somber in palette and "gothick" in character, Beckett's canvas depicts a group of mounted tourists ascending a bridle path toward a hostel located on top of one of the White Mountains' most popular summits. In order to establish an ambient mood of sublimity, the artist deployed a sinister stand of dead trees in the painting's foreground. This morbid conceit imparts a gloomy aura to the canvas while also documenting a region of wind-kill often found near the tree line in the White Mountains.

Beckett's turgid canvas forms an instructive companion to Winslow Homer's *Summit of Mount Washington* (fig. 108), executed about fifteen years later. In Homer's light-shot view, the intensity of coloration has been elevated in order to impart a

1. Compare with Bulkley 1958. See also Lapham 1975 for images of the great hotels and Koelsch 1982 for an interesting account of tourism.

less threatening aspect to the scene. At the same time the vibrant new palette suggests affinities with French Impressionism. A group of tourists, momentarily dismounted, are offered, through a break in the clouds, a distant view of the Tip Top House. Others make their way on foot toward the summit through the swirling sea of clouds.

Significantly, Homer's painting stresses the experience of the tourist rather than a more emblematic representation of nature as seen, for example, in Beckett's view of the Pleasant Mountain House. The qualities of light and color evoked by Homer's brush absorb the figures and the observer into an atmospheric drama that has little known precedent in previous depictions of the White Mountains. Homer's shift from the representation of the face of nature to the experience of tourists doubtless reflects his affiliations at this juncture of his career with popular magazines and his role as an illustrator of commissioned articles on tourism. A sketch for *Summit of Mount Washington* did in fact appear as an illustration in *Harper's Magazine* for July 10, 1869. A popular lithograph from about a decade earlier, designed after a painting by Benjamin Grant Stone (fig. 109), also displays (despite pronounced gothic inflections) significant affinities with Homer's painting.

Perhaps the finest of the paintings of tourists (as distinct from paintings for tourists) is Winslow Homer's *The Bridle Path, White Mountains* (plate 11) executed as

109. After Benjamin Bellows Grant Stone, Summit of Mount Washington, *1857–58. Lithograph by Sabatier. Courtesy of Dartmouth College Library.*

a consequence of one of the two summers (1868–69) spent in the White Mountains on assignment for *Harper's Magazine* and *Appleton's Journal* (Tatham 1992). This brilliant canvas is one of the artist's most evocative images of the activities of the newly leisured industrial class after the Civil War. Employing a bright color scheme and strong lighting, Homer elevates the tourist experience to new heights both figuratively and literally. Imparting an air of inwardness and reflection to the scene, a dreamy, meditative, melancholy common to much art of the period, Homer both internalizes and, through the persona of its central figure, feminizes the composition. The centrality of the woman, a new protagonist for the White Mountains, further transforms the intended meaning of the work. Liberated from the garden, the woman assumes a new role in the mountain wilderness. Self-absorbed and with no eyes for nature, Homer's equestrian tourist dominates the composition physically and psychologically. Unlike the previously considered *Summit of Mount Washington*—in most respects a conventional popular image—*The Bridle Path, Mount Washington* strongly foregrounds the solitary human figure while simultaneously repressing the blandishments of the natural setting. A manifestation of a wider process of the secularization of American space, Homer's canvas offers a new orientation toward the material world. This revised focus on humans, and women in particular, is also encountered in the contemporaneous writings of Henry James and William Dean Howells, where tourists rather than the land become the focus of cultural experience.[2]

Homer's radical shift from the face of nature to the facts of tourism served to reshape the vision of mountain scenery. Neither threatening nor spiritually elevating, Homer's landscape is, at best, a mere backdrop for the artist's exploration of human agency. An expression of reserve, Homer's painting both discloses and withholds diverse meanings while involving the observer in a complex process of decoding his work. Along related lines, the carefully delineated foreground rocks, more geological than theological, have devolved into lithic facts rather than sermons in stone. Among the first American artists to feminize and aestheticize the idea of wilderness, Homer explores, among many things, the formal premises of his art at the expense of traditional narrative content. In particular, Homer's women, enjoying a brief season in the open, are given an active role in nature before being consigned to domestic interiors by artists of the Boston school around the turn of the

2. Nicolai Cikovsky, Jr., in the magisterial Homer catalogue (1995, 75–76), quotes the critic Eugene Benson in *Putnam's Magazine* (June 1870): "Here is no faded, trite, flavorless figure, as if from English illustrated magazines, but an American girl out-of-doors, by an American artist, with American characteristics."

110. H. Morse, after Harry Fenn, The Descent from Mount Washington. Illustration for Picturesque America, ed. William Cullen Bryant, New York, 1872. Courtesy of Dartmouth College Library.

century. As indicated by the content of *The Bridle Path*, the trajectory from the nine-teenth-century cult of nature to the cult of domesticity passed through the White Mountains.

Not all of Homer's contemporaries shared his human-centered approach to representing the experience of mountains. A nearly contemporaneous engraving in *Picturesque America* (fig. 110), the most important illustrated travel book of the era, depicts the identical event, the descent of the Bridle Path on Mount Washington by women on horseback, in a decidedly more traditional manner. Harry Fenn's illustration of this harrowing experience draws upon the commercially popular conventions of sublimity, substituting acute stress for Homer's lyric quietude. Howling winds, billowing clouds, and naked precipices threaten the travelers who proceed anxiously in the presence of an emphatically hostile nature. The contrast between Homer's aestheticism and Fenn's Sturm und Drang discloses the emergent

111. *Winslow Homer,* A Mountain Climber Resting, *1869–70. Oil on canvas; 10¾ in. x 14¾ in. Photograph courtesy of Vance Jordan Fine Art, New York.*

divide between elite and popular levels of culture in the post–Civil War era. In lieu of the relative homogeneity of high romantic culture, the artistic culture of the later nineteenth century allowed for greater diversity, particularly with regard to the representation of human interaction with nature.

Another characteristically quietistic painting of outdoor recreation by Homer is entitled *A Mountain Climber Resting* (fig. 111), which dates from the same years of 1868–69. Based on a known drawing, Homer's solitary figure served as the basis for a wood engraving published in *Harper's Bazaar* under the title "The Coolest Spot in New England—Summit of Mount Washington."[3] Homer's depiction of a lone climber, contemplating the land from on high, is among the earliest representations of the new sport of mountaineering, which began to gain popularity in America shortly after the Civil War. Before then, touring in the White Mountains was undertaken most often on horseback; in only about 1870 did the vogue for climbing on foot become widely practiced.[4] A late century embodiment of Thomas Cole's questing pilgrim, Homer's mountaineer, in the pose of a classical god,

3. Compare with Goodrich 1968, fig. 87. Cikovsky (1995, 64–65), following David Tatham's lead (1992), argues that several of Homer's White Mountain paintings were based on a process of "mechanical pictorial assembly," where figures based on drawings were recycled as prints or oils, often in new, reinvented contexts.

4. Compare with Waterman and Waterman 1989 (151–59).

observes the spectacle of the lowlands from the heights—an embodiment of the "magisterial gaze" at rest. Homer's lyric painting is among the earliest documentations of this new sensibility together with the representation of a new form of outdoor activity.

Homer's pictorial celebration of the consolations of mountain climbing carried with it an inherent contradiction. The wider public, confronting the actuality of hiking, frequently experienced mountaineering in a less pleasant manner. A satirical cartoon, published in *Scribner's Monthly* (fig. 112) for September 1871 cleverly marks the tensions generated by the collision of the ideality of art with the reality of climbing. Another satirical drawing by the genre painter David Claypool Johnston, entitled *White Mountain Pedestrians* (fig. 113), further documents the divide between the travails of actual mountain climbing and the imagined blandishments of popular alpinism. An overweight male tourist clings precariously to a tree while his shrewish wife looks on disapprovingly, an inverted duet of Jack Spratt and his spouse.

112. *"Reminiscences of Mount Washington,"* Scribner's Monthly, *September 1871. Courtesy of Dartmouth College Library.*

113. *David Claypool Johnston,* White Mountain Pedestrians, *n.d. Drawing. By permission of the Houghton Library, Harvard University.*

The persistent impact of institutional tourism on representation is suggested by
a lithographed cover for sheet music entitled *White Mountain Echoes* (fig. 114), made
in the mid-1870s. Distilling the practices of landscape tourism into nine seminal
experiences, ranging from the ascent to the Tip Top House to a visit to the Flume,

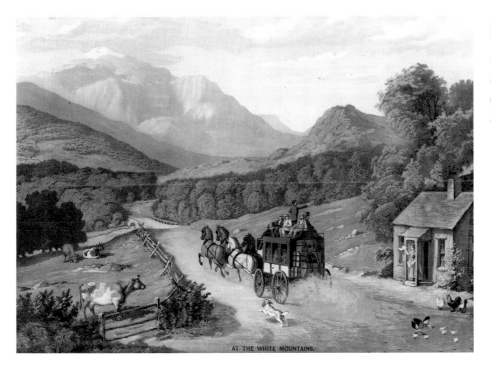

AT THE WHITE MOUNTAINS.

the designer configured an episodic nature liturgy, akin to traditional Christian representations of the stations of the cross. In a manner clearly analogous to the verbal exhortations contained in the Reverend Starr King's guidebook, celebrated White Mountain sites are encoded in a sequence of emblematic images. In this regard, the tourist, as a kind of latter-day pilgrim, is guided through the landscape by prescribed and predetermined canons of behavior and thought. As the popularity of a given site was incorporated into its larger meaning, the content derived from such core experiences of nature formed the basis of later nineteenth-century tourist experience. In disassociating the image from its underlying reality, this mode of pictorial displacement provided still another means of uncoupling art from actuality. The imagery of landscape tourism, as a substitute for experience rather than a record of it, sought to shape a reality independent of the external referent.

In addition to generating a popular appreciation for nature, commercial artists also documented the logistics of travel to and from the White Mountains. Trains and horse-drawn coaches occur frequently as means of access to the White Mountains in both popular and academic art, especially during the last quarter of the century. A chromolithograph from the American and European Chromo Publishing Company of Boston from about 1875 (fig. 115) depicts a stage traversing the Pinkham Notch between Jackson and Gorham. Mount Washington presides majestically over this scene of human mobility and geologic stasis. A humorous dis-

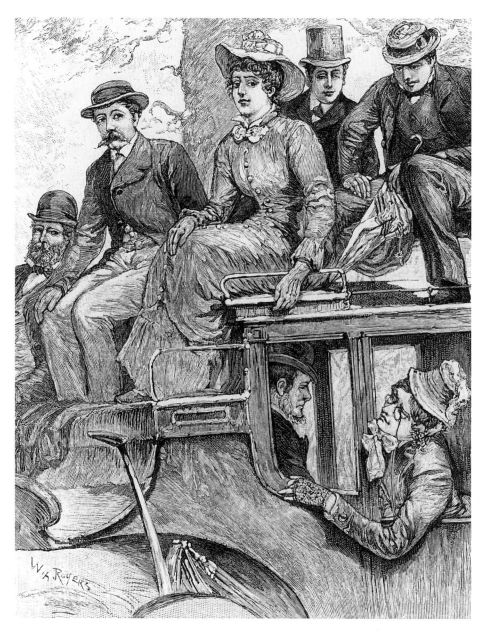

116. Charles H. Gibson, "Alone with All Those Men," illustration for The Heart of the White Mountains, *1882. Wood engraving. Courtesy of Dartmouth College Library.*

course with this popular mode of transportation is found in an illustration (fig. 116) for Samuel Adams Drake's noted guidebook, *The Heart of the White Mountains*, published in 1889. Entitled "Alone with All Those Men," Charles Henry Gibson's re-creation of gilded age tourism, together with its attendant anxieties, introduces a new social dialectic into the canon of White Mountain tourism.

A somewhat later canvas, Enoch Wood Perry's *Pemigewasset Coach* (fig. 117) of circa 1900 is, in point of fact, a nostalgic reflection upon an entirely vanished mode of transportation. As indicated, for example, by the previously discussed view of

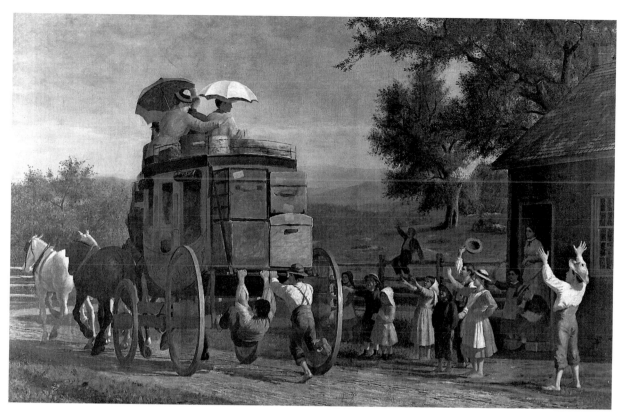

Echo Lake by Edward Hill (see fig. 91), a small-gauge railroad had already traversed the Franconia Notch (the route of the famed Pemigewasset Coach) by the 1880s. Consequently, Perry's image is more a reflection upon the passage of time, than an accurate representation of the passage of travelers to and from the region. *Pemigewasset Coach* is also one of many paintings of the period employing children as major protagonists where, as in so many post–Civil War images, they function as symbols of innocence and loss.[5]

The persistent transformation of the ideal of nature by the culture of tourism is eloquently documented by Otto Grundmann's *Interior at the Mountains* of 1879 (plate 12). A transitional work between the canonic White Mountain view and the "Boston interiors" of the turn of the century, Grundmann's canvas affords a radically revised perspective on the mythic landscape. In this distinctive work the silhouette of the Franconia range, viewed through a bay window of a friend's summer home in Whitefield (operating today as the Inn at Whitefield), is framed by the accessories of genteel tourism: a map of Europe, prints of Roman monuments, sculpture, and wicker furniture. There is the implied presence of a reader who has recently arisen from a chair. A fluttering awning outside the window is contrasted

5. Compare with Hills 1974 (74–79).

117. Enoch Wood Perry, The Pemigewasset Coach, ca. 1900. Oil on canvas, 42½ in. x 66½ in. © The Shelburne Museum, Vermont.

with the quiescent stillness of the room. Grounding his aesthetic in the light-filled interiors of the seventeenth-century Dutchman Johannes Vermeer, Grundmann, the first director of the Boston Museum School, imparted a conscious aura of refined gentility to the setting. An impulse to escape into nature through the open windows is effectively countered by an agreeable assemblage of cultural artifacts. The conceptual space between Grundmann's work and the values embodied in the languid ladies of the celebrated "Boston interiors" is clearly prefigured in this engaging canvas. Displacing the cult of nature with the cult of domesticity, the Boston painters of the fin de siècle ascribed to the female figure values that had formerly resided in nature: purity, virtue, morality, and redemption.

21

From the White Mountains to the Black Hills

Thanks to the nervous rocky west, we shall yet have an American genius.

—Ralph Waldo Emerson, *Journals*

MOUNT Rushmore's colossal usurpation of the cultural and political agenda formerly associated with New Hampshire's Presidential Range marks not only a shift from the metaphoric to the figurative, but another instance of the *translatio imperii* from East to West. This monument to the colonization of nature by culture undertaken by Gutzon Borglum in the 1920s and 1930s eclipsed by far any residual claims the White Mountains had to being "the National Shrine of Democracy." Henceforth the presidential portraits carved on Mount Rushmore rather than New Hampshire's metaphoric mountains would embody the highest imperatives of "nature's nation."

The material subjugation of the mountain at Rushmore—a modernist exemplum of the triumph of technics over nature—finds no parallel in the cultural appropriations practiced in the White Mountains during the nineteenth century.

In a related manner Thomas Starr King's midcentury attempt to restore Mount Washington to its original Abenaki name "Agiochook" ("The Brow of the Great Spirit") finds no equivalent in the Black Hills. Suggestively named in light of the tragic dislocation of the Lakota Sioux from their sacred grounds to the Pine Ridge Reservation during the 1880s, the Black Hills have only recently become a site of contestation between whites and Native Americans.

Finally, the realization of many of the potential meanings of the "Great Stone Face" in Rushmore's stone deities is a megalomaniacal occurrence of romantic anthropomorphism, the White Mountains natural prototype eventuating in the *colossi* of the Black Hills. The mountain as man transmuted into the man as mountain.

In the shadow of these events, it remained only for the White Mountains vainly to emulate the superior culture of the West, a transaction that had already begun during the last decades of the nineteenth century.

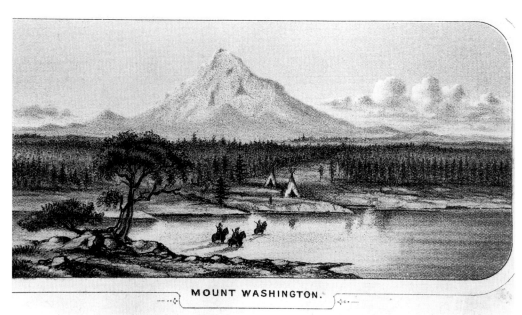

118. *Anonymous,* Mount Washington, *ca. 1875. Lithograph. Courtesy of Dartmouth College Library.*

119. *R. Hinselwood, after R. Swain Gifford,* Mount Hood from the Columbia River. *Illustration for* Picturesque America, *ed. William Cullen Bryant, New York, 1872. Courtesy of Dartmouth College Library.*

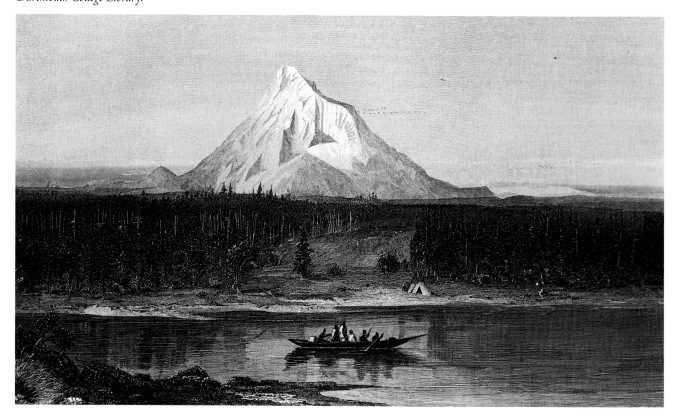

The West Comes East

It is in vain that we look for genius to reiterate its miracles in the old mountains.

—Ralph Waldo Emerson, *Essay on Art*, 1841

COMMERCIAL postcard of *Mount Washington* from about 1875 (fig. 118) affords a sharply hyperbolized vision of improbable alpine heights. A perfectly formed pyramid, the mountain soars above a river and plain dotted with tepees and pointed firs. Mounted Indians traverse a foreground river. Uncharacteristic for the White Mountains, isolated, towering snow-covered peaks are a rarity, and a perusal of the celebrated travel book *Picturesque America* quickly reveals the derivation of the image from an engraving of Mount Hood in Oregon (fig. 119). Looking for all the world as a mountain should, the silhouette of Mount Hood provides a paradigmatic image of sublimity—an icon of western scale and grandeur, confected for eastern delectation. As the most lavishly illustrated travel book of the post–Civil War era, *Picturesque America* introduced Americans to the armchair sublimities of the western landscape through numerous engravings of the Rockies, Sierras, and Cascades.

Among the many White Mountain views found in *Picturesque America* is a wood engraving of the Carriage Road on Mount Washington (fig. 120). Soaring summits enframe deep chasms as the horse-drawn stage clings precariously to the steep mountainside. Projected against the vertical profile of Mount Adams, the scene possesses the look of an alien, imported aesthetic. A comparison, for example, with a contemporary mammoth plate photograph by the renowned western survey photographer William Henry Jackson (fig. 121), reveals the probable inspiration for Fenn's exaggerated view. What poet Robert Frost truculently described in his great epic poem on New Hampshire as the "pitiful reality" of the White Mountains here draws inspiration from a recently imported vision of the distant and dramatic West. Jackson's striking photograph of the San Juan mountains in Colorado was among those intended to document Ferdinand Vandeveer Hayden's Survey of the Rockies of 1870–78 and, as a group, they were the best-known views generated by

120. S. V. Hunt, after Harry Fenn, The Mount Washington Road. *Engraving. Illustration for* Picturesque America, *ed. William Cullen Bryant, New York, 1872. Courtesy of Dartmouth College Library.*

the influential post–Civil War surveys of the American West. First exhibited in the larger eastern cities in the early 1870s, these photographs stimulated the imaginations of Americans seized by the political imperatives of Manifest Destiny. At the same time that they offered a new model of seemingly limitless verticality, they also posed a potentially catastrophic cultural—and by extension commercial—threat

122. *Edward Hill*, Mount Washington Carriage Road, *1887. Courtesy of Littleton Public Library, New Hampshire*

to such traditional loci of the "sublime" as the White Mountains. A letter published in *The Crayon* from the painter Albert Bierstadt, who accompanied Colonel Frederick W. Lander on an earlier expedition to Colorado in 1859, articulated this emergent perception with prophetic clarity: "We see many spots in the scenery that remind us of our New Hampshire and Catskill hills, but when we look up and measure the mighty perpendicular cliffs that rise hundreds of feet aloft, all capped with snow, we then realize that we are among a different class of mountains" (Spencer 1980, 102).

The emergent, operatic western vision not only retroactively influenced the evolving representation of New England scenery—as seen, for example, in Edward Hill's *Mount Washington Carriage Road* of 1887 (fig. 122)[1]—but also provided new pictorial formulas for mountain grandeur. Whereas the sequential compositional mode of the "picturesque" was inspired by theater scenery, the binary aesthetic structure of the more recent model is derived from the practice of the mammoth plate camera to focus sharply on the foreground and cast the background into

1. This interesting painting can also be compared with Joseph M. W. Turner's *Snowstorm, Mount Cenis* of ca. 1810. See Jean-Petit-Matile 1987, fig. 60.

obscure haziness.[2] The resulting formal configuration, seen both in Fenn's engraving and in Jackson's photograph, attenuates the landscape and bifurcates it into roughly equal parts along a dramatic diagonal axis.

Along somewhat related lines, Albert Bierstadt's magisterial six-by-ten-foot canvas of 1870 entitled *The Emerald Pool* (fig. 123) imparts an aura of western grandeur to White Mountain scenery. Executed after the second of three trips to the West, Bierstadt's painting of Mount Washington from the vantage of the famed pool at the base of Pinkham Notch affords a theatrical vision of turbulent clouds, writhing trees, and a distant summit. The baroque operatics of this work, as well as its emphatic pastiche quality, contrast strongly with the artist's earlier White Mountain views (e.g., plate 6) in which a quasi-photographic realism provided the dominant aesthetic. This curious and unique instance in Bierstadt's oeuvre of the superimposition of Rocky Mountain scale on New England scenery belies a San Francisco exhibition notice of 1871 that claimed that the painting was "a faithful

123. Albert Bierstadt, The Emerald Pool, *1870. Oil on canvas, 76½ in. x 119 in. Courtesy of the Chrysler Museum, Norfolk, Virginia.*

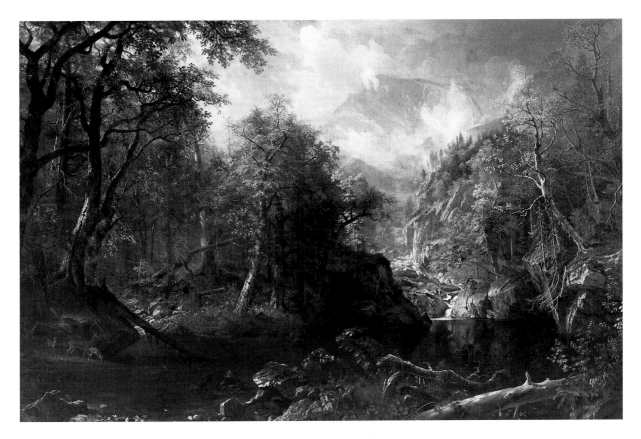

2. Oliver Wendell Holmes perceptively described the new aesthetic of photography in commenting on the work of photographer Carleton Watkins as "Clear, yet soft, vigorous in the foreground, delicately distinct in the distance like Chinese landscapes" (Naef 1975, 70).

transcript of an actual scene—combining perfect truth with freedom, largeness and sentiment." For his own part, Bierstadt claimed that he "never had so difficult a picture to paint as the White Mountains subject of the Emerald Pool—my artist friends think it is my best picture and so do I" (Hendricks 1974, 196).[3]

Not all East Coast artists appreciated or appropriated the new scale of the western landscape with a facility equal to that of the foreign-born Bierstadt. The Hudson River School painters Worthington Whittredge, Sanford Gifford, and John Frederic Kensett traveled west in 1870 and were clearly intimidated by the prospect of representing the Rocky Mountains. As Whittredge presciently remarked of one of his traveling companions: "When [Gifford] accompanied Kensett and myself to the Rocky Mountains he started fully equipped for work, but when he arrived there, where distances were deceptive . . . he left us and his sketch book in cold blood in the midst of inspiring scenery. He had done literally nothing in the way of work during a whole summer spent in a picturesque region" (Trenton 1983, 225).

Alienated by the vastness and alterity of the western terrain, Kensett complained of "landscapes without a single patch of bright green . . . mountains rising up in ragged brawny masses without the apology of color for their nakedness" (Trenton

124. William Henry Jackson, Mountain of the Holy Cross, *1873. Photograph. Courtesy of Dartmouth College Library.*

3. See also Campbell 1981 (14–23).

1983, 58). In confirmation of Bierstadt's assessment, neither Gifford nor Kensett produced major landscapes on their western sojourn.[4]

One of the most instructive examples of the westering course of "sublimity," and the consequent retrograde efforts by easterners to salvage some of its lingering vestiges, can be found in a comparison of William Henry Jackson's celebrated photograph of the *Mountain of the Holy Cross* (fig. 124) with the work of the New England photographer H. C. Peabody (fig. 125). One of the most influential images of the nineteenth century, Jackson's remarkable photograph inspired works as diverse as the paintings of Thomas Moran and the poetry of Henry Wadsworth Longfellow (Kinsey 1990, 24–36). Certainly no image of the later nineteenth century more dramatically documented the migration of "sublimity" to the "distant West." By contrast Peabody's doctored photograph of a snow cross on Mount Lafayette suggests

125. *H. C. Peabody,* Snow Cross on Mount Lafayette, *ca. 1890. Photograph. Courtesy of Dartmouth College Library.*

4. A similar response is found in Francis Parkman's celebrated 1848 account of approaching the Rocky Mountain front in Colorado: "not one picturesque or beautiful feature; nor had it any of the features of grandeur, other than its vast extent, its solitude and its wilderness" (1982, 105–6).

126. *Unknown photographer,* Snow Cross on Mount Lafayette, Sugar Hill, White Mountains, N.H., *ca. 1905. Postcard. Courtesy of Dartmouth College Library.*

a meretricious effort to recoup for the White Mountains the vestigial remains of a relocated cultural "sublimity."

As a visible manifestation of God's overt signature in the landscape, the Mountain of the Holy Cross was interpreted as a natural icon of the Christianized "sublime" in America. An emblem of nineteenth-century transcendental nature reverence and a glorification of the new landscape, Jackson's photograph resonated widely throughout the last quarter of the century. Expressing his preference for the new landscape dispensation, Moran once remarked: "Eastern mountains, I have no use for. The Alleghenies are mountains to be sure, but they are covered with trees. The others in the East are but foothills" (Trenton 1983, 71).

With a near certain predictability, Jackson's celebrated image continued to engender fictive snow crosses in the White Mountains. Even the most jaded observer, inured to the blandishments of modern advertising, would be astonished at the sizable proportions to which the cross had grown in a postcard view of the early twentieth century (fig. 126). Such palpable image manipulation, a form of obsequious truckling to the Rockies, reveals all too clearly the altered status of the White Mountains during the period. With the opening of the West, efforts to

recover a minimal aura of "sublimity" from a landscape no longer capable of bearing the older freight of meaning strike the modern observer as more pathetic than humorous. Scenery that formerly had signified the American sublime was revisioned to resemble the image of an imported West that, in and of itself, was more artifact than fact. Vainly attempting to turn the irresistible tide of cultural evolution, one eastern apologist noted: "It is singular that, according to this writer's impression, a White Mountain summit gives a fairer idea of the immensity of space than the highest of the Rocky Mountain peaks. From the highest of the Rocky Mountains, the view unfolded resembles a desolate ocean; from the White Mountains it is an unearthly paradise" (Trenton 1983, 72).

Confronted with these cultural machinations, it is little wonder that Moses Sweetser, who in 1879 published the first White Mountain guide book to employ photographs (see fig. 24), shifted the imagery of tourism from nature to machine technology while simultaneously deploring the excesses of his fellow eastern image makers. With clear and certain reference to the pictorial legerdemain of *Picturesque America*, Sweetser noted that his volume had "at least the merit of accuracy since its views were taken by photography—so that no false idealization or vulgar hyperbole can intervene to belie the aspect of scenery and prepare the traveler for grave disappointments" (1879, 4). This verbal disclaimer, as well as Sweetser's marked preference for the representation of trains and trestles over mountains and streams, reveals an aspect of the cultural processes whereby the inherent forces of nature were transferred onto machine technology in the ongoing dialectic of the age. The machine in the garden had yielded to a garden for the machine.

Even this final lease on "sublimity," afforded by the advent of technology in the White Mountains, however, could not stay the tides of cultural transformation. By the last quarter of the nineteenth century, the celebration of nature (together with the definition of the national landscape) would henceforth be largely a matter for western artists. As for the White Mountains at the turn of the century, Oliver Wendell Holmes summarized their altered physical and cultural status with characteristic pungency: "the mountains and cataracts which were to have made poets and painters have been mined for anthracite and dammed for water power" (Miller 1993, 9).

A distantly related pictorial reflection upon the conditions of cultural desuetude of the eastern mountains can be seen in pendant paintings by Cole's former White Mountain traveling companion Henry Cheever Pratt. Entitled *Night* and *Dawn* (figs. 127 and 128), these paintings were executed in 1892 and afford insight into the perceived eclipse of the White Mountains by the new image of the West. *Night* con-

tains a view of a generic White Mountain landscape, complete with a Federal style
country house and a New England church steeple. By way of contrast, *Dawn* is con-
structed as a Southwestern landscape including a view of a Spanish mission
church. Again, the emerging light of the West is understood to succeed the dark-
ness of the East, providing a natural analogue for what the turn-of-the-century

128. *Henry Cheever Pratt,*
Dawn, *1892. Private
collection.*

writer Owen Wister referred to as "the pale decadence of New England"—or, in the
equally apt formulation of a critic of the time—"the painted-out . . . North."[5]

5. A related early modernist painting is Marsden Hartley's *Last of New England—The Beginning of
New Mexico* of ca. 1920 (The Art Institute of Chicago). Hartley, however, eventually returned to his
native Maine during his late career. Compare with Kammen 1992, fig. 2–60. See also Burns 1995
(21–32).

129. *Albert Bierstadt,*
White Mountains, *ca.*
1865. Oil on paper, 11 in. x
15 in. Courtesy of Thomas
Gilcrease Institute of
American History and Art,
Tulsa, Oklahoma.

In addition to the persistent cultural erosion of the image of the White Mountains, the actual landscape was subjected to increased depredations. By the turn of the century, the region was the most heavily logged in America. Extensive clear cutting and the leaving of slash led not only to further physical disfigurations but also to devastating fires that swept the mountainsides.[6] As early as the 1860s Bierstadt had documented these frequent conflagrations with an unusual painting depicting a raging forest fire (fig. 129). The bright coloration and active brushwork of this sketch render it one of Bierstadt's most engaging and enigmatic paintings. For what purpose was it created? A probable answer lies in another of Bierstadt's oil sketches, a form of outdoor still life entitled *Maple Leaves, New Hampshire* (fig.

6. Compare with Slade, deploring the depredations of logging at the end of the nineteenth century: "The denudation of the primeval forest begun during the past year or two, and still continuing, with all its serious consequences, such as diminished streams, barren mountain sides, districts rendered unsightly, immense uncouth saw mills . . . seems an unwise and uncalled for evil. If the . . . proprietors of inns and lodging houses, whose interests are most at stake . . . are powerless to prevent such vandalism, what can be done?" (1895, 95).

130) and dated 1862. Employing the salient emblem of a man-made stump to symbolize humanity's destructive penchant, he enframed it with new-growth maple saplings to suggest the processes of rebirth and regeneration. In addition to documenting the presence of logging in the region, Bierstadt's paired paintings may also be viewed in a broader context as references to the conflagration of the Civil War and to function as a pictorial allegory of death and life.

Another classic instance of the simultaneous cultural and physical erosion of the White Mountains after the turn of the century is afforded by a calendar illustration of 1911 that served as an advertisement for the New Hampshire Fire Insurance Company (fig. 131). Depicting a Gibson Girl flirting with the Old Man of the Mountain, it reveals not only the commercial exploitation of this sacred symbol, but also the loss of meaning formerly ascribed to it. Surely Nathaniel Hawthorne would have turned in his grave if confronted with this pictorial blasphemy. Even Daniel Webster, who first associated the Great Stone Face with the idea of advertising, could certainly not have anticipated the extent to which the image would be exploited during the early twentieth century.

130. Albert Bierstadt, Maple Leaves, New Hampshire, 1862. Oil on canvas, 13½ in. x 19¼ in. Courtesy of Indiana University Art Museum, Morton and Marie Bradley Memorial Collection.

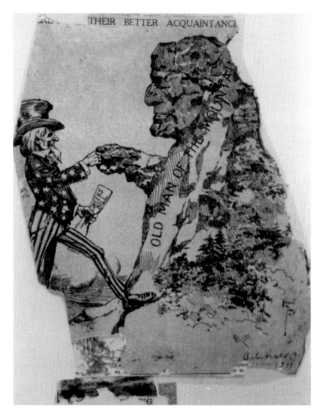

ABOVE LEFT

131. Anonymous artist, A New Hampshire Cloud, *illustration for New Hampshire Fire Insurance Company calendar, 1911. Courtesy of Dartmouth College Library.*

ABOVE RIGHT

132. Anonymous artist, Making Their Better Acquaintance, *illustration for the* Boston Herald, *February 14, 1911. Courtesy of the Society for the Protection of New Hampshire Forests, Concord, New Hampshire.*

Paradoxically, 1911, the date of the calendar, was also the year of the Weeks Act, the legislation that created the White Mountain National Forest, the first national preserve east of the Mississippi. A cartoon from the *Boston Herald* of February 14, 1911 (fig. 132), depicts Uncle Sam holding a copy of the Weeks Bill and shaking hands with the Old Man of the Mountain. Referring to the recent passage of the congressional act that established the White Mountain National Forest, the cartoon also draws upon the lingering traditions of emblematic anthropomorphism associated with the Great Stone Face since its discovery in the early nineteenth century.

23

The Modern Vision

"ARS POTENTIOR NATURA"

The mountain calls for courage on the part of those who are fated to live with it, for it is at all times indifferent to them, it asks no trust and no sublime hope against its cruelty, and like all great places on earth calls for great sacrifice.

—Marsden Hartley, "On the Subject of the Mountain," 1932

WHEN George Inness painted a view of Mount Washington (fig. 133) shortly after his return from Europe in 1875, he represented the old mountain in a new manner. Employing a foreground of grazing cows, together with signs of an ancient orchard and the spire of a church, Inness's view invests the scene with a patina of pastoral harmony. A color scheme composed of light pinks and blues is deliberately employed to form a misty veil of atmosphere that softens natural contours and embodies a Barbizon-like mood of tranquility and civilized usage. The summit of Mount Washington rising in the distance is serenely adumbrated in the mood of the domesticated foreground. Eschewing the gritty resonances of traditional images of the Presidentials, this dulcified view communicates few of the meanings formerly ascribed to the mountain. Rather, for all intents and purposes, the once numinous mountain has been defanged by European aesthetics and divested of its ability to evoke traditional spiritual meaning. At one level, the White Mountains have been revisioned by Inness to resemble the Forest of Fontainebleau. The palpable atmospherics, the preference for pastel coloration, and the densely pigmented surface of the canvas denote the practices of Barbizon aesthetics. As previously noted, this shift from symbolic form (the climax architecture of nature) to a more prosaic view is congruent with the aesthetic direction taken by French landscape painters toward the middle of the nineteenth century. In Inness's genteel vision the deity of American pantheism is sacrificed upon the altar of French aesthetics. As the celebrated clarity of north country light is diffused by French

133. George Inness, Mount
Washington, *ca. 1875. Oil
on canvas, 19⅝ in. x 29½
in. Meredith and Cornelia
Long Collection, Houston,
Texas.*

painterliness, Mount Washington is spiritually depotentiated by an imported pastoral vision. In his journal, the artist affirmed his intentions and preferences: "The civilized landscape . . . I love it more and think it more worthy of reproduction than that which is savage and untamed. It is more significant" (1917, 148).

On another remarkable occasion Inness painted the Intervale at North Conway without any direct reference to the surrounding mountain environment. Entirely suppressing the canonic view of Mount Washington by enveloping the summit in a cloak of clouds, Inness produced a study of weather and atmosphere rather than mountain glory. Echoing the advice of a contemporary artist in counseling a younger painter, Inness bodied forth a manifesto of bucolic serenity: "Do, for heaven's sake, paint a field, a meadow, a flat, a swamp—anything without that everlasting stream and that inevitable hill" (Cikovsky 1993, 86). A follower of the mystic divine Immanuel Swedenborg, Inness also sought, for heaven's sake, to relocate paradise in the pastoral lowland.

By way of added significance, Inness's optical and aesthetic approach to mountain scenery also served as a major precursor to the emergence of impressionism in

late nineteenth-century America. John Joseph Enneking's *Mount Washington* of 1895 (fig. 134), for example, enlists the French aesthetic to delineate the fabled mountain from the vantage of Green's Hill in Jackson. Among the earliest *plein-air* painters, Enneking was one of a handful of American impressionists to work in the White Mountains. Characteristic of the New England approach to the international French style, Enneking employed a loaded brush, high pitched color, and active brushwork, but did not strive to dissolve landscape forms. As with most American artists of the era, the topographic impulse, and the desire to preserve the God-given landforms, overrode the atomizing imperatives of the French movement.

The Ashcan School painter William Glackens employed impressionist brushstroke and coloration under the broad rubric of early modernism. His view of *Conway Lake, New Hampshire (Walker's Pond)* (fig. 135), dated 1923, affords an agreeable and informal view of summer tourism in the White Mountains. Significantly, the foreground bather and boathouse are rendered with greater pictorial focus than the distant profile of Mount Washington. Known as the "American Renoir,"

134. John Joseph Enneking, Mount Washington from Green's Hill in Jackson, New Hampshire, 1895. Oil on canvas, 22¼ in. x 30 in. Private collection.

135. *William Glackens,*
Conway Lake, New
Hampshire *(Walker*
Pond), *ca. 1923. Oil on can-*
vas, 22 in. x 32 in. Courtesy
of the Hood Museum of
Art, Dartmouth College.

Glackens imparted a vibrant aura to the scene through dappled light, high-pitched coloration, and active brushwork. Glackens's summer idyll forms an interesting comparison with a rare winter scene of the identical subject by the little-known late-nineteenth-century Boston painter A. M. Gregory (fig. 136). Influenced by Dutch baroque snowscapes rather than French art, Gregory is among the few nineteenth-century painters to depict the pleasures of winter recreation in the White Mountains.

An artist whose early landscapes lie intermediary between impressionism and post-impressionism is the little-known Boston painter E. Ambrose Webster. His scintillating canvas of 1914 entitled *Tamworth, New Hampshire* (fig. 137) is a lively, decorative work that borders on fauvism with its striking palette of high-keyed violets, blues, and greens. A turn-of-the-century student at the Académie Julian in Paris, Webster brought an academic commitment to verism into an unstable alignment with his own idiosyncratic love of strident, uncomplementary color. His startlingly intense coloration compelled one contemporary critic to revise a celebrated criticism of Whistler by John Ruskin: "at close quarters some of his pictures appear a blur—a paint box spilled onto a canvas" (*Jamaica Times* 1906).

136. *A. M. Gregory,* Winter Sunset, Walker's Pond, Conway, *1886. Oil on canvas, 11¼ in. x 19¾ in. Private collection.*

137. *E. Ambrose Webster,*
Tamworth, New
Hampshire, *1914. Oil on
canvas, 28½ in. x 38½ in.
Courtesy of Babcock
Galleries, New York.*

Claiming a position somewhere between the symbolic forest interiors of the American romantics and the resonant woods of Scandinavian symbolist painters, Webster's snowscapes also anticipate several modern and postmodernist paintings of the White Mountains during the winter season. In this regard a critic, commenting on the artist's hardy *pleinairism*, observed that "he has found his winter subjects in the wilds of New Hampshire, painting directly out of doors with the thermometer often many degrees below zero" ("Praise for E. A. Webster" 1914).

The first artists consciously to impose modernist European aesthetics upon the White Mountains were William and Marguerite Zorach, who spent the summer of 1915 at Randolph, at the foot of the Presidential Range. Only recently returned from Paris, the Zorachs brought to the region an eclectic program of fauvist expression and a cubist structure gleaned from experimental aesthetics. Like most American modernists of the first generation, the Zorachs were compelled to seek relief from the burdens of positivist ideology—the brave new world of science, technology, and urbanism—by periodic retreats into the mysteries of American nature. William Zorach's *Plowing the Fields, New Hampshire* (plate 13) is a characteristic example of several symbolic landscapes in oil and watercolor executed at this time. Composed of broadly outlined shapes and vivid non-naturalistic colors, Zorach's canvas depicts the region as a primitive Arcadia in which archetypal nudes (derived from the bucolic pastorals of Cézanne and Matisse) work the land. Drawing somewhat freely upon the agrarian myth and the literary trope of the American Adam, Zorach viewed the mountains as a fallen Eden, recovered by human labor and the agency of the sacred plow. A Paradise lost, the New England landscape is here subjected to a modernist revisioning both ideationally and aesthetically. The transcendent world of the romantic painters has undergone transformation from the sacred to the secular as Thoreau's "New Hampshire, everlasting and unfallen" becomes the site of redemption, or alternatively, the origin of "the fortunate fall." Zorach's landscape, no longer a window on the "real" world, is a highly subjective and psychologically charged interpretation of it. In the decorative patterning and coloration of *New Hampshire*, resemblance to the actual world is replaced by the sovereign imperatives of the artist's liberated imagination.

Another symbolist landscape from the same period is Peter Blume's *Winter, New Hampshire* of 1917(fig. 138), which also explores the experience of rural life in the Granite State. Executed in a deliberately neoprimitive style, Blume's work prefigures the hard-edged geometries of precisionism and other quasi-abstract styles of the 1920s. Like most modernists who worked in New Hampshire, Blume responded to the landscape both subjectively and eccentrically. Filtered through the

lens of the artist's sensibility, the land becomes the point of departure for individual aesthetic expression rather than the locus of a collective response to nature. As over and against the wider cultural imperatives of the nineteenth century, the modern movement cannot be viewed as a collaborative effort with site-specific goals. Every twentieth-century artist who worked in the region brought a discrete freight of visionary baggage that he or she freely imposed upon the north country.

During the middle and late 1920s John Marin made frequent artistic incursions into the White Mountains. Withdrawing periodically from the city into nature, Marin produced a remarkable series of studies of such diverse locales as Mount Chocorua, Dixville Notch, and the Franconias. Synthesizing elements of cubism, futurism and expressionism, he imparted new aesthetic strategies to the depiction of the traditional landscape. Viewing nature as the city, Marin represented the mountains as a repository of modern energies. Not since the early canvases of

138. Peter Blume, Winter, New Hampshire, 1917. Oil on canvas, 20¼ in. x 25 in. Courtesy of the Museum of Fine Arts, Boston, bequest of John T. Spaulding. Reproduced with permission. © by the Museum of Fine Arts. All Rights Reserved.

Thomas Cole had the White Mountains been viewed as the locus of such force. Pulsating with a dynamic flux that suggests nature's forms and processes, the artist's watercolors and oils resonate with organic and aesthetic power.

In his copious writings Marin disclosed his perception of the mountains as "weights pushing and pulling" and as "fighting and being fought against" (Marin 1970, 161). Whether shaped by an awareness of modern plate tectonics or the art of the European avant-garde, these views also seem like metaphoric projections of the painter's own artistic struggles. Oscillating between representation and abstraction, the images struggle to emerge from a dense matrix of formalist experimentation. Employing the formal language of cubist and fauvist experimentation to reawaken the power of the land, Marin revisioned the White Mountains as a modernist wilderness. For the most part, however, a formalist rather than a spiritual point of view animates these works.

With regard to the Franconia region in general and the image of Mount Lafayette in particular, Marin appears to have been less certain of his priorities, and unable to resolve the imperatives of aesthetic experimentation with a landscape of mystical power. In the watercolor titled *Franconia Range, White Mountains, No. 1* of 1927 (fig. 139), the artist strove as always to relate his forms to the internal structure

139. John Marin, Franconia Range, White Mountains, No. 1, 1927. Watercolor on paper, 13¾ in. x 18⅛ in. Courtesy of the Phillips Collection, Washington, D.C.

140. *John Marin*, Rainbow, Franconia Range, White Mountains, *1924.* © 2000 *by the Estate of John Marin/Artists Rights Society (ARS), New York.*

of the picture, subordinating the unity of the site to the logic of the composition. Tilting the perspective and shifting his point of view, he created a self-contained pictorial emblem of Mount Lafayette grounded in the geometric and planar structure of the design. A resurgent triangle (Thoreau compared Mount Lafayette with the Great Pyramid of Egypt) rising above the plain, the mountain is enframed by the surrounding flux of landscape forms. Yet the dramatically back-lit summit of the mountain, illumined by shafts of radiant light, registers an aura of neoromantic sublimity, as if the artist were attempting to reconsecrate the landscape. At some level of Marin's consciousness, the old mountains were still capable of working their miracles.

A related, albeit slightly earlier view of Lafayette, entitled *Rainbow, Franconia Range, White Mountains* (fig. 140), invokes another well-traveled romantic symbol to denote the Creator's covenant with the nation. Functioning as a fluid arc in a quasi-abstract composition of diagonal shapes, the colorful rainbow also serves to render the landscape luminous and mysterious. In retaining this link to a spiritualized world, Marin remained committed nonetheless to the creation of an autonomous art object. "When a pictive edge has been reached," he claimed in a critical statement, "the story is told" (Marin 1970, 174).

Marsden Hartley's sojourn at Sugar Hill in the Franconia region during the summer and fall of 1930 appears even more emphatically to have been an attempt

141. Marsden Hartley, Mountain, Number 21, 1929–30. Oil on canvas, 34 in. x 30 in. Courtesy of Whitney Museum of American Art.

to make modernist aesthetics yield to the core of "material experience." His goal in the works produced at this time, Hartley claimed, was "to uncover the principle of conscious unity in all things," and to witness the "living essence present everywhere." Falling between his paintings of Provence, dating from 1927, and the work after the later retreat to his native Maine, Hartley's White Mountain oeuvre represents a critical transition from buoyant early modernism to the stable, brooding forms of his late style. Rejecting the sober palette of the Maine works, Hartley's view of Mount Moosilauke (fig. 141) affords a colorful and emblematic vision of mountain grandeur. Though he complained that the region was overrun with tourists ("Yankee hustlers and scenery hounds") and that by the end of the season he was "chilled psychologically" (Haskell 1980, 81), Hartley found in the mountain a

significant form that could mediate between his early inspiration, Cézanne's Mont Sainte-Victoire, and the artist's own late views of Mount Katahdin. Claiming that he was the only American artist that "really understands the mountains both as fact and symbol" (Hokin 1993, 96), Hartley's centered icon affords an emblematic vision of autonomous nature. His isolated conical summit surging upward mediates between earth and heaven, as nature is reanimated by his symbolist-inspired vision.[1]

Hartley's search for a solitary archetypal symbol of mystic power, unlike Marin's process art, provides a significant rupture with normative modernist aesthetics and ideology. Stable, fixed, and weighted, Hartley's mountain embodies some as yet undefined spiritual essence. Now bearing the weight of history and despoliation, rather than serving as a metaphor for a young and uncorrupted nation, the mountain rises to new levels of spiritual meaning. As exhausted as the mountains themselves, Hartley avowed at the end of the summer that it were "as if Siberia were nothing to what these hills have become of my soul—they are simply full of chimeras and spectres" (Hokin 1993, 73). Responsive to some undefined yet lingering vestiges of White Mountain gothicism, the artist beat a hasty retreat to New York City.

The hermetic image of *Mount Washington*, of 1934, by the Canadian painter Lawren Harris (fig. 142) closes the circle initiated by the early romantic wilderness views of Thomas Cole. Transforming the venerable mountain into an isolated Himalayan-like peak and inflecting it with an aura of theosophic musings (spiritual and cultural regeneration from the North), Harris restored the mountain to its primal origins in cultural and geologic time. For one of the last times, the White Mountains, in a *succès de l'arrière-saison*, were to provide an artist with mystical inspiration. In addition to viewing the symbolist landscapes of Hartley and Harris as modernist projects, they can also be understood as a final stage of northern romantic landscape painting.[2]

Among the many European artists who visited the White Mountains during the last two hundred years, the Frenchman Fernand Léger was the first to bring thoroughly inflected modernist vision to bear on the subject. In *La Forêt* (fig. 143), painted during a sojourn in the Franconias during the summer of 1942, Léger imposed his abstract, cubist-based aesthetic on the landscape. Striving to represent the mechanical workings of nature through his signature "machine-aesthetic," Léger

1. The Swiss symbolists Giovanni Segantini and Ferdinand Hodler were both strong influences on Hartley. Cf. his essay: "On the Subject of the Mountains: Letter to Messieurs Segantini and Hodler" (1932) reprinted in Hokin 1993 (135–37).

2. Compare with Appelhof 1988 (24).

142. *Lawren S. Harris, Mount Washington, 1930. Oil on masonite, 18 in. x 22 in. Courtesy of the Hood Museum of Art, Dartmouth College.*

deployed forms in conformity with industrial rather than natural organization. The resultant image is an abstract equivalency for a forest interior that constitutes a visual antithesis to normative realist landscapes. In this determined imposition of modernist aesthetics upon the White Mountain landscape, the artist's fragile sensibilities were affronted by the appearance of the tangled maze of the American forest. In a letter to a friend, he wrote: "I was struck by the difference between the American forest and that of Normandy. At home, wood is precious and the peasant gathers each branch like he picks up each nail. In the American forest tree trunks are left to rot. No one uses them. I tried to express that in this canvas" (Sekota 1988, 52).

The calculated formal order of the Frenchman's canvas, however, suggests little of the dense, organic undergrowth of the north country forests. Without the ver-

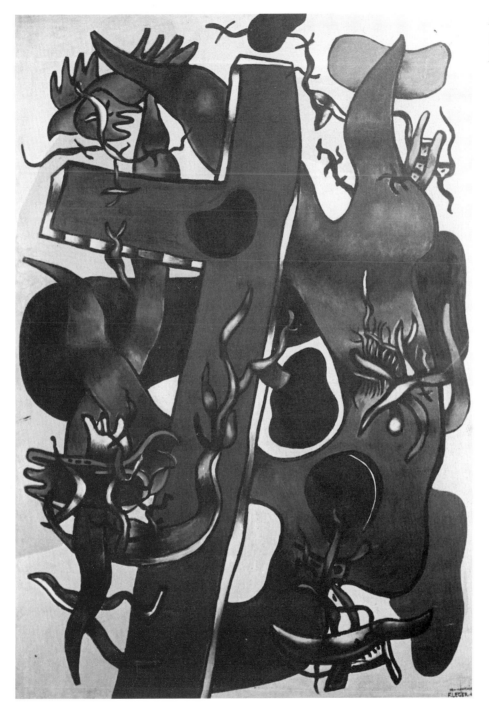

143. *Fernand Léger, La Forêt, 1942. Oil on canvas. Private collection.*

144. *Carleton Plummer,*
Mount Washington
Climber, Rest from the
Climb, *1985. Watercolor.*
Private collection.

bal signifiers of the title and the artist's comments, an observer would be hard pressed to discover any visual equivalent of the New Hampshire forests in Léger's metallic shapes.

Among contemporary artists working in the White Mountains, the noted watercolorist Carleton Plummer depicts a mountain climber contemplating the view of Tuckerman Ravine (fig. 144). A form of pictorial homage to America's greatest painter in watercolor, this retrospective view offers an inviting comparison with a painting by Winslow Homer from over a century earlier (cf. fig. 111). Consciously basing his work on Homer's style and subjects (he has a studio over-looking the coast of Maine), Plummer is among the many postmodern artists engaging in an extended pictorial discourse with America's art historical past. In exploring the nature of an image's connection to its source, the artist poses the rela-tional question of an original work of art and the modern representation of it. Similar scenes of hunting, fishing, and climbing continue to form the basis of Plummer's protean vision of the New England land and seascape.

The works of the young New Hampshire painter Blair Folts (fig. 145) also display a strong penchant for relating to the mountains physically as well as spiritually. Viewing the White Mountains less as scenery than as a locus of personal adventure, Folts engages with them as an artist and as an athlete. An avid hiker and ice climber, she depicts the region from the vantage of a skilled mountaineer. In short, her aggressive neo-expressionist paintings of such traditional sites as Tuckerman Ravine and Boott Spur function both as pictorial metaphors for, and documentation of, her own physical encounter with the environment. The dizzying perspectives produced by Folts are those experienced by an active climber rather than a lover of scenery. In addition, her preference for scenes of winter alpinism further suggests the seasonal preferences and usages of the twentieth century, when snow sports have become more prominent than summer activities. Folts, like many contemporary artists, responds to the mountains primarily as an arena for self-actualization rather than as a place for the passive viewing of nature. Preferring the

145. *Blair Folts*, Boott Spur, *1988. Acrylic with ash, oil, beeswax on canvas, 40 in. x 52 in. Artist's collection.*

summits to the valleys, she absorbs the viewer into a vertiginous experience of the mountain world together with the arduous labor of scaling those peaks in winter. Reflection, self-renewal, and spiritual growth, however, remain, as in the past, the ultimate goal of her artistic and physical encounter with the White Mountains.

In another connection such contemporary painters as Plummer and Folts parallel the literary efforts of the well-known author John Updike, several of whose short stories have been set in the White Mountains.[3] Employing the sport of skiing as a vehicle for self-awareness, Updike has written tales in which the major protagonists—usually female—discover their identities and competence in encounters with snow and slope. In a manner related to these more recent paintings, Updike views the White Mountains as a "gymnasium for vigorous physical tests and challenges" (Waterman and Waterman 1989, 560).

The Boston realist painter George Nick also depicts the White Mountains from a resolutely contemporary perspective. Painting the landscape from a glassed-in studio located in the back of a pick-up truck, Nick frequently represents roadside views of the White Mountains. *Over Pemigewasset River* of 1986 (plate 14) is a strikingly actualized image of the Franconia range in winter. Painted *en plein-air*, so to speak, Nick's view approximates that of a motorist experiencing the landscape through a windshield while speeding by. Ice blues, warm pinks, and violets are employed to elicit the dominant hues of the season while the low angle of vision is congruent with most travelers' experience of the region. Like Robert Frost, who faulted the White Mountains for not being "quite high enough," Nick created a mundane roadside view that stands in marked contrast to the nineteenth century's celebrations of mountain glory.

Two contemporary New Hampshire artists whose works suggestively challenge the mythic image of the White Mountains as wilderness refuge are the tapestry weaver Suzanne Pretty and the painter Louise Hamlin. Both artists are concerned with contemporary intrusions of industry into the forest and mountains of the region. Pretty's brilliantly crafted tapestry *Fragmentation* (plate 15) positions the fractured images of a bulldozer and a logging truck against a carpet of lush forest greenery. Employing a medium typically associated with the artisinal and the domestic, Pretty assaults the viewer's sensibilities by producing a cognitive dissonance between the violence of machinery and the beauty of the northern forests. The product of her hand-operated loom, the elegant tapestry forms a jarring contrast with the pilotless onrushing bulldozer. In the formulation of the curator of a

3. See Updike 1966 (191–202) and Updike 1972 (98–108).

recent exhibition of Pretty's work: "Her tapestries . . . are not sentimental elegies for the lost pastoral landscape but rather are sobering reminders of the economic forces that shape, and sometimes permanently alter, the look of the land" (Schlegel 1998, 12).

Somewhat more ambivalent are the industrial landscapes of Louise Hamlin. Her steaming, belching, nocturnal image of the *Boise Cascade* (fig. 146) lumber mill, a plant located at Rumford, Maine, near the eastern border of the White Mountains, resonates with evocations of the romantic technological-sublime. Simultaneously attractive and repellent, Hamlin's painting of man-made mountains of logs surmounted by plumes of smoke, and illumined by artificial and reflected light, suggest the ceaseless operations of extraction, processing, and production. "Mill yards steamed and shifted," the artist recalled, "as invisible workers

146. *Louise Hamlin*, Boise Cascade, *1991. Oil on canvas, 36 in. x 46 in. Private collection.*

lined a vast network of functions, wood and water became pulp and smoke, and the New England night creaked and groaned and smelled as nowhere else" (Schlegel 1998, 13).

As over and against the postmodern polemics of Pretty and Hamlin, the paintings of Robert Jordan provide a hopeful closure to this study of the evolving imagery of the White Mountains. The sensuously evocative canvas entitled *The Trail to Champney Falls* (plate 16) speaks of the capacity of the much used and abused forests and mountains to regenerate themselves in the face of the complex and continuing intrusions of history. Invoking the naturalistic style of the past century and paying homage to the spiritual father of the North Conway painters, Jordan locates the viewer on a path that leads to the picturesque cascades, named after the doyen of the White Mountain painters. Beyond the falls a hiking path leads to the summit of Chocorua, the mountain that generated the first excited stirrings of the romantic imagination. A site redolent of the art and history of the region, the image of Champney Falls affirms the White Mountains' continuing capacity to evoke the sentiment of landscape. Jordan's second-growth woodland, illumined by light falling through tiny apertures in the trees, elicits historic associations while remaining a place of elusive mystery, recalling T. S. Eliot's verses from the *Four Quartets*:

> We shall not cease from exploration
> And the end of all our exploring
> Will be to arrive where we started
> And know the place for the first time.
> (240–44)

WORKS CITED

INDEX

WORKS CITED

Allen, Gay Wilson. 1981. *Waldo Emerson: A Biography*. New York: Viking.

Anderson, Nancy K., and Linda S. Ferber. 1991. *Albert Bierstadt: Art and Enterprise*. New York: Hudson Hills.

Anonymous. 1857. Letter. *The Crayon* 4: 318.

Appelhof, Ruth S. 1988. *The Expressionist Landscape: North American Modernist Painting 1920–1947*. Seattle: Univ. of Washington Press.

Appleton and Co. 1857. *Appleton's Illustrated Hand Book of American Travel*. New York: Appleton and Co.

Arkelian, Marjorie Dakin. 1980. *Thomas Hill: The Grand View*. Oakland, Cal.: Oakland Museum of Art.

Arnot Art Gallery. 1966. *William H. Bartlett and His Imitators*. Elmira, N.Y.: Arnot Art Gallery.

Barrell, John. 1980. *The Dark Side of the Landscape: The Rural Poor in English Painting, 1730–1840*. Cambridge: Cambridge Univ. Press.

Bath, Michael. 1992. *The Image of the Stag: Iconographic Themes in Western Art*. Baden-Baden: V. Koerner.

Belknap, Jeremy. 1777. "Description of the White Mountains in New Hampshire." *London Magazine: Or Gentleman's Monthly Intelligencer*, 109–13. London: J. Wilford.

———. [1784] 1876. *Journal of a Tour to the White Mountains in July, 1784*. Edited by Charles Deane. Boston: Massachusetts Historical Society.

———. [1793] 1970. *The History of New Hampshire, with a New Introduction by John Kirkland Wright*. Reprint. New York: Johnson Reprint Corp.

Bermingham, Ann. 1986. *Landscape and Ideology: The English Rustic Tradition, 1740–1860*. Berkeley: Univ. of California Press.

Betsky, Celia. 1985. "Inside the Past: The Interior and the Colonial Revival in American Art and Literature, 1860–1914." In *The Colonial Revival in America*, edited by Alan Axelrod, 241–56. New York: Norton.

Boime, Albert. 1991. *The Magisterial Gaze: Manifest Destiny and American Landscape Painting, c. 1830–1865*. Washington, D.C.: Smithsonian Institution.

Bulkley, Peter B. 1958. "A History of the White Mountain Tourist Industry, 1818–1899." Master's thesis, Dartmouth College.

Burns, Sarah. 1995. "Revitalizing the 'Painted Out' North: Winslow Homer, Manly Health and New England Regionalism in Turn-of-the-Century America." *American Art* 9, no. 2: 20–37.

Burt, Henry M. 1883. *The Boulder and the Flume. The Franconia Avalanche. A Geological Revelation*. Boston: George H. Ellis.

Camille, Michael. 1992. *Image on the Edge: The Margins of Medieval Art*. Cambridge, Mass.: Harvard Univ. Press.

Campbell, Catherine H. 1978. "Two's Company: The Diaries of Thomas Cole and Henry Cheever Pratt on Their Walk Through Crawford Notch, 1828." *Historical New Hampshire* 33, no. 4: 109–33.

———. 1981. "Albert Bierstadt and the White Mountains." *Archives of American Art Journal* 21: 14–23.

Champney, Benjamin. 1893. "The White Hills in 1850: The Advance Guard of the Grand Army of Painters." *White Mountain Echo and Tourist Register* 12: 6.

———. 1900. *Sixty Years' Memories of Art and Artists*. Woburn, Mass.: News Print. Wallace and Andrews.

Church, Frederic E. 1850. Letter. *Bulletin of the American Art Union* 3 (Nov.): 135.

Cikovsky, Nicolai, Jr. 1993. *George Inness*. New York: Abrams.

———. 1995. *Winslow Homer*. New Haven: Yale Univ. Press.

Cikovsky, Nicolai, Jr., and Michael Quick. 1985. *George Inness*. New York: Harper and Row.

Clark, Marcia. 1975. "A Visionary Artist Who Celebrated the Wilds of America." *Smithsonian* 6: 12–36.

Cole, Thomas. 1972. "To Mount Washington." *Thomas Cole's Poetry*. Edited by Marshall B. Tymn. York, Pa.: Liberty Cap Books.

Constable, W. G. 1953. *Richard Wilson*. London: Routledge and Paul.

Cooper, Helen A. 1986. *Winslow Homer Watercolors*. New Haven: Yale Univ. Press.

Craven, Wayne. 1981. "Winckworth Allan Gay, Boston Painter of the White Mountains, Paris, the Nile and Mount Fujiyama." *Antiques* 120: 1222–32.

Crawford, Lucy. 1978. *Lucy Crawford's History of the White Mountains*. Edited by Stearns Morse. Boston: Appalachian Mountain Club.

Cross, George N. 1924. *Randolph, Old and New: Its Ways and By-Ways*. Randolph, N.H.: Town of Randolph.

Daniels, Stephen, Susanne Seymour, and Charles Watkins. 1998. "The Politics of the Picturesque in the Middle Wye Valley." In *Prospects for the Nation: Recent Essays in British Landscape, 1750–1880*, edited by Michael Rosenthal, Christiana Payne, and Scott Wilcox, 157–76. New Haven: Yale Univ. Press.

Drake, Samuel Adams. 1882. *The Heart of the White Mountains, Their Legend and Scenery*. New York: Harper.

Driscoll, John Paul. 1985. *John Frederick Kensett: An American Master*. New York: Norton.

Durand, Asher. 1855. Letter. *The Crayon* 2: 133.

Dwight, Theodore. 1826. *The Northern Traveller*. New York: G. C. Carvell.

———. 1829. *Sketches of Scenery and Manners in the United States*. New York: A. T. Goodrich.

———. 1834. *Things As They Are: or, Notes of a Traveller Through Some of the Middle and Northern States*. New York: Harper and Brothers.

Dwight, Timothy. 1822. *Travels in New England and New York*. Vol. 2. New Haven: Timothy Dwight.

Eliade, Mircea. 1959. *The Sacred and the Profane: The Nature of Religion*. New York: Harcourt Brace.

Eliot, T. S. 1943. *Four Quartets*. New York: Harcourt, Brace.

Emerson, Ralph Waldo. 1960. *Journals and Miscellaneous Notebooks*. Cambridge: Harvard Univ. Press.

Erwin, Kathleen. 1990. Transcription of Thomas Cole's "Sketch of My Tour of the White Mountains with Mr. Pratt." *Bulletin of the Detroit Institute of Arts* 66, no. 1: 1–36.

"Exhibition at the National Academy." 1861. *New York Evening Post*. 7 Feb., 21.

Farmer, John. 1823. *Gazetteer of the State of New Hampshire*. Concord, N.H.: Hill and Moore.

Felker, Tracie. 1990. "Charles Codman: Early Nineteenth-Century Artisan and Artist." *The American Art Journal* 22: 61–86.

Ferber, Linda S., and William H. Gerdts. 1985. *The New Path: Ruskin and the American Pre-Raphaelites*. Brooklyn, N.Y.: Brooklyn Museum.

Fleming Museum. 1973. *George Loring Brown: Landscapes of Europe and America*. Burlington, Vt.: G. Little Press.

Fox, Charles. 1842. *The New Hampshire Book*. Nashua, N.H.: D. Marshall.

Fried, Michael. 1965. *Three American Painters: Kenneth Noland, Jules Olitski, Frank Stella.* Cambridge, Mass.: Fogg Art Museum.

Gidley, Mick, and Robert Lawson-Pebbles, eds. 1989. *Views of American Landscapes.* Cambridge: Cambridge Univ. Press.

Glanz, Dawn. 1978. *How the West Was Drawn.* Ann Arbor: UMI Research Press.

Gombrich, Ernst. 1960. *Art and Illusion: A Study in the Psychology of Pictorial Representation.* New York: Pantheon.

Goodrich, Lloyd. 1968. *The Graphic Art of Winslow Homer.* New York: Museum of Graphic Art.

"The Great Flood of 1936." 1936. *Boston Globe.* 14 Mar., 21.

Gretchko, John M. 1991. "The White Mountains, Thomas Cole and 'Tartarus': The Sublime, the Subliminal, and the Sublimated." In *Savage Eye: Melville and the Visual Arts,* edited by Christopher Sten, 127–45. Kent, Ohio: Kent State Univ. Press.

Grzesiak, Marion. 1993. *The Crayon and the American Landscape.* Montclair, N.J.: The Montclair Art Museum.

Haskell, Barbara. 1980. *Marsden Hartley.* New York: Whitney Museum of American Art.

Hawthorne, Nathaniel. 1946. *Hawthorne's Short Stories.* Edited by Newton Arvin. New York: A. A. Knopf.

Hendricks, Gordon. 1974. *Albert Bierstadt: Painter of the American West.* New York: H. N. Abrams.

Hills, Patricia. 1974. *The Painter's America: Rural and Urban Life 1810–1910.* New York: Praeger.

Hokin, Jeanne. 1993. *Pinnacles and Pyramids: The Art of Marsden Hartley.* Albuquerque, N.M.: Univ. of New Mexico Press.

Holcomb, Adele M. 1974. "The Bridge in the Middle Distance: Symbolic Elements in Romantic Landscape." *The Art Quarterly* 37: 31–58.

Howarth, William. 1982. *Thoreau in the Mountains.* New York: Farrar, Straus, Giroux.

Huntington, Daniel. 1855. Letter. *The Crayon* 2: 215.

Inness, George, Jr. 1917. *Life, Art and Letters of George Inness.* New York: Century.

Isham, Samuel. 1910. *The History of American Painting.* New York: Macmillan.

James, Henry. 1907. *The American Scene.* New York: Harper and Brothers.

Jean-Petit-Matile, Maurice. 1987. *Les alpes vues par les peintres.* Lausanne: Edita.

Josselyn, John. 1672. *New-England's Rarities Discovered.* London: G. Widdowes.

Kammen, Michael. 1992. *Meadows of Memory: Images of Time and Tradition in American Art and Culture.* Austin, Texas: Univ. of Texas Press.

Kandinsky, Vassily. 1914. *Concerning the Spiritual in Art.* Translated by M. T. H. Sadler. 1977. Reprint. New York: Dover.

Kilbourne, Frederick W. 1916. *Chronicles of the White Mountains.* New York: Houghton, Mifflin.

Kinsey, Joni L. 1990. "Sacred and Profane: Thomas Moran's Mountain of the Holy Cross." *Gateway Heritage* 11: 4–23.

———. 1992. *Thomas Moran and the Surveying of the American West.* Washington, D.C.: Smithsonian Institution Press.

Koelsch, William A. 1982. "Antebellum Harvard Students and the Recreational Exploration of the New England Landscape." *Journal of Historical Geography* 8: 362–72.

Koke, Richard J. 1982. *American Landscape and Genre Paintings in the New-York Historical Society.* Vol. 1, no. 717: 345. New York: New-York Historical Society.

Lanman, Charles. 1844. *Letters from a Landscape Painter.* Boston: James Monroe and Co.

Lapham, Donald A. 1975. *Former White Mountain Hotels.* New York: Carlton Press.

Leary, Lewis Gaston. 1962. *John Greenleaf Whittier.* New York: Twayne.

Lewis, Virginia E. 1956. *Russell Smith, Romantic Realist.* Pittsburgh: Univ. of Pittsburgh Press.

Lindquist-Cock, Elizabeth. 1970. "Stereographic Photography and the Western Paintings of Albert Bierstadt." *Art Quarterly* 33, no. 4: 360–78.

Lipke, William C., and Philip N. Grime. 1973. "Albert Bierstadt in New Hampshire." *Currier Gallery of Art Bulletin* 2: 20–34.

Lipp, Wilfred. 1987. "Der Wanderer: Anmerkungen zu einer Real und Kunst-figur der Frühmoderne." *Kunsthistorisches Jahrbuch Graz* 23: 122–45.

Little, Nina Fletcher. 1948. "J. S. Blunt, New England Landscape Painter." *Antiques* 112: 772–74.

Longfellow, Henry W. 1893. *The Complete Poetical Works of Henry Wadsworth Longfellow.* Boston: Houghton Mifflin.

MacAdam, Barbara J. 1988. "'A Proper Distance from the Hills': Nineteenth-Century Landscape Painting in North Conway." In *A Sweet Foretaste of Heaven: Artists in the White Mountains 1830–1930,* by Robert L. McGrath and Barbara J. MacAdam, 21–38. Hanover, N.H.: Hood Museum of Art.

Marin, John. 1970. *John Marin.* Edited by Cleve Gray. New York: Holt, Rinehart and Winston.

Martin, Elizabeth Gilbert. 1904. *Homer Martin: A Reminiscence.* New York: W. Macbeth.

Marx, Leo. 1964. *The Machine in the Garden: Technology and the Pastoral Ideal in America.* New York: Oxford Univ. Press.

Mayo, Lawrence S. 1946. "History of the Legend of Chocorua." *New England Quarterly* 19: 31–56.

McCoubrey, John W. 1965. *American Art 1700–1860: Sources and Documents.* Englewood Cliffs, N.J.: Prentice-Hall.

McGrath, Robert L. 1978. "The White Mountains in the Brown Decades." *Dartmouth College Library Bulletin* 19, no. 1: 15–20.

———. 1989. "New Hampshire Observed: The Art of Edward Hill." *Historical New Hampshire* 44: 30–47.

———. 1993. *Scenes of Placid Lake.* Lake Placid, N.Y.: Lake Placid Center for the Arts.

McGrath, Robert L., and Barbara J. MacAdam. 1988. *A Sweet Foretaste of Heaven: Artists in the White Mountains 1830–1930.* Hanover, N.H.: Hood Museum of Art.

Melville, Herman. 1855. "The Paradise of Bachelors and the Tartarus of Maids." *Harper's New Monthly Magazine* 10: 670–78.

———. 1991. *Clarel: A Poem and Pilgrimage in the Holy Land.* Chicago: Northwestern Univ. Press. Canto 1:17, verses 82–91, 57.

Merrill, John. 1858. *Lecture Delivered at the Flume House Parlor Before a Company of Editors on the System of the Earth's Being Hollow.* Gloucester, Mass.: John S. E. Rogers.

———. 1860. *Cosmogony: or Thoughts on Philosophy.* East Canaan, N.H.: G. F. Kemball.

Miller, Angela. 1993. *The Empire of the Eye: Landscape Representation and American Cultural Politics, 1825–1875.* Ithaca, N.Y.: Cornell Univ. Press.

Mitchell, W. J. T. 1994. *Landscape and Power.* Chicago: Univ. of Chicago Press.

Moore, James C. 1994. "The Storm and the Harvest: The Image of Nature in Mid-Nineteenth-Century American Landscape Painting." Ph.D. dissertation, Indiana University. Ann Arbor, Mich.: University Microfilms.

Mummy [pseud.]. 1856. Letter. *The Crayon* 3: 348–49.

Myers, Kenneth. 1987. *The Catskills: Painters, Writers and Tourists in the Mountains, 1820–1895.* Hanover, N.H.: Univ. Press of New England.

Naef, Weston. 1975. *Era of Exploration: The Rise of Landscape Photography in the American West, 1860–1885.* Buffalo: Albright-Knox Art Gallery.

———. 1980. "'New Eyes'—Luminism and Photography." In *American Light: The Luminist Movement 1850–1875,* edited by John Wilmerding, 267–89. Washington D.C.: National Gallery of Art.

Noble, Louis L. 1964. *The Life and Works of Thomas Cole*. Edited by Elliot S. Vessell. Cambridge, Mass.: Belknap Press of Harvard Univ. Press.

Novak, Barbara. 1969. *American Painting of the Nineteenth Century: Realism, Idealism and American Experience*. New York: Praeger.

———. 1971. "Grand Opera and the Small Still Voice." *Art in America* 59: 64–73.

———. 1980. *Nature and Culture: American Landscape and Painting 1825–1875*. New York: Oxford Univ. Press.

Nygren, Edward. 1986. *Views and Visions: American Landscape Before 1830*. Washington, D.C.: The Corcoran Gallery of Art.

Oakes, William. 1848. *Scenery of the White Mountains*. Boston: Little and Brown.

Parkman, Francis. 1982. *The Oregon Trail*. 1848. Reprint. New York: Viking Penguin.

Parry, Ellwood C., III. 1988. *The Art of Thomas Cole: Ambition and Imagination*. Newark: Univ. of Delaware Press.

Pearce, Roy Harvey. 1979. "The Cry and the Occasion: 'Chocorua to Its Neighbor.'" *The Southern Review* 15: 777–91.

Plymouth State College Art Gallery. 1985. *Edward Hill: A Man of His Time*. Plymouth, N.H.: Plymouth State College Art Gallery.

Poppy Oil [pseud.]. 1856. Letter. *The Crayon* 3: 317–18.

"Praise for E. A. Webster." 1914. *Springfield [Mass.] Republican*. 7 Oct., 12.

"The Recent Slide in the White Mountains." 1883. *Harper's Weekly*. 14 July, 27–38.

Reynolds, David S. 1988. *Beneath the American Renaissance*. New York: Knopf.

Richards, T. Addison. 1856. "The Summer Life of the Artist." *Art Journal* 18: 371–84.

Roberts, Guy. 1924. *The Flume and All about It*. Littleton, N.H.: Courier Printing Co.

Roppen, Georg, and Richard Sommer. 1964. *Strangers and Pilgrims: An Essay on the Journey*. New York: Humanities Press.

Rosenblum, Robert. 1975. *Modern Painting and the Northern Romantic Tradition: Friedrich to Rothko*. New York: Harper and Row.

Roth, Edward. 1864. *Christus Judex*. Boston: I. N. Andrew.

Schapiro, Meyer. 1952. *Paul Cezanne*. New York: H. N. Abrams.

Schlegel, Amy Ingrid. 1998. *Post-Pastoral: New Images of the New England Landscape*. Hanover, N.H.: Hood Museum of Art, Dartmouth College, 1998.

Sears, John F. 1989. *Sacred Places: American Tourist Attractions in the Nineteenth Century*. New York: Oxford Univ. Press.

Sekota, Nochola. 1988. *Fernand Léger: The Later Years*. Munich: Prestel Verlag.

Sheets, Paul D. 1985. "John Muir's Glacial Gospel." *Pacific Historian* 29: 42–53.

Slade, Daniel Denison. 1895. "In the White Mountains with Francis Parkman in 1841." *New England Monthly* 17: 95–112.

Solkin, David H. 1982. *Richard Wilson: The Landscape of Reaction*. London: Tate Gallery of Art.

Southall, Thomas. 1979. "White Mountain Stereographs and the Development of a Collective Vision." In *Points of View: The Stereograph in America—A Cultural History*, edited by Edward W. Earle, 97–108. Rochester, N.Y.: Visual Studies Workshop Press.

Spencer, Harold, ed. 1980. *American Art: Readings from the Colonial Period to the Present*. New York: Scribner.

Starr King, Thomas. 1859. *The White Hills: Their Legends, Landscape and Poetry*. Boston: I. N. Andrews.

Sweeney, J. Gray. 1977. *Themes in American Painting*. Grand Rapids, Mich.: Grand Rapids Art Museum.

Sweetser, M. F. 1879. *Views in the White Mountains*. Portland, Maine: Chisholm Brothers.

Talbot, William. 1972. "Jasper Cropsey." Ph.D. diss., New York Univ. Ann Arbor, Mich.: University Microfilms.

Tatham, David. 1966. "Winslow Homer in the Mountains." *Appalachia* 36: 73–90.

———. 1992. *Winslow Homer and the Illustrated Book*. Syracuse: Syracuse Univ. Press.

Taylor, Bayard. 1862. *At Home and Abroad: A Sketch Book of Life, Scenery and Men*. New York: Putnam.

"A Tour of the White Mountains." 1852. *Harper's New Monthly Magazine* 5: 11.

Trenton, Patricia. 1983. *The Rocky Mountains: A Vision for American Artists of the Nineteenth Century*. Norman, Oklahoma: Univ. of Oklahoma Press.

Truettner, William H. 1991. "Ideology and Image." In *The West as America: Reinterpreting Images of the Frontier, 1820–1920*, edited by William Treuttner, 30–36. Washington, D.C.: Smithsonian Institution Press.

Tuckerman, Frederick. 1926. "White Mountain Notes." *Appalachia* 16: 292–97.

Tuckerman, Henry T. 1867. *Book of the Artists: American Artists Life*. New York: G. P. Putnam and Son.

———. [1852] 1967. *The Home Book of the Picturesque: or American Scenery, Arts and Letters*. Reprint. Gainesville, Fla.: Scholars' Facsimiles and Reprints.

Turner, Victor, and Edith Turner. 1978. *Image and Pilgrimage in Christian Culture.* New York: Columbia Univ. Press.

Updike, John. 1966. *The Music School.* New York: A. A. Knopf.

———. 1972. *Museums and Women.* New York: A. A. Knopf.

Wallace, Anne D. 1993. *Walking, Literature and English Culture: The Origins and Uses of Peripatetic in the Nineteenth Century.* Oxford: Clarendon Press.

Wallach, Alan. 1981. "Thomas Cole and the Aristocracy." *Arts Magazine* 56: 94–106.

Ward, Julius H. 1890. *The White Mountains: A Guide to their Interpretation.* New York: D. Appleton and Co.

Warnke, Martin. 1995. *Political Landscape: The Art History of Nature.* Cambridge, Mass.: Harvard Univ. Press.

Waterman, Laura, and Guy Waterman. 1989. *Forest and Crag: A History of Hiking, Trailblazing and Adventure in the Northeast Mountains.* Boston: Appalachian Mountain Club.

Weiss, Ila. 1987. *Poetic Landscape: The Art and Experience of Sanford R. Gifford.* Newark, Del.: Univ. of Delaware Press.

Whittier, John Greenleaf. 1904. *The Complete Poetical Works of John Greenleaf Whittier.* Boston: Houghton, Mifflin.

Wiegand, Wilfried. 1971. *Ruisdael-Studien: Ein Versuch zur Ikonologie der Landschaffsmalerei.* Hamburg: Prestel Verlag.

Willey, Benjamin G. 1856. *Incidents in White Mountain History.* Boston: Nathaniel Noyes.

Willis, N. P., ed. 1829. *The Token; A Christmas and New Year's Present.* Boston: S. G. Goodrich.

———. 1839. *American Scenery: Illustrations of Transatlantic Nature.* London: George Virtue.

Wordsworth, William. [1798] 1985. "Tintern Abbey." *William Wordsworth.* Edited by Jonathan Wordsworth. New York: Cambridge Univ. Press. 33–40.

INDEX